PRAISE FOR

T0151672

"In recounting the secret history of *L'Origine*, Lilianne Milgrom offers us an entertaining, provocative read, which will continue to intrigue us and invite speculation, long after we have turned the last page."
—*California Review of Books*

"*L'Origine* got me hooked—what a story! Milgrom brings the reader right along on her adventures as a copyist of one of the most well-known paintings in all of France and maybe even the world."
—Harriet Welty Rochefort, author of *French Fried, French Toast, Joie de Vivre*, and *Final Transgression*

"*L'Origine* is a testament to the wealth of talent that deserves wider recognition in the publishing world."
—Cevin Bryerman, CEO and publisher of *Publishers Weekly*

"*L'Origine* is, indeed, an apt title for Lilianne Milgrom's debut novel, since it is the painting itself—*L'Origine du monde*—that is the heroine of this vividly written, well-researched, and highly compelling book. Part historical fiction, part personal journey, *L'Origine* tells the story of 'the world's most erotic masterpiece' and

its effect on those who tried to capture it, in one way or another—including Milgrom herself. The notorious little painting is, above all, a survivor. Its page-turning odyssey, told in richly textured prose, is an original story well worth reading."

—Barbara Linn Probst, awarding-winning
author of *Queen of the Owls: A Novel*

"What a gorgeous, captivating novel: a tour de force! Who knew that a painting's provenance could make for such a profoundly moving and thought-provoking page-turner? I couldn't read fast enough and at the same time didn't want to reach the end. Milgrom has written a masterpiece worthy of the iconic Gustave Courbet painting that lies at the heart of *L'Origine*."

—Joan Dempsey, author of the award-
winning novel *This Is How It Begins*

"What an enterprising choice for a story by an artist who was simply bewitched by her subject. The book ends up being part mystery, history lesson, personal quest, and an examination of what sexuality is all about."

—Peter Eisner, veteran foreign correspondent,
author, and winner of the Christopher Award

"Lilianne Milgrom has produced a vivid and well-told novel that tells the story of one of the more notorious paintings in the history of art. Immaculately researched and full of verve, the book is a real achievement,

one which I read with fascination and admiration. Milgrom is an artist as well as a novelist, and her story of Courbet's masterpiece is prefaced with a tale of her own: how she spent several weeks in the Musée d'Orsay making a painted copy of Courbet's original *L'Origine du monde* painting, under the curious and sometimes lascivious eye of other museum goers. When the narrative transports the reader back to nineteenth-century Paris and into Courbet's studio, we are already primed in the intimate and complex processes that the act of looking initiates. The author clearly has a deep admiration for Courbet and his infamous painting. One of the pleasures of the novel is that there is still room for a book that celebrates the creative and erotic possibilities generated between an artist, their model, and the centuries-old act of looking. Five stars."

—Christopher P. Jones, historian, art critic, and author

"There's nothing like a good story to grip a reader, and Milgrom's own tale of witnessing and emulating Gustave Courbet's *L'Origine du monde* is the perfect way to get into—and attempt to understand—this infamous masterpiece. Highly recommended for art history aficionados, Francophiles, and history and biography fans. It exposes readers who stand outside the normal confines of the art world to the fascinating world beyond the frame."

—Jennifer Dasal, podcast host of *ArtCurious* and author of *ArtCurious: Stories of the Unexpected, Slightly Odd, and Strangely Wonderful in Art History*

L'Origine

L'Origine

A NOVEL

*The secret life of the world's
most erotic masterpiece*

LILIANNE MILGROM

GIRL FRIDAY BOOKS

Published by Girl Friday Books™, Seattle

Produced by Girl Friday Productions
www.girlfridayproductions.com

Design: Lilianne Milgrom
Project management: Devon Fredericksen
Cover image: Courtesy of Metropolitan Museum of Art / H. O. Havemeyer Collection, Bequest of Mrs. H. O. Havemeyer, 1929

ISBN (paperback): 978-1-954854-14-7
ISBN (e-book): 978-1-954854-15-4

Library of Congress Control Number: 2021906019

For Mira

Men dream of women.
Women dream of themselves being dreamt of.
Men look at women.
Women watch themselves being looked at.

—John Berger

I feel there is something unexplored about women
that only a woman can explore.

—Georgia O'Keefe

PROLOGUE

The Copyist

Paris, Winter 2011
The Orsay Museum

It stopped me dead in my tracks. Granted, I *was* in Paris, but nonetheless, this wasn't something you'd expect to see in one of the most celebrated museums in the world. Prominently displayed on its own dedicated wall and hanging at eye level was a realistically rendered, X-rated, peep-show perspective of a woman's exposed genitals. Not a fig leaf in sight. The parted thighs drew my eye toward the riotous pubic bush just left of dead center. The vulva was split asunder by a palette-knife slash of scarlet. A shadowed ravine divided the buttocks into two creamy rounded orbs and only a single breast, crested by a blush-colored nipple, peeked out from beneath rumpled sheets. No face, no legs, no arms. Just lady bits.

I knew that staring was rude, but what could possibly be ruder than what I was staring at? Even *sans* the strategically angled museum lights and the dusky aubergine backdrop, the painting was riveting. For its modest size, it packed a monumental punch, yet it exuded dignity and reverence—a fitting homage to nature's inspired genius. The tasteless reproductions stamped

onto T-shirts and mugs bore little resemblance to the original painting before me.

Stifled guffaws reminded me that I wasn't the only voyeur. People were milling about trying not to gape, while others took a good long gawk and scurried off like lecherous patrons at a girlie show on the south side of town. I felt inexplicably affronted on behalf of the headless, nameless model. By contrast, she seemed unfazed and unabashed. The more I gazed, the less she appeared constrained by the ornately carved and gilded frame that confined her. One could almost hear her sigh as she stretched her invisible arms lazily overhead and settled her naked rump deeper into the white bedclothes. The word *languishing* came to mind. I bent forward to read the caption.

<div align="center">

L'ORIGINE DU MONDE
(THE ORIGIN OF THE WORLD),
1866 GUSTAVE COURBET

</div>

I was contemplating the pairing of the salacious subject with its provocative title when my reverie was interrupted by a young fellow standing next to me, shaking his head in equal parts disbelief and glee. He too seemed hypnotized by the painting.

"That's gotta be the first beaver shot in the history of art!" he finally announced to no one in particular. He had a point. There was no disputing that Gustave Courbet had created an unprecedented image for his time. The

explanatory wall text informed me that the painting had been hidden or thought missing for close to a century and a half and that it measured a mere eighteen by twenty-two inches. As an artist, I felt sheepish about my ignorance apropos the iconic vulvic portrait. What had motivated Gustave Courbet to paint *The Origin of the World* and why the eccentric perspective? Who was the model? Clearly, I should've been paying more attention during Art History 101 instead of mooning over that cute art student in the back row. Tom? Or was it Trevor? Back then, the painting's whereabouts were still unknown. Where had it been all that time?

Glancing at my watch, I realized that the afternoon was slipping by. I'd just arrived in Paris on an extended artist residency and was visiting the Orsay to get the creative juices flowing. It was time to expand the aperture beyond female sex organs and take advantage of the museum's superlative art collection. I stole one last look at *L'Origine* before meandering through the museum's galleries and corridors brimming with the choicest paintings, sculptures, and objets d'art from the nineteenth and early-twentieth centuries. Yet Courbet's *The Origin of the World* had exacted a strange hold over me. Not even my favorite psychedelic Van Gogh portraits, nor Gauguin's bare-chested Tahitian beauties, could totally erase the lingering afterimage of *L'Origine du monde*. From the moment I laid eyes on Gustave Courbet's sensational masterpiece, I was smitten. The audacity, the beauty, the fearlessness of it!

I felt a little frisson working its way up my spine. The frisson, however, didn't reach all the way down to my feet, which were beginning to rise up in mutiny at having to walk the museum's hallowed halls for the past four hours. It was time to call it a day. I had to pace myself—this was only the second day of seven glorious weeks in Paris during which I could follow my muse as I pleased. Seven weeks! I wanted to pinch myself.

What transpired next is still something of a mystery. As I made my way to the museum's exit, my feet took a sudden detour toward the information desk. Elbowing my way through the throng, I tried to catch the eye of the sultry mademoiselle behind the counter who cut a striking figure in her black-and-red striped blouse and matching two-toned hair.

"*Excusez-moi*," I said, vying for her attention. "How do I find out about becoming a copyist here at the Orsay?"

My question caught me as much by surprise as it did the Striped Wonder, who, apart from handing out maps and pointing to the impressionist galleries, probably spent most of her days directing visitors to the restrooms.

I repeated my request in French, and her demeanor softened an iota. With a bit more prompting, she outlined an arduous application process that took up to

three months and sounded even harder than biting into the end of a stale baguette. Not to be deterred, I explained that I'd come to Paris for seven weeks in toto and therefore could not *possibly* go through the normal channels. Her helpful demeanor turned mildly sour. With a thin smile she inquired as to which tableau "madame" had set her sights on? Without a moment's hesitation, I blurted out: *"L'Origine du monde!"*

Raising one perfectly groomed eyebrow, the young woman regarded me with renewed interest. *"Un petit moment, madame,"* she declared as she reached for the phone by her elbow and whispered into the receiver. She instructed me to wait, and I stood nervously off to the side. Even though copying the masters is a time-honored means of artistic edification, I had never attempted, nor been tempted, to copy another artist's work, let alone in public, where one's artistic shortcomings might be all too evident. I much preferred to make my creative blunders in the privacy of my own studio.

A slightly disheveled woman in black-rimmed glasses appeared and introduced herself as the head of the museum's *bureau des copistes*. I listened politely as she repeated the museum's cumbersome application process. Unable to censor the words coming out of my mouth, I appealed to her for special consideration as if my life depended upon copying Courbet's painting, a painting that until a few hours before had not even been a blip on my radar. After some intense grilling, my interrogator confided that I was the first artist to request permission

to copy the iconic *L'Origine*. Copying that painting would be a courageous undertaking, especially for a woman, she said warningly. She scanned my over-the-knee boots, ankle-length mohair coat, and the pink-tipped bangs just quirky enough to pass as artsy without setting off any alarm bells.

"*D'accord*," she said, evidently finding nothing that would indicate a potential threat to one of the museum's most prized possessions. "It will be interesting to see the results. Giselle will give you the contract. Come by my office tomorrow afternoon with all the necessary documents. And don't forget to bring along a canvas that's fifteen percent larger, or smaller, than the original—that's up to you. If everything's in order, you can start copying by the beginning of next week."

I tried my best to look overjoyed as I gushed my thanks to Madame la Directrice. But as I walked dazedly toward the exit, a terrible sinking feeling was settling itself in the pit of my stomach. What had I gotten myself into? I was riddled with doubt and anxiety. Did I really want to spend my precious time in Paris copying a painting? What purpose would it serve? And how on earth would I manage to gather the required documents by the next afternoon, not to mention the custom-made canvas?

Once I stepped outside, the smell of roasted chestnuts snapped me out of my funk. I looked around at the darkening Parisian cityscape with its copper-streaked cupolas and gold-tipped monuments glittering in the

distance. Paris—the city of my birth—never failed to enchant. My previous visits to this magical city had primarily consisted of nostalgic walks down memory lane, punctuated by a daily regimen of *pain au chocolat*. But this visit was different. I'd come on a mission, albeit a vague one.

For the past several months, I'd been holed up in my studio in Washington, DC, trying to come to terms with the somewhat abrupt realization that I'd reached an age that qualified me as a "woman of a certain age" and with that came the looming prospect of diminishing sexual appeal—a most *un*appealing thought. I was not prepared to take this injustice lying down and had begun to examine the subject of sexuality and aging in my studio practice. But translating my inchoate emotions into visual language had proven to be an exercise in frustration. It dawned on me one morning that Paris would be the perfect place to pursue this topic. It's no secret that French men still wax lyrical about octogenarian sex-kitten Brigitte Bardot, and Napoleon himself remarked: "Give a woman six months in Paris, and she knows where her empire is, and what is her due."

I latched onto the idea with a vengeance, imagining myself enacting my youthful fantasies of the artist's life in some seventeenth-century garret on the Left Bank. But bankrolling an extended stay in Paris was another matter altogether. After being rejected by the few residencies in Paris that sponsored artists (in one case,

because of my age!), I hit a low point in my crusade. That's when I heard about Madame G.

Rumor had it that the modern-day patroness of the arts offered her residence on the outskirts of Paris to the occasional visiting artist. I wasted no time petitioning the mysterious Madame G. A volley of feisty emails rapidly established that we were kindred spirits, and it was a matter of days before she offered me her Parisian loft rent-free for two months. What artist in his or her right mind could refuse such an offer? There was only one catch—Madame G was leaving forthwith for parts unknown and the offer was good starting immediately, as in *tout de suite*. I had nothing to lose and everything to gain. My husband was on the road more often than not, and my children had flown the coop. That left the cat, who could easily be compensated for my absence with gourmet cat treats. My response to Madame G was a resounding *oui!*

Barely one week later, I found myself pulled into the vortex of one of the world's most erotic masterpieces and into the arms of one of the most alluring bad boys in the history of art. As I stood outside the Orsay weighing up the pros and cons of copying *L'Origine*, a bedraggled accordionist began playing Edith Piaf's "Non, je ne regrette rien" ("No, I regret nothing"). Suddenly, everything fell into place—I had no road map for how to find what I was searching for and no idea what exactly I was hoping to find, but *The Origin of the World* offered as good a starting point as any.

Winding my long woolen scarf around my neck and chin in typical French style, I crossed the plaza and headed up rue de Solférino with a determined spring in my step and a smile on my face.

I awoke the next morning chilled to the bone and disoriented from a dream involving goats rampaging through the Orsay Museum. After a few half-hearted jumping jacks, I shrugged my winter coat on over my pajamas and padded downstairs. The space-age gas fireplace looked as petulant as it did the night before when I'd tried unsuccessfully to ignite it. French appliances were sexy, but they required a counterintuitive logic to operate.

Looking around the airy multilevel loft with its soaring ceiling, state-of-the-art appliances, vintage flea-market decor, and impressive wall art, I wondered if I was still dreaming. My arrival at Madame G's had been hectic, and my new circumstances had not totally sunk in. Only three days had elapsed since I'd juggled my suitcases up Madame G's impossibly steep spiral staircase like the Hunchback of Notre-Dame. She had greeted me as if the prospect of a rain-soaked stranger about to move into her home was the most natural thing in the world. Madame G belongs to that rare breed of free spirit who crisscrosses the globe, embracing adventure, and picking up lovers and strangers along the way like so many stray cats.

Dispensing with unnecessary formalities, she ush-
ered me inside. There was no time for lengthy introduc-
tions or grand tours because in the hours left before her
departure, Madame G had yet to sort out an impending
lawsuit, a backed-up sink, and a pinched nerve. After an
endless parade of visitors and numerous frantic phone
calls, she fired off an onslaught of last-minute remind-
ers. Delivering a final, ominous warning about the high
cost of electricity, she bid me adieu and handed over the
keys to her kingdom.

Not having had a moment in the three days since my
arrival to stock up on groceries, I vainly rooted around
in the fridge to see what breakfast-worthy edibles
Madame G might have left behind. Two pears, an open
jar of Dijon mustard, a bottle of Bordeaux, and, peeking
from beneath a blue-checkered tea towel on the bottom
shelf, the remains of a tart. My mouth watered as I cut
through the flaky crust and sweet-smelling frangipane
filling.

Ingesting an admittedly gluttonous morsel, I yelped
in pain as my teeth bit down on a rigid object that I
promptly began to choke on. Reaching down my throat,
I extracted an inch-tall plastic figurine of a buxom, blue-
faced she-warrior from the sci-fi blockbuster *Avatar*. I
hadn't been partaking of any mind-altering substances,
but I could think of no other reasonable explanation until
the realization slowly dawned on me—the innocent-
looking tart must have been a *galette des rois*. Only
eaten in January, these specialty tarts contain *une petite*

surprise in the form of a little porcelain or plastic figurine known as a *fève*. The person served the slice with the hidden *fève* is believed to be blessed with good fortune. I rinsed the sticky she-warrior figurine and put it in my purse—I was going to need all the luck I could get in order to round up the mountain of copyist documents listed in the information packet sitting on the ruby-red kitchen counter.

I knew Paris well enough to know that nothing was going to be simple or straightforward. Commercial enterprises and administrative offices in France pride themselves on providing specialized niche services—the idea of one-stop shopping had yet to cross the Atlantic. Even if I succeeded in tracking down everything on my *copiste* to-do list, it was almost a given that every stop along the way would be on opposite ends of Paris and that their hours of operation would have no rhyme or reason.

Bundling up against the cold, I turned off all the lights (Madame G's parting words still ringing in my ears) and grabbed a withered pear for sustenance. I was soon crisscrossing Paris, collecting documents and desperately hunting for a photocopy machine, eventually finding one hidden away in the sub-basement of a Galeries Lafayette department store. My next stop was the train station, where I contorted myself into a grimy photo booth. Sidestepping the used condom stuck to the floor, I longed for a bottle of hand sanitizer. Attempting a variety of poses—a pout, a smolder, a smile (with teeth

and without)—I finally settled on the least damaging to my ego and tore up the rest.

Ducking into the nearest café, I nursed a tiny cup of espresso until feeling was restored to my extremities. My stylish suede boots and sleek leather gloves were no match for the worst winter France was experiencing in half a century. Once my fingers were operational, I pulled out my phone and started calling around to art stores, only to discover that most were closed on that day of the week. When one lone store finally picked up, I almost cried in gratitude. The owner put me on hold while he checked his inventory, returning after what seemed like an eternity to inform me that he had one canvas approximating the dimensions I'd given him. Eureka! But the store was closing in thirty minutes and *non*, he couldn't keep the shop open until I got there. Muttering unpleasant thoughts about the unyielding and lackadaisical business practices of the French, I tossed ten euros on the table and dashed to the nearest métro station.

I arrived winded, just as the shop owner was locking up. He looked up with a startled expression at the sight of a panting woman holding on to the wall to catch her breath. French women do not run. Raising both eyebrows, he inquired, *"Où est le feu, madame? Where is the fire, madam?"* After composing myself, I entered the shop and was instantly transported back in time. The ancient wooden beams and worn stone floor were permeated with decades-old fumes of rabbit-skin glue, turpentine, and linseed oil. A sprinkling of dust

covered the snowy sheets of Arches watercolor paper, and behind the glass of an antique credenza, handmade squirrel-hair brushes rested alongside silver-nibbed quills. This was Paris—with every step one took, one tripped over the past.

I wished I could linger, but the bespectacled storekeeper was impatient to get home. The blank canvas that he placed on the counter was a work of art in itself. Dozens of hand-hammered tacks anchored the fine Belgian linen to its sturdy frame, like the nailhead detailing on a vintage leather armchair. It was worlds away from the made-in-China, shrink-wrapped canvases sold in the mega art emporiums back home. Holding my prize close to my chest, I felt like the winner of a marathon scavenger hunt. It was back to the métro station, where I descended once again into its urine-stained subterranean depths in the direction of the Orsay Museum.

Madame la Directrice looked surprised to see me. I surrendered my paperwork and canvas for inspection and held my breath, my fingers surreptitiously searching for the plastic talisman at the bottom of my pocketbook. Ten minutes later, I exited her office the proud owner of an official *copiste* badge from the venerable Musée d'Orsay. The museum being closed on Mondays, I was to report at 9:30 a.m. sharp on Tuesday morning.

I spent most of the weekend recovering from my ordeal and getting my affairs in order. I explored the neighborhood, stocked up on groceries, and caught up on emails, including one to my husband informing him of my intention to copy one of the most controversial paintings in the history of art. To prove my point, I attached an image of *L'Origine du monde*, not realizing that he was still at the office. The poor man practically leapt across his desk to slam his laptop shut in case a coworker might accuse him of watching porn on company time. The image that Courbet painted a hundred and fifty years ago still wasn't ready for prime time, as some unsuspecting Facebook users learned the hard way when their private Facebook accounts were suspended for having innocently shared *L'Origine*'s image. The French dragged Facebook into court for attempting to censor their precious national treasure. (Spoiler: The social media goliath lost the battle.)

On Tuesday morning, the temperature plummeted well below freezing and there was a dusting of snow on the ground. I piled on layers of warm clothing and headed off to battle, armed with charcoal sticks, paints, brushes, rags, and an empty Bonne Maman jam jar found under Madame G's kitchen sink. On my way to the train station, I dropped a coin for a homeless man huddled against the cold with his poor little pet rabbit. The air

smelled of fresh bread, coffee, and cigarettes. Though not everybody's idea of olfactory heaven, it was music to my nose.

Waiting on the freezing open-air train platform, it was hard to suppress my excitement. Every time a commuter looked my way, I wondered if they could sense the adventure I was about to embark upon. The notoriously unreliable RER C train finally arrived and delivered me to the Orsay Museum's doorstep, where I clocked in at the employee entrance as instructed. The director was already waiting for me in the marble-checkered foyer dominated by a majestic staircase. Originally built as a train station, the Orsay Museum's grandiose Beaux Arts architecture and exquisite detailing rivaled the art it housed.

Madame la Directrice introduced me to the jovial and uniformed Pierre, whose job it was to record the arrival and departure of every employee. She then ushered me through the security door and into the museum, which was already humming with the anticipated arrival of visitors by the thousands. We rode down a tight elevator into the bowels of the museum, where the smell of turpentine was a sure giveaway that we were approaching the artists' lair. The little windowless room was a jumble of easels, stools, and unfinished paintings. The first order of the day was to have my virgin canvas

stamped and signed on both sides to avoid any forgery attempts I might entertain in the future. My chaperone then rattled off a long list of rules and regulations, and pecked me on both cheeks before getting back to more pressing duties.

I selected the least wobbly of the available easels and struggled to release it from its locked combat with neighboring easels. After a final tug I hoisted a *tabouret* (a wooden stool) over one shoulder and, with my back-pack hanging off the other, clumsily maneuvered myself into the deserted, fluorescent-lit hallway. Possessing zero sense of direction, I took several wrong turns before finding the service elevator that would take me back up to the ground floor. The first wave of visitors trans-formed my path into an obstacle course as I wheeled my *chevalet* along the wide passageways flanked by the world's greatest masterpieces. I imagined that genera-tions of artists past were welcoming me into their ranks like a ghostly honor guard.

My heart beat frenetically inside my chest, its drum-beat increasing tenfold as I entered the Courbet galler-ies. Stopping at the threshold of the interior room that housed *The Origin of the World*, I stood for a moment facing the painting. There was no turning back. A hand-ful of visitors gave me strange looks as I parked my easel in front of the cordon that protected *L'Origine*. An acute attack of embarrassment threatened my resolve. Looking at a painting like *L'Origine* on one's own is one thing, but having others watch you looking is awkward, to say the

least. My hands trembled and my confidence wavered. I busied myself setting up a makeshift studio under the watchful eye of the museum guard sitting in the corner of the room. One of my acrylic tubes had leaked, leaving a sticky red residue at the bottom of my backpack. Not a great start. Cleaning up as best I could, I then began the satisfying task of squeezing out a rainbow of colored paint worms onto my disposable palette, arranging the cool colors on one side and the warm colors on the other.

After fussing with my brushes and my rags I still couldn't bring myself to start, so I took a nervous stroll around the room pretending to be engrossed in the other Courbet paintings on exhibit. There were scenes of fighting stags and dense forests as well as naked, supine women. But I swear I could feel the white expanse of my canvas following me with its blank eyes. The Russian abstract painter Wassily Kandinsky once remarked that an empty canvas is crammed with thousands of underlying tensions and is full of expectancy. Until that moment, I had never truly grasped the full force of that statement.

Mustering courage from my anonymity, I circled back to my easel. *L'Origine du monde* wasn't the first nude to enter into the museum's collection—not by a long shot. The Orsay was filled with sleek marble buttocks and breasts, and innumerable painted females in various stages of undress. What differentiated Courbet's painting was its exposed, unguarded nakedness. In the 1500s, the Church issued a decree censoring the portrayal of genitalia, forcing artists to use props such as an

errant hand, a curled fig leaf, or a cascading fold of fabric to cover the offending body parts. In one fell swoop, Courbet swept away centuries of taboo.

Most people find *L'Origine*'s nakedness uncomfortable to behold. The inimitable late art critic John Berger gave voice to the root of that discomfort: "Nudity," he said, "is placed on display. Nakedness reveals itself. To be naked is to be without disguise." Gustave Courbet was never interested in pandering to our finer sensibilities—he'd made it his mission in life to battle artifice and deception no matter the cost. In keeping with the uncompromising principles of the realist movement he spearheaded, Courbet had insisted on painting only what he could see with his own eyes. "Show me an angel, and I shall paint one!" he goaded his detractors. Indeed, the image staring back at me was clearly no angel, but a very real woman, as Mother Nature intended her to be.

I couldn't stall any longer and picked up a stick of charcoal, forcing myself to ignore the curious onlookers. I began by dividing the canvas into quadrants and mapping out the image with large gestural strokes. The act of copying almost immediately neutralized the painting's erotic aura. I was no longer processing an image—I was concentrating on angles, planes, and curves, my practiced eye-hand coordination kicking in. Without an accurate drawing to build upon, a painting is like a crooked house with a flawed foundation. Once I entered Courbet's intimate world, I blanked out all activity around me. For the next few hours I was in the zone,

totally immersed in the act of drawing and seeing, any thoughts of sexuality and aging far from my mind.

Although I knew that *L'Origine du monde* was one of the museum's superstars, I hadn't anticipated the continuous foot traffic. In the course of my first day, I witnessed a stream of guided tours, art aficionados, gawkers, twittering Japanese tourists, and weary middle-aged American couples.

"Hey, Doris! Stand in front of this one and I'll take a picture!"

"Ew! No way, I don't want to . . ."

"Oh, c'monnn, Doris. Do it!"

Before I knew it, I'd completed a fairly accurate drawing, even receiving an approving nod from the museum guard. But when I realized what time it was, I flew into a panic. Protocol called for all *copistes* to sign out by 1:00 p.m. *No Exceptions.* I had five minutes to pack my gear, return the *chevalet*, and sign out with Pierre. I couldn't wait for my next session with *L'Origine*.

My second day was easier on the nerves, and the day after that, easier still. It was becoming almost routine for me to greet Pierre in the morning with a singsong bonjour, scan my ID badge, and ride the elevator down to the basement to collect my mobile studio. As I wheeled my easel into the Courbet galleries, I often paused to greet Courbet's dreamy self-portraits. I searched the

handsome, Johnny Depp–like face and those liquid brown eyes for signs of the rebellious youth who, against his father's wishes, had left his provincial town for Paris, forecasting that within five years he would conquer the big city. That he did, surprising almost everyone except himself.

By week's end I'd made substantial progress. The charcoal sketch was refined and outlined with alizarin crimson, and a tonal underpainting was blocked in to establish the dark and light values. Nonetheless, I felt self-conscious because I knew that people were comparing my rudimentary copy with Courbet's original. To the average museumgoer, my copy probably looked like an amateurish mess. But a painting develops in stages. It is a process that demands as much intellectual application as technical know-how and talent. The next phase— applying and matching the colors—would be a greater challenge. Courbet, like all artists of his day, used oil paints, and although acrylic paints were my medium of choice (they dry fast and I don't have to bother with toxic fumes), it would be difficult to match the skin tones and creamy textures of Courbet's oil painting. I believe it was Willem de Kooning who came up with the delightful hypothesis that oil paints were invented specifically to render human flesh.

No less of a challenge was getting used to being the object of people's gaze. I was subject and object, artist and viewer, all rolled into one. Visitors were baffled, curious, or amused by what they considered to be my

very adventurous undertaking. The most common question asked of me was: "Why did you choose to copy this painting?" I came up with a canned response couched in quasi-artspeak, although in reality, I was still asking myself that same question. What was I hoping *L'Origine* would divulge? Would I discover something about myself through this intensely personal slash public endeavor?

The more I interacted with the public, the more fascinated I became with what *others* saw in Courbet's painting. For one elderly gentleman, it triggered memories of his deceased wife, while for one sweet little grandma it seemed like the perfect teaching tool to introduce her granddaughter to the birds and the bees. It didn't quite go as planned.

"Look, *chérie*," said Grandma. "That's where all babies come from."

"No, it isn't!" whined her young charge.

"But it is, my little cabbage. You too came into the world from there."

"No, I didn't!" replied the little girl, stamping her foot. "Maman had a caesarean!"

It should be noted that Gustave Courbet is something of a celebrity in France. The men and women who have contributed to France's rich cultural legacy enjoy the equivalent star power that Hollywood movie stars do in the United States. Courbet's legendary eccentricity and revolutionary accomplishments are a source of Gallic pride. For the most part, Courbet's countrymen have taken him under their collective wing, treating him

with the sort of indulgence one reserves for a lovable but scandalous uncle. In a society reputed for its permissive, laissez-faire attitude, *L'Origine du monde*'s explosive public debut in 1995 won over the last of the Courbet skeptics.

I observed this French perspective firsthand at my friend André's dinner party. After a week's worth of copying and interacting with strangers, I was looking forward to spending time with friends. Arriving at André's boho Bastille apartment thirty minutes late (punctual by French standards), I followed the jazzy strains of Charlie Parker up to the fourth floor. The André who opened the door was a few pounds heavier than the last time we met, but he still wore a scruffy beard (now streaked with gray), and the Rabelaisian glint in his eye was still intact behind his frameless glasses. We hugged like the old friends that we were. After relieving me of the bag of pungent cheeses I had brought along, André introduced me to his friends as an American artist and official *copiste* of Gustave Courbet's *L'Origine du monde*. Instant stardom! This juicy bit of news caught everyone's immediate attention. Even though I struggled to understand the torrent of French delivered at a pace faster than the speed of sound, it was clear that my stint at the Orsay Museum made me something of a celebrity.

Over a delicious multicourse meal, André and his friends quizzed me about my copyist experience and weighed in with their own impressions of *L'Origine du monde*. Raising his glass of Sancerre, André summarized

his sentiments in an irresistible French accent. "I agree *absolument* with Gustave! Zee woman, she is everything in zee world—mother, lover, sister, confidante . . . !" While I was privately swooning at those words and wishing my husband would make similar pronouncements, André's partner dismissed his romantic notions, insisting that the painting was solely a representation of motherhood and childbirth.

A lively debate ensued until Philippe, the soft-spoken author sitting to my right, tentatively recounted how, days after a visit to the Orsay some years back, he'd received the shocking news that his mother had unexpectedly passed away. He immediately made arrangements to be present at her funeral and, upon arriving at the funeral home, was ushered in to view the body and pay his final respects. He described placing his hand on his mother's inner thigh in a spontaneous gesture that communicated not only the intimate maternal bond but also acknowledged her as the source of his creation. It was only later that he made the connection between his actions and his recent viewing of *L'Origine*.

If I had any lingering doubts about the wisdom of my choice to copy Courbet's painting, they were dispelled by the enlightening soirée. *L'Origine* was no ordinary painting, and by default, I was no ordinary *copiste*. I now saw myself through the eyes of André's guests—a valiant artist using her brush to declare to one and all: I Am Woman. I felt ripe with feminine empowerment and was itching to get back to work.

By the third week, my copy was beginning to shape up nicely. I knew this because I was getting that heart-thumping feeling that happens when I know, just *know*, that a painting I'm working on could be a winner. This was the moment when I had to resist becoming overly cautious, a tendency that almost guarantees sabotaging all the promising work done thus far. I could also tell that my copy was hitting the mark by the increasing number of people giving me the thumbs-up.

I did have my critics, however. One morning, two dapper Frenchmen in tailored dark suits ambled into the room at a delicate juncture in my painting—defining the clitoris (have I mentioned that Courbet took realism seriously?). The two silver foxes stationed themselves behind me, arms folded, murmuring together. Even though I was becoming inured to intrusions and comments, I was acutely aware that two attractive men were looking on as I tickled a clitoris with my brush.

I laid the brush down on the edge of my paper palette and faced my spectators. "So how do you like it so far?" I inquired with a cheeky smile. They practically fell over each other with praise. *Bravo! Formidable! Chapeau!* They hung around for a while, talking and flirting, and when they left, I giggled to myself and picked up where I'd left off. But a moment later, one of the two came back. In a low, intimate voice, he asked if he might give me some critical input.

"*Bah, bien sur*! Of course!" I said, curious.

"*Alors*," he said, pointing to my copy. "The lips." For a moment I considered the possibility that he was talking about a different painting. Lips? *L'Origine du monde* didn't even have a face, let alone lips. He turned to Courbet's painting. "Courbet's lips, they are ready for love. Your lips . . . ," he said, turning sadly to my copy, "are not open enough for love . . ." He stood back and allowed his words to sink in. I let out an involuntary I-can't-believe-he-just-said-that laugh, but looking at my critic, it was clear that his comment was meant in earnest.

I compared the two painted vulvas and conceded that the guy knew the difference between a woman who was ready for *amour* and one who wasn't. I thanked him for his invaluable observation.

"Could I invite you for a drink later?" he asked in response.

I cannot lie—I was sorely tempted by his sapphire eyes and handsomely weathered face but declined his proposition, one of several I had received over the past few weeks. Not to be coy about my undisputed attractions, but I was pretty sure that he was confusing me with someone else, namely, *L'Origine du monde*. As the painting's copyist, some men saw me as the living embodiment of *L'Origine* by proxy. It was made abundantly clear one night when I went out for a drink with a cute jazz musician who lived in the same complex as Madame G's. I admit I was flattered by the attentions of

this much younger man. We were both mildly inebriated by the time he walked me back to my door. As I inserted my key in the lock and turned to bid him good night, he enveloped me in his arms and, pressing his cheek against mine, whispered, "I want to kiss your *L'Origine du monde*..."

Besides starring in an array of male fantasies, I found that copying *L'Origine* had other unexpected bonuses. In addition to being called upon to consult on the design of a dildo in the shape of the Eiffel Tower, I was invited to speak at a symposium on the socioeconomic ramifications of *L'Origine du monde* and asked to pen an essay for an anthology on the uterus. Never in a million years did I imagine that I would become an authority on female anatomy outside of my own. When I was growing up, there were no vaginas. Sure, there were countless furtive references to our privates and no lack of humorous and fanciful nicknames, but the *V* word was to be avoided at all costs.

But this part of a woman's anatomy is clearly done waiting in the wings and has now burst forth onto center stage, making it hard to explain why Courbet's modestly sized nineteenth-century painting still stirs such controversy. Nowadays, everywhere you turn, it's *vagina* this and *vagina* that. It's almost impossible to avoid mention of the word. Take, for example, the *New York Times* bestseller *Vagina: A New Biography*, or trendy exhibitions with titles like *The Visible Vagina*, not to mention a plethora of magazine articles with catchy headlines like

"My Vagina Has a Headache." I couldn't agree more with *Marie Claire*'s Judith Newman, who proclaimed that there's never been a better moment to be a vagina.

Sometime during my fourth week, I found myself sitting across from the museum's public relations director as he gripped the edge of his desk and looked at me as if I'd just grown horns. His facial features were contorted into a grimace that vacillated between horror and stupefaction.

Finally, he prevailed over his vocal cords and spluttered, "You mean . . . that is to say . . . without c-clothes?"

"Yes," I said.

In hindsight, I've often wondered if the person who answered so glibly in the affirmative was really me. But I dare say it was, and I place the blame squarely on *L'Origine*'s shoulders. The painting had bewitched me. What else could explain my unorthodox and, frankly, questionable request for permission to continue copying *in the nude* ("without c-clothes").

"Just for one hour," I said, trying to reason with the bewildered man facing me. Words failed him yet again.

All I can say in my defense is that I was no longer operating as an independent sentient being. After spending three weeks replicating every fold, crevice, and pubic hair of Courbet's (in)famous tableau, *L'Origine* and I had become one and the same. In Naomi Wolf's book *Vagina*,

she asserts that the vagina is part of the female brain and has been proven to directly correlate to female creativity and confidence. The experience of copying *L'Origine* had left me feeling stripped and exposed, yet oddly empowered. Pride had replaced my original embarrassment. I had visions of sitting on a high wooden stool without a stitch on, legs apart, communing with *L'Origine du monde*. My creativity knew no bounds.

Only much later did I discover that there was such a thing as "yoni gazing." The yoni is defined as "the place all life is birthed through," and as one tantric website explains it, gazing at the yoni can be a deeply transformative, meditative experience. "For women, gazing at her own or another woman's yoni can help her accept that this incredible channel for life lives in her own body and, therefore, she is an embodiment of the divine feminine."

Perhaps I was simply over-channeling the divine feminine when I put in my request, but the museum's public relations director didn't see it that way. I was lucky that he didn't yank my *copiste* badge from around my neck as he shooed me out of his office. Needless to say, I went back to work fully clothed. I wasn't the first artist, nor would I be the last, to succumb to *L'Origine*'s witchery. Some years later, a young artist would successfully carry out her own vagina-mirroring fantasy, the difference being that she was savvy enough not to seek approval first.

Aside from the technical challenges and the exhausting performance aspect of being *L'Origine du monde*'s copyist, my unique situation plunged me into the turbulent waters of society's ambiguous and contentious attitudes toward a woman's sex. Henry David Thoreau once said that it's not what you look at that matters, it's what you see. Every day I learned to see *L'Origine* anew through the kaleidoscopic lens of a global citizenry.

The sight of a mature woman reproducing a painting of a vagina impelled total strangers to confess their most intimate thoughts and feelings. There isn't much that can top a hairy mons pubis in terms of stripping away inhibitions. A young Spanish artist showed me a painting of her own genitals, a tribute to what she called the ultimate source of joy and pain. A writer living in Paris claimed that any man who denied that the painting made him want to fuck it would be lying; whereas a group of young studs was not in the least turned on by the painting—they needed a face to go with the rest of the body. The eyes and the mouth, they said, were the true sensual triggers.

An American couple thought it inappropriate for a public institution, and a group of young women were grossed out by the thick pelt of pubic hair. That baffled me. What did they think their manicured cooches would look like without a monthly waxing? Standing nearby, a young boy asked his bemused father what "all that black

stuff" was, and though I never heard the response, I hoped that the answer would paint a positive light on a woman's body au naturel.

On another occasion, a little girl in dark pigtails wandered innocently into the room, alone. She stood openmouthed, watching me paint. I smiled down at her, but before I could ask if she was lost, her frantic parents, wearing matching "I ♥ PARIS" sweatshirts, rushed in, seized her by the arm, and hustled her out at top speed before she could become contaminated. By what, I'm not quite sure. French schoolteachers regularly brought their second- and third-graders in to see Courbet's masterpiece, throwing out questions like, Why do you think the painting is called *The Origin of the World*? Why might the artist have chosen not to show the head? Although there was some giggling, French kids were mostly nonchalant about nudity and regarded sex as a natural function.

For their part, scholars never seemed to tire of *L'Origine*. New revelations about its past were constantly surfacing, along with fraudulent claims, such as the discovery of a painting purporting to be the model's missing head. In the midst of my stint at the Orsay, the media covered the explosive claim made by respected French art historian Thierry Savatier that the model was in fact pregnant at the time Courbet painted *L'Origine*. The gynecologists with whom he consulted referenced the model's rounded, puffed belly, although they concluded

that her genitals showed no medical signs of having pre-
viously given birth.

Even in our jaded times, the subject of Courbet's
painting continues to elicit debate. Is it sacred or profane?
Beautiful or repulsive? Threatening or empowering? And
as the symbol of life itself, a woman's reproductive
organs are still inexplicably subject to debate as to whose
jurisdiction they fall under. Upon seeing *The Origin of
the World* for the first time, art historian Christopher
P. Jones experienced "a swirling blend of fascination,
aversion, embarrassment and liberation all at the same
time." Ultimately, it's the eye of the beholder that deter-
mines whether one sees in *L'Origine* a beloved mother, a
lover, a saint, or a whore.

Gustave Courbet would have been thrilled to know
that his ribald painting continued to live on in infamy.
During his lifetime he consciously worked at being con-
troversial, fully aware that any publicity is good public-
ity. But the truth is that *L'Origine* was originally painted
for a private collector and never intended for public
consumption. Courbet might even have been peeved
that it overshadowed the groundbreaking works that
marked him as a true iconoclast. Two of those works—*A
Burial at Ornans* and *The Artist's Studio*—hang in the
same museum as *L'Origine*, in a spacious hall that can
accommodate their colossal dimensions. It's difficult
to understand from a twenty-first century perspective
why these seemingly innocent, yet monumental paint-
ings so provoked the ire of the Parisian public when

they were first exhibited. In the late 1800s, government institutions dictated not only the subjects that painters should tackle, but *how* they should paint them. Gustave Courbet thumbed his nose at them all—at great personal and professional risk. He valiantly chose to paint his unconventional subjects in the manner that he saw fit, and in so doing, he paved the way for the creative freedom that artists enjoy today. I, for one, am eternally grateful.

The last day arrived, and I was frazzled. Six weeks may seem like enough time to copy one painting. But in fact, it was a race against the clock—drawing, underpainting, color balance, glazing, reglazing, and reworking are not only time-consuming but painstaking. My eyes were skipping back and forth between the original and my copy, scanning for inaccuracies. There were quite a few that still needed to be addressed.

That's why, when I was mixing up a peach-colored glaze, I didn't have much patience for the guy getting up in my face, photographing me and my copy from every conceivable angle.

"I just can't believe it!" he crowed in a thick Long Island accent. "This is amazing. It's like seeing things in triplicate!"

I threw him a pained smile. I had no idea what he was talking about, and frankly, small talk was not on the day's menu.

"This is blowing my mind," he plowed on. "I'm Len, by the way. Who are you and what's your story?"

My patience was running thin, and I tried to impress upon him my rapidly approaching deadline. His bouncy, ADHD personality wouldn't take no for an answer.

"Look. I'm not some kind of weirdo, OK? Here's my press card. It's just that I can't believe I'm seeing you copying this painting after what I saw today! I'll leave you in peace if you promise you'll meet me at the République métro tonight. You can't miss this, trust me. You'll thank me."

His animated American face matched the face on the press card issued from a notable news bureau, and I lowered my guard. Following my gut had gotten me this far, and meeting up at a métro station didn't sound too risqué. Besides, his excitement was contagious.

Len handed me a business card. "See you at eight o'clock," he said, grinning with secret knowledge of some sort. "And great copy, by the way."

I didn't give him too much thought after that. My brush was flying over the canvas, tweaking contours, adding a rosier tone to the nipple, enhancing a shadow here and a highlight there. The peach glaze over the inner thighs had made all the difference. There was just enough time left to accentuate the silhouette of fabric in the top left corner with some black. Courbet was one

of the few artists who wasn't afraid of black. Many of his paintings were painted on a canvas that he had first covered in black, including *L'Origine*.

After applying the final brushstroke, I plopped my brushes into the water jar with a sense of accomplishment I'd rarely experienced before or since. I was proud of myself. It was a damn good copy, but it would never be a Courbet. As I began to pack up my materials, people gathered around to look at my copy. On my way out, I turned to bid *L'Origine* a silent adieu and smiled at the museum guard who had witnessed the entire process from start to finish. He smiled back and mouthed a *bravo*. It meant the world. I hurried down to the basement, where I was scheduled to meet the director of the copyist department before returning my equipment for the last time. She'd only put in a brief appearance during my six-week stint, and I was anxious for her to see the finished product.

Her face lit up when she saw my copy. "It's excellent. Even better than expected," she said. I was grinning like a loon as she stamped the back of my copy. "*Bon courage. Keep up the good work.*" She handed it back to me and kissed me on both cheeks.

I lingered in the dank, musty storeroom as relief and elation washed over me. But it was also a sad moment. Saying goodbye to *L'Origine* meant saying goodbye to Gustave Courbet. With every copied brushstroke, I had absorbed the rhythm of the great artist's brush, felt the

motion of his hand, glimpsed the inner workings of his mind, and sensed the beating of his heart.

Reluctantly gathering my belongings, I hitched my trusty backpack over my shoulder, leaving only my empty jam jar for the next lucky *copiste*. As I slipped my ID badge into the back pocket of my jeans, my fingernail caught on the sharp corner of Len's business card.

At five minutes before eight, I emerged from the République métro. My copy of *L'Origine du monde* was safely swaddled in my suitcase back at Madame G's. It was my last night in Paris, and I was feeling slightly giddy. I'd arranged to meet Len at the base of the monument of Marianne in the Place de la République, the enormous plaza where Parisians gather for massive demonstrations that cripple the French capital every other day. Just as I was beginning to wonder if I would recognize him, there he was, walking toward me with a camera swinging from his neck and a mutt at the end of a leash.

"OK. Follow me," he said in greeting. Clearly, he had never doubted that I'd show up. "Oh, this is Ralph," he added, pointing to his four-legged friend. I fell in step beside Ralph, but Len refused to give me any clues as to where we were headed or what we were about to see. We made a left and a right and another left through a

typical Parisian neighborhood, stopping when we got to rue Oberkampf.

"We're here. It's around the corner, but you have to close your eyes."

What? This was getting bizarre. But I had come all this way, so I played along, closing my eyes and letting myself be led for about twenty feet.

"Open your eyes."

And what an unforgettable sight it was—there, on the side of a building adjacent to a small neighborhood square, was a mural-sized rendition of *L'Origine du monde*! But wait! As I ventured closer, my jaw dropped. This jumbo copy of *L'Origine* was fashioned entirely out of squares of bread, cheese, and chocolate, creating a pixelated effect and adding a delectable sensory layer to Gustave Courbet's masterpiece. *Only in Paris,* I thought. How much more French can you get than bread, cheese, and chocolate—the very staples of life! I ran my hand over the appetizing mural and laughed in disbelief. Ralph rooted around at my feet, snapping up crumbs that had flaked off *L'Origine du monde*'s backside, while Len clicked away on his camera. It was a bittersweet moment. As I looked up at the giant billboard, I had to accept that *The Origin of the World* was no longer mine and had never truly belonged to me. The profusion of artistic renditions I was to discover over time only served to compound this truth.

"What did I tell you?" said Len, hopping from one foot to the other like a shadow boxer. "I just had to bring

you here! The art on this wall changes every month. I live around the corner and I saw this one this morning, but I'd never heard of *L'Origine du monde.* So I went to the Orsay to check out the real thing, and there you were making another copy! Unreal! And if I'd gone tomorrow, I would've missed the whole thing!"

It was the perfect ending to a journey full of chance and magic. Len invited me for a drink at his favorite brasserie, and this time I said yes, but not before breaking off a piece of chocolate pubic hair and popping it into my mouth.

PART ONE

1865–1878

Every work of art must retain something
from the first days of creation.
 —Wilhelm Lehmbruck

1

Paris
Winter 1865

The two men ogling the large oil painting in the center of the atelier made a comic pair. Short, stocky, and balding, Charles Sainte-Beuve cut an impish figure beside the imposing Ottoman diplomat in his scarlet fez and embroidered topcoat. Charles cocked a bushy eyebrow in the pasha's direction, a what-did-I-tell-you expression animating his jowly face. But the pasha's oriental eyes remained riveted on the painting's two naked figures. His pink tongue flicked over lips sandwiched between a bristly mustache and a vigorous black beard.

Gustave Courbet was thoroughly enjoying the moment—the exotic fellow was obviously besotted with his latest painting. And little wonder. He'd taken the liberty of depicting the goddess Venus as a voluptuous, dark-haired jezebel, leaning suggestively over a sexy, slumbering redhead posing as her mortal rival, Psyche. The painting was deemed so immoral, it had been rejected by the standard-bearing Paris Salon. That only confirmed his belief that the judges of the annual Salon were reactionary old farts. Who were they to dictate

what constituted "good" and "acceptable" art? Ever since his arrival in Paris twenty-five years before, he'd not been shy about making his feelings public. But, he acknowledged with a sly smile, by rejecting his painting, those mummified idiots had only brought more people flocking to his door.

The Ottoman attaché had insisted on coming to see the painting with his own eyes after hearing Sainte-Beuve's vivid description of *Venus and Psyche*. Always on the lookout for works to add to his burgeoning collection of erotica, Khalil Bey was not disappointed. The painting before him shimmered with innuendo and fantasy, a far cry from the romanticized, virginal nudes favored by most artists of the day.

"How much?" blurted Khalil Bey, forgetting in his excitement that he was in an artist's studio in Paris, and not in the souks of Cairo or Constantinople.

Sainte-Beuve chuckled and turned to Gustave. "You have a new admirer, Monsieur Courbet! I leave it in your hands now." The little poet grunted as he lowered his backside into the upholstered comfort of a faded armchair.

Gustave inclined his head. "Your Excellency," he said, addressing the Ottoman diplomat. "Please, have a seat. Wine?" Khalil Bey declined the alcohol but accepted a chair after swiping it with the red silk handkerchief that had been protecting his nose against the pungent mix of oil and varnish. Courbet remained standing. "I commend you on your good taste, monsieur," he said with a

twinkle in his eye. "You won't find anything like *Venus and Psyche* in any other atelier! I alone paint women like the good Lord intended. *Real* women, with *real* desires. The whole of Paris is talking about me!"

Sainte-Beuve's eyebrows shot up at this unfettered display of vanity. For a provincial yokel, Gustave Courbet had done very well for himself, but his arrogance knew no bounds. Khalil Bey, on the other hand, took the artist's boastful pronouncements as a signal that negotiations over the painting were about to commence. Schooled in the delicate art of haggling, he narrowed his rheumy eyes and took stock of his opponent—the handsome face filling out in middle age, the wild hair, and the full beard that rivaled his own. The artist's flamboyantly striped trousers, paint-splattered smock, and wooden sabots pegged him as one of the bohemian crowd, those artists, writers, and critics whose sole purpose in life seemed to be the upending of the status quo.

However, it was the artist's self-assured stance—legs akimbo, hand on hip, the other cradling a pipe—that cautioned the Turk of some feisty haggling ahead. But before the pasha could even begin to formulate an opening bid, Gustave announced that *Venus and Psyche* had been sold.

"But my dear fellow," spluttered Sainte-Beuve, his indignation propelling his rotund behind off his seat. "Khalil had his sights set on this very painting—"

The Turk raised a silencing manicured index finger, forcing his companion to plop impotently back down

into his armchair. "Everything has a price," said Khalil Bey in surprisingly refined French. "How much do you want for the painting?"

"I'm flattered, sir, but there's nothing I can do," offered Gustave by way of apology. "I entered into a gentleman's agreement with Monsieur Lepel-Cointet two days ago." Khalil Bey's eyes betrayed his displeasure, but Gustave was not about to let a client of such renowned wealth and status slip through his fingers. "May I suggest a commission, monsieur? A similar painting in the same genre . . ."

Khalil Bey tugged mechanically at his beard while he studied the painting with renewed intensity. A shaft of light from the large skylight above reflected off the ruby ring on his little finger, strobing the painted nudes with crimson bands. At length, he turned to Gustave and cleared his throat. "If I agree, would it be possible for you to position the models . . . umm . . . closer together? And preferably, with slightly paler complexions?" A fine sheen was beginning to form on his forehead.

Courbet drew noisily on his pipe, already composing the new painting in his head. It was simply a matter of humoring yet another patron. In fact, Monsieur Lepel-Cointet, the buyer of *Venus and Psyche*, had requested that he add a white cockatoo on the outstretched arm of the dark-headed nude. He accepted these onerous petitions, for they kept him in bread and brandy, but he knew that they would never immortalize him. It was paintings like his colossal *A Burial at Ornans*

that would establish him as the preeminent painter of his time. He'd defied all convention by usurping the monumental scale traditionally reserved for biblical or battle scenes to portray downtrodden peasants from his village engaged in the gritty, prosaic act of burying one of their own.

Condemnation had rained down on him—the subject of the painting was ruled undeserving of its majestic scale, the people ugly, and the paint style unrefined. Parisian high society was averse to confronting the hardships that existed beyond their pampered existence and much preferred to look at insipid, bucolic scenes of peasants frolicking gaily in perfectly manicured landscapes.

But Gustave had no intention of changing course— the world demanded to be painted as he saw it. "Walk tall and shout loud" was the mantra his dear *grandpapa* had instilled in him. Besides, the frenzy of criticism had catapulted him to fame and—even better—infamy. Although thousands of hopeful young artists migrated to Paris every year, very few had tasted the success enjoyed by the self-proclaimed renegade, Gustave Courbet. Unlike most of his dreamy-eyed peers, Gustave had made the pilgrimage to Paris with more than a desire to produce paintings palatable to bishops or noblewomen—he had come with grandiose ambitions of taking Paris by storm. From day one, he understood that only by getting tongues wagging would he gain attention—the day his name ceased to be whispered on everyone's lips would be the day he would fall into obscurity.

"How much did you sell the painting for?" asked Khalil Bey, steering the conversation back to the matter at hand.

Venus and Psyche had fetched an honorable sum, and Gustave saw no reason to lie. "Eighteen thousand francs. But a commission would raise the price to twenty thousand—"

"What?" balked Khalil, pushing his blue-tinted wire-rimmed glasses indignantly up the bridge of his nose. "Why should I pay more for a painting just like it? I may be a foreigner in your charming city, Monsieur Courbet, but I am no ingenue. My home is filled with works by Delacroix, Ingres, Corot, Fragonard, Boucher, Gérome—we'll be here until nightfall if I have to name them all. Sainte-Beuve can vouch for me!" He looked over at the poet, who confirmed the Turk's claim with a vigorous nod.

"Absolutely!" said Sainte-Beuve. "Your painting would find a place of honor among the world's greatest artists, living and dead!"

Courbet smiled at this artless appeal to his vanity, but an idea that had been flitting around in his head for some time was beginning to take shape. He removed the pipe from between his lips and turned to his honorable guest.

"Your Excellency, my sincerest apologies but I simply can't accept less for a commission of that size. However," he said, holding both hands up to deflect any premature opposition, "I have another proposition—a painting in

the style of *Venus and Psyche*, plus a second, smaller canvas included in the same price. What I have in mind will surpass your wildest imagination. I'll paint you a painting that no painter has ever dared to paint, and it will be yours, and yours alone . . ."

Khalil Bey shot Sainte-Beuve a questioning glance. What could Courbet be up to this time? The artist was a notorious provocateur—gossip and scandal followed him like stray dogs, and he seemed to delight in tossing a juicy bone their way at every opportunity. Even when Khalil had been in Paris representing Egypt at the Universal Exposition ten years earlier, Courbet had caused a sensation with his Pavilion of Realism. People had never heard of an artist exhibiting his work in his own privately funded gallery, let alone charging money for the pleasure!

Khalil removed his glasses and rubbed his eyes. He grimaced. He sighed. He adjusted his fez and scratched roughly at his beard. He didn't need convincing of the magic that Courbet created with his paintbrushes, nor was the extra two thousand francs a prohibitive sum for a man of his substantial wealth. His pained pantomime was merely a means of saving face before capitulating to Courbet's tantalizing offer.

"Done!" he exclaimed after a respectable degree of feigned deliberation.

Hands were shaken and backs were slapped, and the mood was decidedly gay by the time Sainte-Beuve and Khalil Bey took off in the pasha's cabriolet.

2

Joanna! Jo!" Gustave called out as soon as his guests had departed.

He heard her descending the wooden steps and went to meet her at the bottom of the staircase. *What a beauty*, he marveled yet again as Joanna Hiffernan appeared before him. Waves of coppery-red hair framed her face like a corona of flames, offsetting her lily-white Irish complexion. It was she who had posed as the somnolent redhead that the Turk had practically salivated over.

"*Qu'est-ce qui se passe?*" she asked. "What is it?" Her smile broadened as she caught the gleam in his eye. She adored his passion—in and out of bed. As she stepped off the bottom stair, Courbet proffered his hand.

"*Ma belle Irlandaise,*" he said with a seductive grin. "My beautiful Irish girl. Come. We have a lot of work to do."

"We?" she asked, looking up at him from under her long lashes.

"Yes, we . . . ," he said, leading her to the easel. "You did such a magnificent job posing for *Venus and Psyche*

that the Turk commissioned me to paint another one. You'll have to bear with me once again, I'm afraid."

"You know I can't refuse you anything, Gustave," she said with her full-throated laugh.

He pulled her close and kissed her hard on the mouth. She smelled of wild sage and honey, of lusty village girls and the barnyard trysts of his youth. She kissed him back with parted lips, searching for his tongue. Gustave grasped a handful of hair at the nape of her neck, exposing her throat and tracing the arc of her neck with his tongue until the hollow at the base of her throat glistened moistly. A soft moan escaped her lips as he cupped her breast and pinched her hardening nipple. Reaching beneath his smock, she groped for the buttons of his trousers, releasing him. Wild with desire, Gustave hitched up her skirts and in one dexterous move, pulled aside her culottes and thrust into her. She gasped as he drove deeper inside her, her wild auburn tresses covering them like a veil.

They collapsed, panting and laughing, onto the divan that had served as the mise-en-scène for *Venus and Psyche*. Jo's disheveled hair fanned out across the silk brocade pillows, and her fair cheeks flushed crimson. She let out a satisfied sigh and stretched her arms overhead, like a cat who had just drunk its fill of warm milk. Propped up on one elbow, Gustave caressed her soft rounded belly and wondered how much longer he could keep up with his young nymph.

As she began to rearrange her bunched-up skirts to cover her nakedness, he impulsively took hold of her wrist. Pushing her petticoats aside, he regarded her exposed midriff with an intensity that made her giggle. His gaze descended to her nether regions, and he bent down to kiss the dark-russet tangle between her legs. His fingers deftly examined the moist folds and crevices of her sex like an intrepid explorer, but just as her lake-blue eyes began to flutter closed, he sat up, abandoning her at a most inopportune moment.

"Stay right there," he said, ignoring her disappointed pout. Wiping at his mouth with the back of his hand, he slipped into his sabots, adjusted his undergarments, and buttoned his trousers.

Jo recognized the faraway look on his face and knew that she was all but forgotten, his attention already reclaimed by his next commission. She had to remind herself that his devotion to his work was what had attracted her to him in the first place. That, and his zest for life, so unlike her former lover, the thin-skinned and brooding James, who took offense at the slightest peccadillo. She tried hard not to compare the two men, but it was near impossible. She'd shared her bed with James Whistler for six years, soothing his bruised ego and nursing his scraped knuckles more times than she cared to remember. Their friend Rossetti had even penned a limerick about James's irascible nature that she had cheekily parroted when he was out of earshot.

There's a combative artist named Whistler
Who is, like his own hog-hairs, a bristler:
 A tube of white lead
 And a punch on the head
Offered varied attractions to Whistler.

Joanna would never forget the day James had unleashed his legendary fury upon her. She did not blame him, for she'd been the cause of what had transpired—she *and* Gustave, whom James had considered a mentor and a friend. If anyone was to blame it was Fate, who had seen fit to toss the three of them together beneath the blue summer skies of Trouville.

At first it had been idyllic. The sea, the billowing clouds, the sand beneath their bare feet. The three of them whiled away the days at the Hôtel du Bras d'or, the men setting up their easels by the seaside while Jo sat on the rocks sketching and working on her watercolors. Gustave could not get enough of the sea—as a mountain dweller, the specter of the distant horizon and its promise of the unknown were thrilling.

Only when their growling stomachs forced them to lay aside their brushes did they saunter down to the bustling fish market, where they wove their way between stands heaped with scallop, oyster, and crab, stopping at their favorite stall for steaming bowls of fragrant fish soup.

When the sun dipped below the horizon, their little group descended upon one of the small seaside cafés.

Wine flowed and tongues were loosened. Jo, nostalgic, sang her haunting Irish ballads, and as the sky darkened, talk inevitably turned to the subject that preoccupied them day and night—their moral obligation as artists to enlighten society and lead the charge toward progress. A dog-eared copy of Courbet's "Realist Manifesto" would somehow materialize, and over yet another round of absinthe, they debated every phrase and sentence late into the night.

What has been, has been . . .
To go backward is to do nothing . . .
An epoch can only be reproduced by its own artists . . .

James was wont to collapse into bed in a drunken stupor following these nocturnal sessions, but Jo tossed and turned beside him, aroused by Courbet's words. Despite their age difference, she fantasized about what it would be like to make love to the great man himself. His defiance resonated with her humble Irish roots and independent spirit. From an early age she'd refused to allow norms and conventions to rule her world.

And then, on a breezy afternoon during one of James's absences, Courbet suggested she sit for a portrait. With her heart beating wildly, she knocked on the door of his living-quarters-cum-studio. Stepping onto the makeshift dais in his room, she slipped her silk chemise off her tanned shoulders and let it glide sleekly to the floor. The pretense of a modeling session was short-lived. Courbet

mapped her body with his eyes, recording the curve of her hips, the buttocks silhouetted against the light, and the full breasts peeking beneath vermilion tresses that fell to her waist. In no time he was upon her, caressing her and pressing his groin against her naked thigh.

James's outrage at their betrayal had left in its wake a path of broken lamps and overturned chairs, littered with torn fragments from Courbet's "Realist Manifesto." The very next morning, James had decamped for Valparaiso, eager to drown his sorrows in a revolution playing out on Chile's distant shores. Although Jo had feared for his safety and mourned the circumstances of their parting, she had had no regrets about following Gustave back to Paris.

Adjusting her clothing, she sat up on the silk divan and watched him now as he paced about the studio, rummaging through rows of canvases leaning against the walls. He let out a pleased grunt, and she came to stand beside him, hooking her arm through his and looking down at the three paintings he had spread out on the worn floorboards. Each canvas captured a different version of the same scene—the mouth of a dark grotto carved into a craggy rock face that rose out of the murky green waters below. Textured clumps of undergrowth and gnarled branches vibrated with life. The scenes looked so real that Jo could almost hear the gurgling of the river and smell the dampness rising from the saturated loam.

"They're *magnifiques*, Gustave. Where is this? Ornans?" Jo had never been that far east, but Courbet returned to his hometown near the Swiss border at every opportunity. For Gustave Courbet, Ornans would always be home. His rare expressions of tenderness and longing were almost exclusively reserved for his beloved Franche-Comté countryside and the family that still resided there.

He nodded. "*La Grotte de la Loue*, the source of the Loue River. They say that fairies live in those caves . . ." He combed his fingers through his mane of tangled hair. "The Loue flows by the house where I grew up. As a child, I could see the river from my window, and I always wondered where it came from. One day, my friends and I followed it all the way to its source." His eyes glazed over as he recalled that exciting day and the many carefree days he spent roaming the countryside with Alphonse and Adolphe in tow.

Gustave lit his pipe and looked fixedly at one of the paintings in particular. The composition led the eye beyond the gaping mouth of the grotto and into the recesses of its impenetrable darkness. The suggestion of turbulence beneath the waters lent an air of mystery. Somewhere in that aqueous, fathomless depth, the mighty river's origins lay submerged, inviting exploration, just as he'd been stirred to explore Jo's most intimate depths moments before. He straightened to his full height, his dark eyes blazing with devilish excitement.

"What do you see?" he asked, pointing at the painting with his pipe. Jo crossed her arms over her chest and tipped her head, searching the rustic scene for an answer to his riddle, but the shadowy grotto refused to surrender any clues. Courbet sidled up to her and plunged his free hand playfully between her legs, cupping her sex through the folds of her dress.

"Ay!" squealed Jo, jumping back and clamping her thighs together. Roaring with laughter, Gustave extracted his roving hand and kissed her cheek.

"Don't you see, Jo? You've got your own secret cave right there! But yours is the source of something much, *much* more precious than a river. It's the source of life itself!" He spread his long, muscular arms and pirouetted as if to embrace all that the universe contained. His face shone with purpose. "Nature's most remarkable creation, her most beautiful gift to mankind, is right *there*," he said, indicating her crotch, "between a woman's legs. And yet it's hidden away like a dirty secret. Not anymore, Jo. Because I'm going to bring it out of darkness and into the light, once and for all."

Jo's eyes opened wide, and a complicit smile spread across her face. Khalil Bey would be getting far more than he bargained for.

3

Paris, five months later
Spring 1866

Constance Quéniaux was drifting in and out of sleep. Gustave had assured his model that it was their last session, but they were three hours in, and he still needed to put some final touches on the inner thigh. He loaded his brush with lead white and rose madder, mixing the colors directly on the canvas. The light was beginning to fade, and an unseasonable chill permeated the air. Laying his brush down on the paint-encrusted table beside his easel, he strode over to the heavy brazier and dragged it closer to the divan to keep Constance warm as she napped. He looked down at her familiar naked body. It wasn't the lithe, lean body of the ballerina that she'd once been, but for a woman in her midthirties, she was still shapely and appealing—he favored his models with a bit of meat on their bones.

Constance hadn't been his first choice for a model. That would have been his lovely Joanna. He had initially resisted Khalil Bey's request to insert his mistress into one of the two commissioned works. But the pasha had insisted. He claimed that Constance Quéniaux was his lucky charm, that whenever she accompanied him to

the gambling dens, Lady Fortune smiled down upon him. To mollify his patron, Courbet agreed to meet with Constance to determine her suitability. More to the point, he needed to gauge her readiness to pose for the exceptionally unorthodox painting he had in mind.

The day she arrived at his studio had been hot and muggy. Neatly dressed in the latest fashion, her waist cinched and her pale shoulders covered by small puffed sleeves, she appeared unaffected by the sweltering heat. A little veiled hat sat coquettishly on her dark coiled hair. The heart-shaped face would have been commonplace save for the strikingly thick brows and pair of obsidian eyes that flashed with intelligence. She had about her the confident air of one who knows how the world works and what one needed to do to get by. And get by, she did. At fourteen, her mother had contracted her to the Paris Opera as a line dancer—a "rat," as those sallow, prepubescent young minions were commonly referred to. They worked from morning till night, but for impoverished young girls like Constance, dancing at the opera offered an escape from an even more miserable fate.

Unfortunately, the privileged position did not come with a wage sufficient to support both Constance and her mother, let alone pay for costumes and dancing slippers. The veteran dancers took pity on her and explained that the only way to supplement a dancer's pittance of a wage was by catching the eye of a well-heeled subscriber of the Paris Opera. In return for the gentleman's patronage, certain favors were naturally expected. Constance

soon learned that the art of seduction was as important in her profession as the art of dance.

Her newfound skills, together with her natural talents, helped her rise through the ranks, even garnering regular solo performances. But when an unfortunate knee injury cut short her dancing days, the seductive charms she'd perfected stood her in good stead as she eased into her new calling as a courtesan. With a shrewd eye toward the future, Constance Quéniaux set out to amass enough wealth to sustain her for the inevitable time when beauty and youth would abandon her.

The Turkish diplomat Khalil Bey was one of her most generous admirers. When he asked her to sit for a painting he'd commissioned from Gustave Courbet, she was intrigued and flattered. Gustave Courbet's name was often bandied about in her social circles, almost exclusively populated by dancers, singers, and artists whose lives, like hers, revolved around Paris's cultural life. She had even fancied the idea of acquiring an original Courbet one day.

Seated across from him during their first encounter, she could see why so many women were drawn to him. He was handsomer than she'd expected for a man in his middle years, and he wore his gaudy clothes with unaffected grace. His beard was still lush, and his lips, full and sensuous. His eyes, even blacker than hers, glowed with a fire that burned bright and hot.

He had wasted little time articulating what would be expected of her, and she had hesitated only a moment before responding.

"Monsieur Courbet, I'm quite certain that you're familiar with those indecent postcards that are all the rage these days? I've received offers from numerous photographic studios that produce them, but I've declined them all. I have a certain reputation to uphold, such that it is. And I don't fancy being ogled by strangers who wish to use me to gratify their basest needs. But you, monsieur, are proposing to pay homage to nature's greatest gift, and for that I applaud you."

Courbet found himself unexpectedly delighted by Mademoiselle Quéniaux. Not only did she appear to grasp the visionary leap they would be taking together, but she also possessed all the necessary curves in all the right places.

"Are you saying, mademoiselle, that you agree to pose?"

"That depends. I'm sure Khalil will make it worth my while, but he would be the first to tell you that discretion is one of my finer qualities. If I were inclined to surrender my sex to your paintbrushes, I would have to insist that you not betray my identity in any way." Hearing no objection, Constance slipped on her gloves, rearranged her bustle, and rose to her feet. "There is one more thing," she added with a dulcet tone, her carmine-dyed lips

smiling sweetly. "I'd like to propose a barter of sorts—one of your paintings in exchange for surrendering my little love cave. A fair trade, don't you think, Monsieur Courbet?"

4

Paris, one month later
Late spring 1866

Gustave stepped away from the easel and studied the work in progress. The painting was taking far longer to complete than anticipated, and he'd had to summon Constance back to the studio. Constance had proven to be the most patient and cooperative of models—it wasn't her fault that the little canvas was being so troublesome. The larger commission was six times its size and already installed in Khalil Bey's luxurious apartment. For *The Sleepers*, he'd posed Joanna and Hortense on a satin counterpane in a sleepy, naked embrace. To fire Khalil Bey's imagination, he'd even painted titillating details—a loose barrette and a broken string of pearls—to dispel any doubt as to what had just transpired between the two women.

The pasha's eyes had gleamed appreciatively, and he'd smacked his lips as if savoring a honey-drenched morsel of baklava.

"Glorious! You never disappoint, my dear Courbet."

Khalil had promptly paid up and then pressed impatiently for the second painting. Courbet had deftly evaded the question, not wanting to let on that the "surprise"

tableau was still sitting on the easel. Constance had agreed to be equally vague about their extended modeling sessions if pressed on the progress and had coyly refused to give Khalil any particulars about the painting.

Gustave's eye darted back and forth between the canvas and the area just above Constance's silky inner thigh. The foreshortened angle that he'd chosen was a tricky one. Narrowing his eyes to ascertain the correct hue of the shadowed crease where her upper thigh met her sex, he loaded his palette knife with burnt umber and Prussian blue and attacked the canvas as if he were slathering butter on a lump of black bread. Then, using his thumb, he smudged the shadow beneath the buttocks and wiped the excess paint on his smock.

A prick of sweat sprang uncomfortably beneath his armpits. In undertaking to paint the truth, uncensored and unshackled, he'd entered uncharted territory. As a young man newly arrived in Paris, he'd learned his craft by copying the Spanish, Flemish, and French masterpieces in the Louvre's immense collection. Despite the fact that his father and uncle were still aggrieved by his refusal to enroll in the government-sanctioned Academy of Art, he'd never regretted his path of independent study. As far as he was concerned, the Academy was a woefully outmoded institution that churned out artists incapable of producing a single independent or creative thought. He would rather burn in hell than relinquish his freedom to paint what he wanted, how he wanted.

But even within the Louvre's hallowed halls, there was no precedent, no masterwork to guide him now. The painting on his easel would even exceed the audacity of Édouard Manet's *Olympia*—the painting that had rendered insignificant the hundreds upon hundreds of Academy-selected artworks hung from floor to ceiling in the previous year's Paris Salon. The feverish talk was of nothing but Manet's *Olympia*.

Despite the Salon's rejection of his own works, Courbet had joined the masses who flocked to the Louvre for Paris's most anticipated annual event. People pushed and shoved to get a glimpse of Manet's painting. Craning his neck, Courbet heard the catcalls and jeering before he could even get close enough to see what all the fuss was about.

"*Putain*! A whore straight from the rue Mouffetard."

"Disgusting! Look at her dirty hands and wrinkled feet!"

"He didn't even bother finishing it!"

"An outrage! No shame whatsoever!"

If not for the guards, the mob would have ripped the painting right off the wall. Once Gustave shouldered his way to the front of the hostile crowd, he instantly grasped what it was about *Olympia* that sparked the outrage. It wasn't the model's nudity—in fact, Manet had placed the young woman's pale hand chastely over her neat *chatte*. Nor was it the swell of her milky-white breasts that triggered the public's wrath. It was the model's *identity*. The woman who stared back at him with

an unapologetic, impudent gaze, her neck encircled by a black velvet ribbon, was none other than Victorine Meurent, the well-known courtesan. *Quelle horreur!* Manet had committed the sacrilege of substituting a high-class prostitute in the exact same pose as Titian's dreamy sixteenth-century depiction of Venus, revered goddess of love, beauty, and fertility.

Courbet doubted that the mild-mannered Manet had consciously set out to breach the tacit, time-honored separation between the "respectable" classes of society, who clung to their privileged status for dear life, and the morally deficient, shadowy demimonde, who were tolerated as long as they knew their rightful place. The critics had torn Manet to pieces. Review after review reviled the work, disparaging everything from the painting style to likening the color of Olympia's body with the putrefying color of a cadaver. "Inconceivable vulgarity," they declared. But *Olympia*'s true crime was the unmasking of the bourgeoisie's thin veneer of respectability.

Returning home, Courbet had been more determined than ever to employ his brushes to expose hypocrisy and destroy the antiquated mores that stood in the way of progress. He'd similarly demurred from taking up arms during the violent Paris uprisings twenty years earlier, choosing his brush as his weapon of choice. It mattered not that his painting of Constance Quéniaux was destined for Khalil Bey's eyes only. In his heart of hearts, Gustave would always know that he,

Jean-Désiré-Gustave Courbet, had shattered the very last bastion of convention and torn down the very last vestige of artifice.

"Gustave?" murmured Constance from the divan. "May I close my legs now?" She let out a sleepy, self-deprecating chortle, cognizant of how outlandish her request might sound to an innocent passerby.

Courbet poked his head around the easel with a foxy smile.

Paris, two months later
Summer 1866

Lifting the hem of her dress to avoid the rivulet of sewage trickling down the center of the cobble-stoned street, Joanna made her way toward the baker's shop. She took her place in line, chatting with the local women whose faces had become familiar. After paying the *fournier*, she tucked the loaf of bread inside her shawl, not wanting to repeat the previous week's experience of having a warm *pain de campagne* snatched out of her basket by a pack of ragamuffins. The bread would be perfect for slopping up the gravy from the stew she'd prepared earlier in the day. She hoped to appeal to Gustave's hearty appetite to entice him to stay home that evening, instead of frequenting the brasserie des Martyrs or the café Guerbois.

She understood the appeal of those smoke-filled, wine-fueled haunts. Gustave was the high priest of realism and a coterie of young artists like Eugène Boudin and Claude Monet clung to his every word, inspired by his radical vision and emboldened by his call for change. But ever since Gustave had embarked on the scandalous little painting for the Turk, Joanna had noticed a subtle

cooling in their relationship. She'd tried to make excuses for Gustave's growing detachment—the physical toll of back-to-back commissions or his recent trips to Ornans and Brussels. But inside, she blamed the little tableau for driving an irreparable wedge between them.

The idea of the risqué painting had at first propelled them to even greater sexual heights, for the whiff of taboo was a powerful aphrodisiac. But after their love-making, Gustave had taken to subjecting her most private parts to the same scrutiny he applied to any other painting subject, be it a bunch of grapes in a bowl or a pair of freshly hooked trout. She began to shrink away from his gaze, and an unaccustomed blush of shame inflamed her ears. Perhaps the old crones were right in warning young women to protect their most intimate parts from the eyes of men—concealment and mystery afforded women a semblance of power in the unevenly matched battle of the sexes. Jo realized with dismay that the erotic allure of her sex had been subverted by Gustave's monomania for realism. His realist philosophy ruled his life, extending well beyond the unblinking style he practiced in his art. It was his religion, his *idée fixe*. She could not hope to compete with such obsession.

Despite her ambivalence about being subjected to his clinical gaze, relations between them became even more strained when he announced that the Turk's whore was to be his model. Every time that tart spread her legs for him, cold flames of jealousy licked mercilessly at Jo's heart. She resented the lengthy painting sessions that

took Gustave away from her, and could barely mask her resentment toward the painting. It was like living with one of his mistresses under the same roof, and she thought wistfully of the innocent portrait that James Whistler had painted of her years before. She had worn a full-length white dress, high-collared and long-sleeved, and her bright-auburn hair was left loose and flowing about her shoulders. *The White Girl* had won James great acclaim, and they'd celebrated his success together. She realized with a start that she missed James, foul moods and all. Perhaps Gustave Courbet was too much for any young woman to handle.

Even after the modeling sessions were over, Gustave had occasionally returned to the little canvas he had christened *L'Origine du monde* to scrape back the paint or enhance a highlight. It was close to midnight on a moonless night when he finally applied the last brush-stroke. Alone in the atelier, he collapsed into an over-stuffed armchair, spent. His gaze rested on the finished work. In the lantern's glow, the pallor of the skin stood in stark contrast to the Cimmerian mound of Venus. It was a brave, brutally honest painting—there was no saccharin narrative, only truth. He imagined the mayhem that would ensue if the painting were ever to be exposed to public scrutiny. *Oh là là!* The gendarmes would relish the chance to add this latest work to their growing

list of his "obscene" paintings, and his reputation for immorality and depravity would rise another notch. Behind closed doors, however, those very same bastards who enforced the moral codes broke them with carefree abandon. Such hypocrisy made the blood thrum in his temples and caused his sensitive stomach to contract.

He reached for the near-empty bottle of *vin rouge* on the floor by his feet and took a long swig, toasting his new creation. After such prolonged intimacy with his subject, it was rare for him to think of Constance's vagina as an erotic gateway to ecstasy. More and more, he was conscious of it as the portal from which new life emerged, violently and painfully. He was suddenly overcome by a flood of disturbing emotions.

Maman, he mouthed silently.

How he missed his mother's laughter and her soft cheeks whipped pink by the brisk mountain air. She alone had understood his true nature. Years of living in the big city hadn't dulled the ache of homesickness for family and for the brute wilderness of the Jurassien countryside, where he had spent his childhood hunting and fishing or painting *en plein air* accompanied by his old donkey, Jérôme. A smile flitted across his face as he pictured a familial scene back home—the house fragrant with the smells of rabbit stew or *tarte à la tomate,* Maman at the piano, accompanied by his three sisters, Zoé, Zélie, and Juliette. His role had been to accompany them with his bawdy songs, sung at the top of his lungs. Papa listened distractedly as he ruminated on the latest

mechanical invention or brooded over his disappointment in his only son.

Nothing could rival a mother's love. It pained him to think about the mother of his own child. He preferred *not* to think about Virginie Binet if he could help it—dwelling on the past did no good to anyone. In the fourteen years since Virginie had left with their young son in tow, he'd masked his devastation with bravado, cognac, and women. But alone, staring into the dregs at the bottom of a beer stein or at the empty bottle in his hand, he felt sorrow cling to his heart like a vampire. The last he heard, mother and son were living in Dieppe. The boy, Désiré-Alfred Émile, would be nineteen years old, he calculated. As a child, Émile had shown early promise in his drawings, and Gustave wondered if Virginie had encouraged their son as she had unfailingly done for him.

In those early, heady days, she'd stood steadfastly by his side, helping him shoulder the criticism and mockery directed at his unconventional paintings and provincial ways. He and Virginie had been content living off the meager allowance his father had begrudgingly sent him every month. They'd built a love nest in a cramped garret furnished only with a narrow cot behind a screen and a small portable stove to keep them warm. Ten years his senior, Virginie had accepted his single-minded ambition as indulgently as she'd accommodated his inexhaustible sexual desires. After long nights of frenzied painting by candlelight,

how comforting it had been to kick off his sabots, strip down to his drawers, and burrow beneath the warm, musty covers to mold his body against hers, inhaling her sharp scent and caressing the generous swell of her hips. To this day, his pulse quickened at the memory of her rump pressed up against him . . .

But he had driven sweet Virginie Binet away as surely as the Seine flowed toward the sea. She'd endured his dalliances with the *cocottes* who modeled for him, suffered the indignity of his refusal to present her to his family, and even bore him a son out of wedlock. But when he proclaimed that he would rather hang himself than marry, she had packed her bags and left. *Bah! It would never have worked anyway*, thought Gustave sourly. *Les histoires d'amour finissent mal.* Love stories never end well. And he didn't believe in the reactionary institution of marriage. There were too many women out there in the world just waiting to be conquered.

He shifted in his chair to relieve the discomfort in his lower intestines. From its perch on the easel, *L'Origine du monde* beckoned, demanding his attention like a spurned lover. The painting seemed to transcend its very materiality, refusing to be relegated to mere layers of paint and varnish fused onto linen. He'd set out to showcase the wellspring of humanity, not fully realizing the raw emotions and memories that such an image could unleash.

Another wave of cramps forced him to get up. His digestive system had never fully recovered from the bout

of cholera he'd suffered in his thirties. He walked to the back of the atelier to clear a shelf where he could set the painting to dry. He grabbed a pile of dusty pig bladders and threw them into a corner. Now that he could afford to buy his oil colors in practical metal tubes, he no longer had to fill pig bladders with pigment and oil. Fame and fortune had its benefits. He placed the painting on the vacant shelf, out of sight. It would be weeks before he would have the inclination to look upon it once again.

When Jo returned home with the warm loaf of bread pressed against her bosom, she found Gustave busy setting *L'Origine* into a gilded frame carved with acanthus leaves. Without looking up, he grunted a greeting and turned the painting over to press his inked stamp upon the back of the canvas: "ATELIER Gustave COURBET." Jo shuddered, her hot Irish blood near boiling. The accursed painting seemed to be calling to her, mocking her. She couldn't remember feeling such jealousy toward a real flesh-and-blood rival. The sooner it left the atelier, the better. Pulling the pin angrily out of her bonnet, she spilled the contents of her basket onto the kitchen table.

Courbet wrapped *L'Origine* in a soft cloth and tied it securely with twine. He wavered a moment, overcome with an unfamiliar sense of loss at the thought of surrendering his painting to Khalil Bey. But having no patience for sentimentality in others, he was loath to discover it

within himself. He reached for his red knitted scarf and tucked the painting resolutely under his arm.

"Jo! *Je m'en vais*," he called. "I'm heading out." And he bounded out the door before she had the chance to ask if he would be returning home for supper. She seized the nearest plate and hurled it at the closed door.

6

Paris, five months later
Winter 1866

Maxime Du Camp sniffed censoriously as he removed his top hat and overcoat and handed it to Khalil Bey's valet. He flicked an invisible speck off his white pants and relinquished his intricately carved walking stick—acquired after long and hard haggling during his latest expedition to Egypt—before passing through the grand vestibule into a generously proportioned salon. Khalil Bey's rooms on the rue Taitbout were sumptuously furnished. Maxime identified the *mecidi* pattern of the magnificent rug underfoot as the work of the Hereke weavers from the Bay of Izmit. No expense had been spared.

"*Mon cher* Du Camp," boomed Khalil Bey as he approached his guest. "We've been waiting for you!" Khalil wore a secretive smile and a floor-length robe, both presumably in honor of the evening's mysterious agenda. A select few, culled from Paris's *Who's Who*, had received invitations promising an unforgettable evening. No further details had been forthcoming, but his gatherings were legendary for their lavish meals and after-dinner card games, and save for one invitee,

curiosity had brought them all here tonight. Maxime Du Camp was no exception. His travels to exotic locales (funded by his family's sizable fortune) had whet his appetite for novel experiences. He had made a name for himself writing of his adventures, though many of the Turkish diplomat's invitees thought Du Camp's opinion of himself overrated.

Khalil steered Du Camp by the elbow toward a group of gentlemen assembled in front of the massive roaring fireplace, its mantel laden with oriental ornaments of silver and bronze. A large circular painting, jam-packed with naked women lolling about on embroidered pillows, took pride of place above the mantel: *The Turkish Bath*, Dominique Ingres's sensual harem scene had, until very recently, been Khalil's favorite painting.

Maxime greeted the gnomelike poet and critic Sainte-Beuve, standing beside Léon Gambetta, the firebrand lawyer with whom Maxime had recently sparred in a volley of politically charged articles. Gambetta interrupted his conversation to extend his hand to Maxime, who shook it half-heartedly and then released it to pluck a flute of champagne from a tray proffered by Khalil's aged retainer. As he sipped, Maxime turned his back on Gambetta and eyed the cluster of gentlemen in the far corner of the room. He nodded to the fair-headed librettist, Ludovic Halévy, but grimaced when he recognized the gentleman with his back turned toward him as Alexandre Dumas the younger—the latter's tight, crimped curls, a vestige of his Haitian roots,

were unmistakable. Dumas was a sermonizing diva, and Maxime begrudged the man for continuing to reap the benefits of his hugely popular novel, *The Lady of the Camellias*, twenty years after the fact.

Other than Prince Alexis Galitzine, the other gentlemen huddled around Dumas were of little interest to Maxime and he turned his attention instead to the circular painting above the mantel. His gaze washed over the swath of female bodies and settled on the sunlit bare back of the curvaceous lute player in the foreground. He was joined in his contemplation by a dark-featured gentleman who made up for his diminutive stature with an extravagant pair of mustaches, their tips so sharply waxed as to constitute a mortal danger to those around him.

"Count Vittorio Benedetto," said the nattily dressed little fellow before returning almost immediately to his whisker twirling and his inspection of Ingres's exotic painting.

Maxime was certain that he'd seen the whiskered aristocrat in one of the *passages couverts*, the covered passageways of luxury shops that were springing up on the right bank. When not traveling to faraway lands, Maxime liked to frequent those skylit arcades, swinging his cane and raising his top hat at the finely dressed ladies, or sipping coffee and gossiping with other *flâneurs* like himself.

A brash voice rose above the buzz of subdued conversation, and Maxime looked around to find its source.

The culprit was none other than that boorish realist painter, Gustave Courbet, who was cornering the critic from *Le Charivari* newspaper.

"The new gallery will be twice as big as my last Pavilion of Realism!" crowed the artist. "I'll have no less than three hundred paintings on display, and I guarantee that I'll draw the crowds away from the Universal Exposition itself! We've already begun construction on the Place de l'Alma, right on the bank of the Seine—"

The artist's last words were cut off by the sound of a brass gong struck by a servant boy in an embroidered skullcap and vest. Having captured the attention of his guests, Khalil addressed the gathering. "Good evening, gentlemen. Welcome to my humble abode," he said, gesturing broadly. "Before we sit down to dine, I have a special surprise in store for you tonight—an exclusive look at my latest acquisitions." He smiled slyly and placed his palm dramatically over his breast. "I promise you won't be disappointed. Please, follow me."

His curious guests followed him through a pair of French doors and into a drawing room appointed with velvet divans and pale-blue damask walls. A multi-tiered crystal chandelier threw its fractured light upon a large painting on the far wall—Courbet's *Sleepers*. Monocles were retrieved and appreciative sounds followed in quick succession as the men took stock of the intertwined young maidens. But the little Italian caught Maxime's eye as if to say, *Why is this being singled out for an exclusive showing?* Despite the painting's Sapphic

connotations, it was no more salacious than others in the pasha's collection. Someone muttered under his breath that Courbet had no idea how to paint the female body. Maxime couldn't have agreed more. The figures were crassly painted, totally lacking the finesse of a Jacques-Louis David or a Delacroix. *They* were true French painters.

Khalil allowed a few minutes to elapse before requesting that the garrulous group follow him through the armaments room and down a hallway lined with more libidinous canvases interspersed with battle scenes. By the time their host stopped before a door at the end of the hallway, some of the guests were beginning to feel uncomfortably aroused. Khalil clapped his hands twice, and a young servant boy scuttled toward him carrying a heavy candelabra in each hand.

The pasha allowed the boy to enter first in order to illuminate the room. As the guests trickled in, they were surprised to find themselves in the pasha's private dressing alcove. Rose petals perfumed the air. The checkered marble floor was partially covered by a striped kilim, and the walls were wainscoted in pink marble. An ornate washbasin and an oval bathtub of burnished copper were the only furnishings, save for a large gilded mirror on the wall beside the door connecting the alcove to Khalil's bedchamber.

The servant boy placed the candelabras against the rear wall on either side of a green curtain before being

dismissed. Maxime's curiosity was piqued despite his discomfort at being herded into such intimate quarters with other men. Courbet, he noticed, was looking mighty pleased with himself.

"The moment has come, gentleman," said Khalil, reverently drawing aside the green curtain and fastening it with a large tassel.

A collective gasp, and then, pandemonium. Some of the men backed away from the sight as if burned, while Sainte-Beuve, Dumas, and others approached in disbelief, mouths agape. Some of the men were overtaken by a familiar but unwanted stirring between their legs. Maxime stood stock-still, his face a mask of revulsion. What was this atrocity? The work of a butcher! For before him was a woman painted so realistically that she seemed alive, almost writhing, yet the painter had neglected to include her feet, her legs, her calves, her hands, her arms, shoulders, neck, and head. What remained was nothing but the vilest part of her anatomy. It did not belong in polite society, pure and simple.

Only Courbet was capable of such barbarity, thought Maxime. The artist was nothing but a clown who had pulled the wool over the Ottoman's eyes. The painting lacked refinement, morality, and instruction, and looked as if it had emerged from the twisted mind of the Marquis de Sade. To make matters worse, Courbet was boasting about his own brilliance, claiming that the painting transcended those of the great masters. It was

all too much. Maxime turned on his heel and went to collect his belongings, eager to rid himself of the disturbing image that seared his eyes.

7

Paris, nine months later
Fall 1867

Khalil grabbed at tufts of hair as he paced the room.

"الله اني دعاسيل" he cried out in supplication. "Allah, have mercy on me!"

His piteous cries to God soon switched to curses directed at the man who had dealt the final blow. *Curse that Kalergis! That Greek bastard. We should have slaughtered them all when we had the chance. May he go blind!* fumed Khalil. But in his heart of hearts, he knew that it was he who had been blinded by his own arrogance. Perhaps it was a blessing in disguise that his father was no longer alive to witness the family's fortune depleted by his own son. Khalil immediately regretted his blasphemous thoughts. Shame overcame him as he recalled his refusal to heed the counsel of his dearest friend on that catastrophic evening.

"Khalil, I beg you, stop! Enough. You're having a bad streak," Jacques Offenbach had pleaded, his domed forehead creased with worry.

Offenbach's appeal had fallen on deaf ears. After losing a small fortune at cards to that Greek Kalergis,

Khalil had stubbornly insisted that he could win back his money at the roulette table. He'd brushed Offenbach's concerns aside. "Remember this, my friend," he'd said in a jocular tone. "I prefer losing by doing as *I* please, to winning by doing as *you* wish!"

Khalil didn't believe in moderation. He slid the remaining tottering tower of gambling chips across the green felt, placing half the chips on the number four and the remaining half on the zero. Forty, a Turk's numerical talisman. He couldn't possibly lose; he felt it in his bones.

"*Rien ne va plus!*" announced the croupier, spinning the wheel. "No more bets!"

Khalil's face was flushed with adrenaline. Onlookers, three deep, crowded around as the ball rattled loudly, hopping erratically from one number to another. As the wheel wound down its dervish dance, the ball bounced jauntily into the groove marked with a seven. Cries erupted from the crowd as the croupier swept up Khalil's chips worth 720,000 francs with his wooden rake. Offenbach placed his hands on his bald pate in disbelief. Khalil was too numb to react. Offenbach, half the Turk's size, helped his friend up and ushered him quickly to the door. The Greek had looked on with smug satisfaction, rubbing his mutilated ear, a parting gift from his Turkish captors some thirty years before.

Reliving that humiliating evening, Khalil let out a string of expletives in Turkish, French, and Arabic, causing his faithful retainer, Kasim, to come rushing into the room. At the sight of his distraught master, Kasim knew

for certain that the rumors were true. His shoulders slumped. All was lost. How many times had he accompanied his master to the gambling dens, waiting outside in all weather, wondering whether Khalil Bey would return in high spirits or with a look as dark as the Bosporus on a moonless night? Even Kasim, a simple servant from Anatolia, did not need to read the coffee grounds to know that his master's sinful habits would eventually wreak disaster. *Ne ekersen, onu bicersin,* he muttered to himself. *One who sows wind will reap a hurricane.*

Over the next few days, the comings and goings in the apartment on the rue Taitbout made Kasim's head spin. It was official—the pasha's fortune was gone. In a matter of weeks, he would be forced to sell off his entire collection of paintings and sculptures, as well as the Sèvres medallions, Saxon porcelains, gold-threaded La Mecque carpets, and exquisite rosewood furniture. Most devastating of all, he would have to divest himself of his beloved Arabian racehorses.

Kasim was run ragged, letting visitors in and out of the apartment and sending the servant boy to fetch sweet tea for the pasha, whose formidable appetite had all but vanished. One thin-lipped visitor, a Monsieur Haro, spent an entire day examining his master's paintings through a loop and scribbling into a large ledger with his quill.

"This one will be one of the key pieces in the sale," Haro had murmured as he stood before Gérome's *Louis XIV and Molière,* a large canvas depicting an extravagant

scene of the late French king and the celebrated play-wright at table, surrounded by members of the royal court in all their finery. Convinced of its authenticity, Haro adjusted his monocle and moved on to the next painting. *Ah! What a gem!* Fromentin's *Smala*, a beautiful rendition of a caravan moving slowly across the Sahara; one could smell the heat, the dust, and the camels . . . *The Turk has good taste*, thought Haro.

Elated by the unparalleled cache, the delighted purveyor of pictures was oblivious to Khalil's misery. In all, Haro recorded one hundred and six works that would be put up at auction to help defray the pasha's gambling debts, estimated at four million francs. Monsieur Haro, however, was unaware of the one hundred and seventh work of art, hidden well out of sight.

When Kasim showed the last visitor out, Khalil retired to his private dressing alcove and closed the door behind him. The gray sky filtered in through the window, bathing the room in a melancholy light. He gently pulled back the green curtain and experienced the exhilarating rush of blood to his genitals. The sight of a woman so openly offering herself was an elixir that could soothe away any man's worries, albeit temporarily. So long as he was in possession of the painting, any woman he called to mind was his for the taking. No, he wasn't yet ready to part with *L'Origine du monde.*

Later that evening, Khalil sat at his desk pawing through a mountain of urgent telegrams and letters from Constantinople. His financial demise had not been well

received by his uncle, nor by the Foreign Office. His days in Paris were numbered. In his capacity as ambassador of Ottoman affairs, he had lived in Cairo, Constantinople, Athens, and Saint Petersburg, but nothing compared to Paris. He adored the city's enlightened ambience, its culture, and above all, its nonchalant embrace of promiscuity. An astute Italian traveler had once remarked that in Turkish culture, the two sexes were like two rivers that ran parallel to one another, their waters never mingling except here and there in some subterranean passageway. Khalil much preferred to wade in open waters.

The depth of his depression at the prospect of leaving Paris rivaled the enormity of his debt, but he could no longer postpone the inevitable. He reluctantly called for Kasim.

"Tell the servants to begin packing the trunks and take this note to the footman to have it delivered to Mademoiselle de Tourbey's residence on rue de l'Arcade." Kasim bowed and took the sealed envelope with a heavy heart. Khalil went through to the dining room and headed straight for the massive, glass-fronted china cabinet. He inspected the scores of exquisite tea sets displayed on its shelves and sighed unhappily. They too would be sacrificed to his creditors. Peering closely at the delicate cups and teapots, he sought out the set that he had in mind for Mademoiselle de Tourbey as a parting gift. There it was. A Sèvres porcelain-and-silver set, with a deep-blue glaze that matched Jeanne's smoldering eyes, her most seductive feature.

From the moment Joséphine d'Ennery had introduced him to Mademoiselle Jeanne de Tourbey, he'd been awestruck by her intellect, her impeccably acquired manners, and her beauty. A thick mane of jet-black hair offset her milky-white throat to perfection. It was no wonder that she counted among her suitors a prince (Jérôme Bonaparte, no less) as well as Khalil's good friend, Gustave Flaubert, who'd warned him from the start that the exquisite creature had the grace of a panther but the eyes of a demon.

Jeanne would surely have heard of his financial ruin and imminent departure. Any one of the intellectuals and artists who frequented her well-attended soirées would have rejoiced in passing along some juicy gossip about her Turkish lover. Although she and Khalil had comported themselves with the utmost discretion, they were no match for the Paris gossip mill.

Khalil allowed himself to daydream about their first night together, the reward for months of courtship and extravagant gifts. He replayed the tantalizingly slow ungirdling and unlacing that had been required to free her small breasts and their rosebud nipples. Jeanne had run her delicate fingers through the coarse hairs on his chest, sending shivers down his spine. Lying on her great canopied bed, he'd kissed her earlobes and suckled her toes. Surprised by his tender touch, she'd responded with urgency to his mounting desire. Khalil closed his eyes. For a brief instant, all thoughts of debt and humiliation were banished from his mind.

8

Vienna, eighteen months later
Spring 1869

Humming a few notes from Mozart's *Don Giovanni*, Khalil Bey descended the highly polished double stairway of the Vienna Court Opera. He was replaying the dazzling performance in his head—the costumes and stage sets had been nothing short of magnificent, but the music had captured every nuance of human emotion. Mozart was a true genius. Not to be outdone by the artistic production par excellence, Viennese high society had come out in full regalia to commemorate the inauguration of their resplendent new opera house. Khalil had naturally allowed his lorgnettes to stray from the stage into the neighboring loges. Unseen behind the magnifying lenses, he'd been free to admire the resplendent, bejeweled ladies, whose opera glasses, when not directed at the handsome tenor, were trained upon the royal box occupied by Emperor Franz Joseph I.

As soon as the final curtain descended, a thunderous roar of "Bravo!" had filled the hall. The emperor and his entourage had made a hasty retreat through the velvet curtains of the royal box for fear of being crushed by two

thousand of his own subjects. Foreign dignitaries and ambassadors followed suit. Khalil Bey, now addressed as Khalil Serif Pasa, undersecretary to the foreign minister for Ottoman affairs, was resplendent in a white cravat and tailored frock coat. Beneath the festooned archways of the opera's grand entrance, he mingled with his peers, the coterie of high-collared, stiff-lipped diplomats, many with medals adorning their chests. Seizing upon the evening's festive mood, Khalil squeezed through the crowd toward the Russian ambassador, who was looking impatiently for his private carriage among the melee of horses and coaches lining the street.

"Your Excellency!" bellowed Khalil with false cheer.

"Ah, Khalil Pasa," replied de Novikoff stiffly. "Allow me to introduce Madame de Novikoff," he added, acknowledging the woman by his side.

Turning to de Novikoff's rotund, powdered wife, Khalil bowed politely. *"Enchanté, madame.* Did you enjoy the performance?" Madame de Novikoff looked at him blankly.

"Forgive her," said de Novikoff. "Madame does not speak French. She speaks only Russian." His tone implied that other languages were of little import in any case. Without skipping a beat, Khalil switched to Russian, surprising the ambassador and delighting his spouse.

"Прошу прощения, мадам," said Khalil apologetically. Madame de Novikoff tittered as Khalil raised her pudgy, gloved hand to his lips. "I had no idea that His Excellency was hiding such a beautiful creature at home!

I insist you do me the honor of gracing my table with your presence next Friday night. I am hosting an intimate soirée."

It was imperative that Khalil maintain a relationship with the Russian ambassador, regardless of his personal views. His directives from the Foreign Office had been abundantly clear: Ascertain any nefarious Russian plans for expansion into Ottoman territories while maintaining a neutral and civil facade.

"Seven o'clock?" he said, addressing the ambassador with an innocent smile. De Novikoff could hardly decline the invitation when his wife was looking bleatingly up at him. The date was set, and the Russian ambassador whisked his wife brusquely away.

Khalil's liveried footman spotted the pasha and urged the horses forward with a clack of his tongue. After ensuring that his master was comfortably installed in the carriage, he signaled to the coachman and hopped onto the back of the carriage. Khalil loosened his cravat and relaxed into the plush, padded seat. Through the carriage window, the opera house lit up the night sky.

They pulled onto the Ringstrasse, past the heroical Town Hall, and continued along the Danube canal. The monumental buildings that lined the Ringstrasse were designed to inspire awe and awaken Austria's nascent nationalism, a disturbing trend that was sweeping through Europe. Khalil was all too aware of the ominous winds of change that were likewise blowing toward Constantinople, threatening to destroy age-old alliances

and upend the world order. His spies had intercepted communiqués that outlined Prussia's intent to unite the German states and challenge France's dominance over the European continent. With Prussia clearly trying to draw Napoleon III into a war that France could not possibly win, Khalil feared for his beloved Paris.

He had been instrumental in negotiating the difficult peace treaty that ended the Crimean War more than a decade before, and the experience had taught him about the unpredictable nature of war and the importance of reading the early signs of unrest. He would need to keep a close eye on the dangerously volatile situation on the European continent. As undersecretary, his intelligence gathering could be pivotal in shaping the unfolding crisis. If not for his old ally, the grand vizier Ali Pasha, he wouldn't be representing the Ottoman Empire in any diplomatic capacity whatsoever, let alone his current high-ranking position. The Paris fiasco had placed his career in serious jeopardy, but Ali Pasha had interceded on his behalf, lobbying and cajoling the sultan into dispatching Khalil to Vienna, where he was once again leading the aristocratic lifestyle he had become accustomed to. Khalil hoped to return the favor one day.

Lulled by the clip-clop of the horses' hooves and the strains of Mozart's arias playing in his head, Khalil nodded off. He awoke with a start as the carriage drew up to his Viennese residence. The footman opened the carriage door, and Khalil hastened up the stone steps of the colonnaded portico to avoid the sudden downpour.

A liveried butler opened the double doors and unburdened the pasha of his damp top hat and overcoat. From the marble entryway, Khalil made his way to the large drawing room, where a fire had been lit in anticipation of his arrival. He settled gratefully into his favorite chair, a monstrous affair of interwoven buffalo horns. Kasim appeared soundlessly with a glass of sweet tea and his master's favorite slippers tucked under his arm, their pointed, upturned tips almost worn through.

"*Teşekkürler*," said Khalil Bey appreciatively. He removed his shoes and slid his feet into the worn comfort of his slippers. "It's late, Kasim. Go to bed. But first, tell Mansour to start preparations for Friday's dinner first thing in the morning. I want him to prepare our finest dishes—maybe *capon à la jambalaya* or *iskender kebab*? And have the table set for eight with the gold-monogrammed service." Kasim bowed and retreated, taking with him the pasha's leather shoes for the negro boy to polish before his master awakened.

Khalil slurped the rest of his tea and placed the gold-rimmed glass on the ornamental table beside him. He ran his forefinger delicately over the tabletop's pearl inlay. How empty life would be without beautiful objects—and beautiful women. With his new position, there was no shortage of women who sought out his company and his lavish gifts. His new residence was once again filled with art, though, for the most part, lacking the sorts of risqué pieces he'd collected in Paris. His ministerial post called for certain responsibilities

as well as sacrifices. Besides, he still possessed the one painting without equal: *L'Origine du monde*.

On the eve of his hasty departure from Paris, he'd personally wrapped the painting in its green cloth and buried it in a trunk packed with his ceremonial garments. The trunk, along with its illicit cargo, had journeyed with him on his humiliating return to Constantinople. There it had remained for some months, hidden away from the prying eyes of nosy household servants. That same trunk had found a new home by the foot of his four-poster bed in his Viennese manse.

In the privacy of his bedchamber, Khalil occasionally removed the painting from its clandestine hideaway, sometimes pleasuring himself, and sometimes propping it up on a pillow beside his head before drifting off in intimate reverie. Although it was Constance Quéniaux's parted thighs that Courbet had immortalized in paint, the headless pose allowed him to conjure up the different mistresses he'd wooed on his various diplomatic assignments. Once he'd learned to compensate for his marginal physical appearance with intellect, charm, and an acute sensitivity to feminine wiles, his conquests had been numerous. But only Jeanne de Tourbey had succeeded in stealing a piece of his heart.

On some nights, the painting taunted him, reminding him mercilessly of the dangers that lurked unseen between a woman's legs. A man was helpless in the face of such temptation, as was regrettably confirmed by his youthful eagerness to bed that ravishing Russian harlot,

Natasha. Who could blame him? The bitter Moscow winters could drive any man to distraction, and Natasha had been the perfect antidote. She kept the cold at bay beneath piles of bearskin, performing sexual acts he'd never dreamed possible. He'd showered her with gifts, and she, in turn, had endowed him with a lasting memento—Cupid's curse, or "the great pox," as his Parisian doctor preferred to call it. Doctor Ricord had been able to stem the spread of the disease, but he had warned Khalil that one could never entirely free oneself of syphilis, and therefore, he should prepare himself for potentially dire complications in the future.

As the church bells sounded the late hour, Khalil removed his glasses and massaged his bad eye in a gentle circular motion. It wasn't the night to be thinking about *L'Origine*. He needed to focus on the upcoming dinner with that imperialist swine and his piggish wife. The invitees, the menu, the wines, the seating arrangement—every detail had to be orchestrated in such a way as to prompt the tight-lipped Russian to let slip a priceless nugget of information for Khalil to pass on to the foreign minister. Spies were one thing, but teasing out an unintended word from the horse's mouth was far more valuable.

9

Khalil engulfed Offenbach in a bear hug, almost crushing the fragile composer and dislodging his monocle. He turned to Hippolyte de Villemessant's towering figure and shook the journalist's massive hand with gusto. What a relief it was to see them both safe and sound. And what a delight to receive close friends at his home after months of soirées and dinners with the likes of de Novikoff, who plotted behind his back and whose every word dripped with condescension or lies.

"*Mes chers amis*! Welcome, welcome—I've been so worried about you all. I can't tell you how happy I am to see you," he said, herding them into the drawing room. "The war has been on my mind night and day. You must tell me everything." He clapped his hands and two servants appeared, one bearing a tray with two champagne flutes and the other, a glass of sweet tea on a round brass tray.

Accepting a flute of champagne, Offenbach looked around the opulently furnished rooms and raised his glass. "*Santé*," he said. "I see you've landed on your feet

again, *mon ami*. It's a good thing you left Paris when you did, before all hell broke loose—"

"That's right," Villemessant chimed in. "We barely made it out. It's been utter mayhem since Napoleon's defeat at Sedan. Léon Gambetta is about to declare the Third Republic, and he vows to continue the fight. People are arming themselves in any way they can, even as the Prussians are marching toward the city as we speak," he said, his jowls wobbling to the tune of his alarming words.

Offenbach shook his head glumly. "Bismarck has been preparing his military for months. Our armies didn't stand a chance. Napoleon fell right into his trap— the outcome was a *fait accompli* before it even began," he said, draining his champagne.

"Otto von Bismarck is a formidable adversary," agreed Khalil. "Our paths crossed in Saint Petersburg. The man's as sly as a fox, and fearless. Even as an ambassador, he never believed in diplomacy. His solution was always 'blood and iron', and now with this victory, he'll be unstoppable. I've read the reports about Napoleon's surrender and his imprisonment in the German states. It's humiliating."

Villemessant nodded morosely. "The Second Empire is done for. Who could have foreseen such an ignoble end for the emperor?"

"I fear for Paris," said Offenbach, who, although born in Cologne, had made Paris his home and adored the city as much as Khalil did. "It's hard to believe that just

a year ago I was staging operettas at Variétés. People are too worried to go to the theater nowadays. Remember the crowds at my last operetta, *La Périchole*?" he reminisced with a wistful look in his eye.

Khalil surprised both his guests by breaking out in song.

> *Ah! quel diner je viens de faire!*
> *Et quel vin extraordinaire!*

> *Oh! What a dinner I am about to prepare!*
> *And what extraordinary wine!*

"You're more French than the French!" Villemessant laughed. Glad for the brief respite from talk of war and defeat, the two men kidded Khalil about his tuneless rendition of Offenbach's popular aria.

As if on cue, Kasim, hands clasped behind his back, appeared at the threshold of the room and announced that dinner was served. Once seated at the lavishly anointed table, Khalil motioned discreetly for Kasim to approach and reminded him to set up the card tables in the game room.

Kasim inclined his head and left the room. *Card tables!* Would the pasha never learn from his mistakes? Allah had already shown his mercy once by saving his master from ruin—he who provokes the Holy of Holies is a fool. Hoping to ward off the evil eye, Kasim silently

recited the ninety-nine names of Allah on his way to the game room.

To the guests' delight, liveried servants filed into the dining room with fragrant dishes of lamb stewed in prunes, couscous piled high with vegetables, and the cook's signature dish, *iskender kebab*. The delicious feast was a far cry from the rationed meals his guests had been accustomed to those last few months in Paris, but they could not avoid the subject that was ever present in their minds. They discussed the pitfalls that lay ahead for the new republic and postulated the far-reaching danger of a now unified Germany. War was like a tiger, observed Villemessant. Once released from its cage, it cared nothing for arbitrary, man-made borders. He inquired about the trouble brewing in Khalil's own backyard.

"Turkey," said Khalil, licking his fingers, "is like a flock of sheep pent up in a stony field who find nothing but rocks and weeds and brambles to feed upon. They continually try to break through the fence to feed on the richer meadows of their neighbors. If only each shepherd would make the effort to pull out the stones and the weeds in his part of the field and provide the sheep with water instead of siphoning it off for palace fountains, we would not be in the situation we're facing."

Sensing that he might have revealed too much about his reformist views, Khalil tactfully changed course. "Jacques," he said, winking at his friend. "What do you hear about that firebrand, Gustave Courbet?"

Offenbach paused before responding. The mention of Courbet's name instantly resurrected that dramatic moment when Khalil had pulled back the green curtain in his marble bathroom. He would have liked to ask Khalil about the demise of the little painting behind the curtain, but Villemessant was notorious for his fiery articles about the "moral gangrene" that had taken hold of Paris. Some things were better left unsaid. He recounted instead the successful showing of Courbet's seascapes at the recent Paris Salon, before the war had turned the public's attention to more pressing matters.

"Nobody's ever painted waves and cliffs like that," said Offenbach. "You could graze your hand on the rocks in that painting. Even the critics couldn't fault him this time around. Say what you will, but he certainly has a way with those brushes of his . . ." *Particularly when it comes to painting the female anatomy.*

Since that initial shocking revelation, Offenbach had often reflected on Courbet's erotic painting. Nothing Courbet produced would ever approach the originality and daring of *L'Origine*, but he disagreed with the artist's boastful claim that the painting portrayed a "real" woman. In Offenbach's opinion, the painting's myopic carnality was but a narrow, incomplete picture of a woman. Women were mysterious and complex creatures given to incomprehensible flights of fancy—without those maddening and mystifying feminine qualities, his heroines would never be believable, and his operas and librettos would never ring true.

Villemessant's irate tone broke into his thoughts. "That self-proclaimed savage may know how to paint rocks and waves, but his insolence knows no bounds," said the journalist. "Khalil, can you believe that he actually had the nerve to refuse the Legion of Honor? Our nation's highest decoration! What an insult. And he wasn't content just refusing it—he published his rebuttal in *Le Siècle*!" he added, wiping grease from his chin and throwing his napkin down in disgust.

"He's got a hell of a nerve," said Offenbach. "People were reading his letter on every street corner. He attacked the government for interfering in the arts, and he justified refusing the medal on the grounds of 'posterity.' He apparently wants to be remembered as a free man—no affiliations to anyone or anything, no church or regime, for that matter. I personally can't understand it. Receiving the Legion of Honor was one of the high points of my life. Napoleon himself presented me with the medal, but now," he said dolefully, "I'm persona non grata because I'm German. I can't go back to Paris until things settle down."

"You've got to admire Courbet's pluck," said Khalil. "He's going to need all that courage, what with the Prussians closing in."

He pushed his chair back with finality and suggested they retire to the smoking room. There, the men sprawled out on long divans covered with tasseled silk pillows. A servant boy had assembled an array of Turkish water pipes encrusted with diamonds and precious stones, and

filled with tobacco-infused rose water. With each sweet puff, their worries receded, and the room soon filled with aromatic smoke and soft laughter. Villemessant opened the buttons of his waistcoat, and Khalil cautioned his friends not to get too comfortable—they would be needing their wits about them for a few rounds of piquet. His guests accepted the challenge with good humor. *"Allons-y!"* they chimed. "May the best man win!"

10

Gustave Courbet looked out through the barred window of his cell and gazed at the full moon. *The fortunes of man rise and fall like the waning and waxing of the moon,* he thought morosely. Moonlight illuminated the cell that he'd inhabited for the past five months; an iron cot against one wall, a stool, a small table by the window, a sink on the far wall, and a sitz bath to relieve his hemorrhoids (approved by the warden of Sainte-Pélagie on doctor's orders). Thanks to the efforts of his devoted sister Juliette, permission to paint in his cell had also been approved, although Gustave's request for a live model was refused on the grounds that "Monsieur Courbet is not here to amuse himself."

Courbet was most certainly not amusing himself, evidenced by the emotional and physical decline that was beginning to alarm his friends and family. He spent a good part of the long, drawn-out days, and the longer solitary nights, grappling with his fate. To be imprisoned for an act he did not commit—after living through the war, enduring the siege, and surviving the butchery that had left countless citizens of Paris dead at the hands

of their own government—was beyond comprehension. When the German forces, commanded by the king of Prussia, had overrun the French army and encircled the city, the situation had turned dire for its citizens. No one had been spared the horrors of war and the cruelty of depravation. Gustave had witnessed the lengths to which men go in order to survive, going so far as to slaughter the poor elephants and camels at the zoo once all the horses and rats had been devoured. The world had gone mad, utterly mad, verifying what his dear, departed friend Proudhon had foretold—that man carries in his bosom a thousand monsters. Paris had been utterly denuded of trees and reduced to blood-soaked rubble by the incessant shelling, and always, the relentless cries of hungry children and the fetid stench of smoldering garbage and rotting carcasses.

And yet, within this hellish landscape, he'd also seen the human spirit rise up like a phoenix from the ashes. Working men and women had banded together under the banner of *la résistance*, summoning their Gallic mettle to defend their beloved city. Prussia's General Bismarck had sorely underestimated the Parisians—they did not crumble after a week without café au lait, as the general had assured his troops. *Non!* The citizens barricaded the narrow streets with cobblestones, bricks, and splintered doors pillaged from the ruins, fortifying their positions with cannon commandeered from the National Guard. Despite the odds, they'd held fast. When word spread that their own government was secretly negotiating

with the enemy, the people swarmed the streets, burned down the guillotine and the city hall, and sent the government and its loyalist soldiers scurrying for cover in Versailles.

Having seized control of the city, the citizens had elected a municipal Commune in place of their treasonous leaders. History was unfolding before his eyes, and Gustave had lusted to be a part of it. He imagined himself as a modern-day revolutionary, a *sans culottes* like his grandfather, who had regaled him with stories of his heroic escapades during the great revolution that had dethroned the kings of France. Courbet surveyed the confines of his cell with bitter irony. Who could have foreseen that his revolutionary zeal would land him in a cell no bigger than a snuffbox, in the very same prison where his *grandpapa* and his fellow partisans had dispatched their wretched victims to await the guillotine? The absurdity and injustice of it all!

He returned to his brooding, reliving for the hundredth time the tumultuous events that led up to his imprisonment. But inevitably, he arrived at the same conclusion: He still believed fervently in the Commune's vision for a society that championed the rights of the common man and stripped the venal clergy of their power and wealth. Despite his sorry circumstances, he would not have done anything differently. Nor did he regret accepting the nomination for president of the Commune's Artists Federation—a role that entrusted him with protecting the city's art museums and, closer

to his heart, gave him the opportunity to steer the hearts and minds of young artists in the direction of realism. He'd thrown himself into his duties with gusto, organizing the fortification of the Louvre's windows and overseeing the construction of scaffolding to protect the city's monuments from bombardment.

He'd been conscientious to a fault, believing it to be his duty to censure any existing monuments that didn't reflect the spirit of the new day. How could he have known that those noblest of intentions would lead to his undoing? He clearly recalled the fateful Commune meeting in which he had publicly identified the Vendôme Column—a soaring obelisk glorifying Napoleon I's victory in Austerlitz—as a blight on the nation's history. He didn't deny recommending that the column be dismantled and replaced with an appropriately revolutionary symbol. But alas! Those overzealous fools had entirely misconstrued his meaning. *Quel désastre.*

He tightened the prison blanket around his shoulders and shuddered at the memory of the crowds that had gathered in the Place Vendôme on that fateful day. The band had been playing "La Marseillaise" as the giant column was lassoed with cables and brought crashing down to earth, practically lifting the surrounding buildings off their foundations and sending plumes of rock and dust into the air. The onlookers, stunned into silence for the briefest instant, had erupted into wild cheering. Courbet had been thunderstruck. The blood had drained from his face as he'd looked down at the

pulverized chunks of twisted bronze plate strewn at his feet. His stomach had clenched with the premonition that his whole world was about to come crashing down like the hapless felled column.

Six days later, government troops descended from Versailles and broke through the tenuous barricades, unleashing a week of bloodletting that exceeded the most brutal atrocities carried out during the French Revolution. *Communards* were rounded up like dogs and shot on sight. In seven bloody days, close to twenty thousand were slaughtered. The government, once more in control of the capital, saw to it that the citizens of Paris paid dearly for their insurrection. Any Parisian, regardless of his or her loyalties, was suspect and subject to summary execution. Courbet was a hunted man, and a few sorry souls had met their end for no other reason than having borne an unfortunate resemblance to Gustave Courbet.

Daylight crept stealthily into the dusty, cobwebbed corners of his cell. Courbet closed his eyes in an effort to block out the memory of his arrest—the humiliating carriage ride in handcuffs, the nightmarish interrogation at Versailles, the trumped-up charges. His vehement protests had fallen on deaf ears. He was sentenced to six months in prison to await trial for allegedly stealing national treasures, and for the more preposterous charge of singlehandedly ordering the destruction of the Vendôme Column. Parading him through the streets of Paris sent a clear message to any *communards* still at

large, or any citizen who still harbored vestiges of rebellion in their hearts. The ministers, heads of institutions, and police commissioners whom Courbet had insulted, ridiculed, dismissed, and undermined, had been waiting for years for their revenge. The time had come for the arrogant, provincial parvenu to get his due.

As he watched the moon dissolve like spun sugar into the pale dawn sky, a few lines of verse popped unexpectedly into Gustave's head. The last time he'd heard those lines was at the café Momus. Charles Baudelaire had been buying rounds of drinks to celebrate the publication of his anthology, *Les Fleurs du mal*. At one point, Charles had balanced precariously on a wicker chair and recited a deliciously suggestive poem to an appreciative, and equally inebriated, audience. Poor Charles. Those poems had cost him dearly after the courts censored them on moral grounds, and now, like Proudhon, Charles too had gone to meet his Maker. Courbet missed him despite the fact that Charles had teased him relentlessly about trying to change the world. With Charles's resonant voice ringing in his head, Courbet sounded out the few lines of poetry he could recall.

This evening the Moon dreams more
 languidly,
Like a beauty who on mounded cushions
 rests,
And with her light hand fondles lingeringly,

Before she sleeps, the slope of her sweet
breasts . . .[1]

His hand twitched with longing for a soft, pliant breast to fill his palm. His loins ached. There was no crueler penalty than to deprive a man of a woman's comforts. His dreams were often filled with the sweet sounds and scents of lovemaking. As much as he yearned for a breath of fresh forest air or the feel of the sun on his face, his craving for a woman's touch was a hundredfold greater. He flitted through a kaleidoscope of women he'd possessed in his lifetime, and those whose bodies he'd memorialized in his paintings—none so memorable as the little erotic portrait for Khalil Bey. It was just as well he hadn't given in to his desire to keep it for himself. Since his imprisonment, the government had confiscated all his possessions as collateral, and there was no doubt in his mind that those deranged reactionaries would destroy *The Origin of the World* if they ever laid their filthy hands upon it.

He wondered what had become of the levelheaded Constance Quéniaux or, for that matter, how his lusty, earthy Joanna had fared after she left him to rejoin Whistler. A sudden burst of inspiration lit up his face, and he threw the blanket off his shoulders. He upended the wooden box that contained his paint paraphernalia onto his mattress and rummaged around until he found

1. Jack Collings Squire, "The Sadness of the Moon," *Poems and Baudelaire Flowers* (London: The New Age Press, Ltd, 1909)

a thick stub of charcoal. Dragging his cot away from the wall, he sat on its edge facing the stone wall. With a grin, he began to sketch by the early-morning light.

The thump of hobnailed boots and the jangle of heavy iron keys announced the warden's midday rounds. Prisoners would later recount that the warden was casting his usual cursory glance into each cell, stopping occasionally to hawk some troublesome phlegm, when he arrived at the cell of the renegade artist Gustave Courbet. Peering in, he let out an angry, disbelieving bellow. Hurling threats and insults at the prisoner, he fumbled for the key and flung open the cell door. A scuffling was heard, the scrape of iron against stone, and more cursing, culminating in unprecedented gales of laughter that echoed off the stone walls.

It was unfortunate that Courbet was forced to scrub the wall clean of the painted vixen whom the warden had mistaken for a live prostitute smuggled into the prison by his infamous ward. The artist's fellow prisoners were denied even the merest glimpse, but their imaginations fed their dreams for weeks to come.

11

Constantinople, one year later
Winter 1872

It was a balmy night. Khalil Bey stepped out onto the moon-drenched terrace before bedding down for the night. He never tired of the view. Moonlight shimmered off the Bosporus, and from his vantage point in Büyükdere, he could make out the silhouette of distant villages that clung to the hills of the Golden Horn. *The fortunes of men rise and fall like the waning and waxing of the moon*, he thought bemusedly. So much had happened over the past year. If he were a believer, he would thank Allah for his beneficence.

A soft breeze ruffled his hair. The howls of the dog packs that roamed the hills and neighborhoods of Constantinople drifted in on the breeze. He had forgotten about the dogs in the years he'd been away. He tightened the sash of his silk caftan and noticed that his waist had thickened considerably since his return to Constantinople a scant three months before. The wedding feast alone could be held responsible for his spreading girth—the never-ending parade of trays laden with succulent mutton, beef, lamb, and fowl; casseroles of spiced vegetables baked with legumes and drizzled

with yogurt; fresh breads and *pide* served with piquant sauces. He must have eaten at least half a dozen skewers of his favorite sweetmeats, flavored with cumin, mint, and coriander. Long tables bowed with the weight of dates, pistachio nuts, plums, quince, and pomegranate. It was a feast worthy of his new wife, Princess Nazli Hanim, daughter of Prince Mustafa Fazil Pasa.

He could still repeat word for word the telegram that had precipitated this new chapter in his life: URGENT STOP RETURN CONSTANTINOPLE STOP FOREIGN MINISTER APPOINTMENT EFFECTIVE IMMEDIATELY STOP. His Viennese household had been thrown into the familiar chaos of a transcontinental move. Kasim had taken charge of the small army of servants who scrambled to prepare for the voyage down the Danube and across the Black Sea to Constantinople. With news of his imminent return, interested parties in Constantinople, who had for some time been trying to broker a marriage between the eligible diplomat and the Europeanized, educated Princess Nazli, began mobilizing their forces.

When his steamship dropped anchor at the port of Stamboul in Constantinople, his senses, accustomed to the Occident, had been assailed by the once-familiar sights and sounds of the Ottoman capital. He felt disoriented. In Paris, he'd been considered a Turk, but stepping back onto native soil, he felt more like a Parisian than a native Turk. Soon, however, the muezzin prayers ringing out from the minarets, the gurgling fountains, and the

perfumed air that wafted up from the walled gardens of the harems had lulled him back into the rhythm of the Orient. He had adjusted quickly to the ethnic mix of Greeks, Turks, Arabs, Gypsies, Armenians, and Jews, and enjoyed the exotic clash of costumes. It had taken longer to adjust to the sight of veiled women, who, with their kohl-lined eyes, were nonetheless adept at speaking volumes without uttering a single consonant.

Khalil had shocked his future wife's chaperones when he'd demanded that she remove her veil during their first arranged meeting. He wasn't about to enter into matrimony without seeing what he was getting. Perhaps the only one who wasn't shocked by his demand—nor by the fact that he wore a top hat rather than a fez—was the youthful princess herself, who was keen to emulate the European women she hosted in her palace quarters. She had unclipped the diamond and emerald brooch that held her *yashmak* in place and returned Khalil's gaze with a shy yet amused regard.

She'd heard much about the new foreign minister, who, by all accounts, was a suitable match. But she hadn't anticipated his slightly myopic look nor his corpulent build. Nazli had sighed inwardly. At nineteen years of age, she would soon be unmarriageable, and her father had warned her that she couldn't afford to turn down yet another prospect. With a determined smile planted upon her lips, she rose and asked the pasha—in French— if he would like to hear her play the piano. Her anxious attendants held their collective breath. Khalil answered

in the affirmative, and she approached the piano stool, pausing a moment for her dark-skinned maid to adjust the voluminous folds of her red tunic.

Khalil listened attentively to the lyrical notes of the piano as he nibbled *lokum* from a golden tray. He took note of Nazli's slender body beneath the tunic, her long neck bent like a swan's over the piano keys, her thin oval face distinguished by an aquiline nose, and brows accented with India ink. The princess was no great beauty, he observed, but her eyes danced with intellect and curiosity. She would make a fine diplomat's wife, versant in five languages and artistically inclined, he had been told. The proposed union held many advantages besides. Not only were her father and uncle politically aligned with him against the new *khedive*, Ismail, but there was also the matter of her substantial personal fortune. Yes, it was time he settled down. An auspicious date was set, and wedding preparations had begun in earnest.

Nazli came to their marriage bed adorned in thick ivory lace from head to toe. Her long hair had been oiled and elaborately styled in braids interlaced with silver tinsel. She had been bathed in rose-scented water, and every single hair on her body had been plucked by her handmaidens. Khalil reached for her limp, clammy hands that were covered in intricate patterns traced in henna.

"Come, Nazli. Don't be afraid." Khalil wished he could summon a verse by Yunus Emre, or even Rumi, to put her at ease, but he had always preferred history

books over poetry. He searched about for a seductive phrase to break the impasse. "The scent of your flower and mine will make beautiful perfume," he ventured. Even to his own ears, the phrase sounded lumbering and clumsy, and Nazli covered her mouth to hide a giggle. Fortunately, he recalled some muddled lines from *The Perfumed Garden*, Sheikh Nefzawi's erotic poems handed down to him by his father when he reached manhood.

"You are as beautiful as the moon," intoned Khalil. "Your navel is like a pearl in a golden cup, Your neck like a gazelle's . . ."

Nazli's eyes remained downcast, but her lips were smiling. Khalil began to unfasten the tiny pearl buttons that formed a luminous chain from her neck down to her waist. She shivered ever so slightly as the gown slipped off her shoulders, exposing her breasts. Khalil wasn't immediately attracted to her long torso and pale down-turned nipples, and her passivity and reticence did nothing to stir his flaccid member. For a moment, he panicked at the thought that he might not be able to consummate the marriage, a mortifying prospect that would make him a laughingstock and threaten the auspicious union. He caught sight of his familiar trunk at the foot of the marriage bed, and the thought of the painting hidden within made his penis leap to attention. He grinned and drew Nazli closer.

But the days when Khalil could rely on Courbet's painting to rouse his sex by reminding him of his willing

mistresses had been numbered. How had he ever imagined that a secret could be kept in a household full of women? He shook his head at his own naiveté. Not long after the wedding night, one of Nazli's maids, whose task it was to air out the bedclothes every morning, had, like Pandora, peeked inside the heavy silver chest by the foot of the bed. It seemed to be shrouded in mystery, but when she peered in, she discovered only the pasha's carefully folded ceremonial garments. Unwilling to accept the mundanity of her discovery, she stubbornly wormed her hand beneath the garments and stopped excitedly when her fingers touched a rigid object.

Her screeching brought her mistress running into the room. When Nazli laid eyes on the unspeakable painting, her face turned ashen. Even she, who had posed in diaphanous oriental garments for the Polish painter Elisabeth Jerichau-Baumann, blanched at the sight. She crumpled wordlessly to the floor, the air escaping her lungs. Surely her eyes were betraying her. Why, oh why, would her new husband encase that abomination in a gilded frame and conceal it as if it were a rare pearl? It shamed her to think that her own pampered, plucked, and perfumed *vajina*—that she had been taught since childhood to keep hidden to be deserving of a future husband—might in any way resemble this hairy, fleshy orifice more suited to a goat than a woman.

A terrible scene ensued. Nazli's threats and tears were stymied only by Khalil's earnest promise to dispose of the painting at the very earliest opportunity.

He realized, sadly, that *L'Origine* did not belong in the Orient. She needed to go home, back to Paris. Only there would she find favor in the eyes of another discerning gentleman who would cherish her, as he had. Khalil and Nazli never spoke of the painting again, but it would forever stand between them as an unpardonable betrayal.

12

The years had not been particularly kind to Khalil. The vagaries of palace intrigues and the struggle for political survival had taken their toll, as had the passing of his infant daughter. His sallow complexion broadcast a lingering illness, and his corpulence spoke of a lifetime of excess. Paris too had changed during his nine-year absence. He espied those changes from the back of the horse-drawn cab he'd hailed in favor of the new omnibuses and tramways that transported the city's bustling population to and fro.

The Paris that revealed herself to Khalil was a city of wide boulevards, parks, and plazas, and row upon row of stately apartment buildings graced with wrought-iron balconies and mansard roofs. Baron Haussmann had apparently made good on his promise to "rip open the belly of old Paris." The sweeping reconstruction project had been in full swing when Khalil was still living in Paris and had disrupted the lives of millions of the city's inhabitants. Very little now remained of the city's medieval quarters. Aside from the Haussmannian metamorphosis, Khalil sensed that Paris was still grappling with

the trauma of war and the devastating denouement of the Paris Commune. He noted an air of restrained gaiety and primness, as if the city were trying to repent for the heydays of hedonism and sexual indulgence he so fondly recalled.

Khalil was suddenly thrown against the door of the cab as the horse reared to avoid a collision with an omnibus. He clutched at the rectangular package on his lap. Since leaving Constantinople, it had rarely left his sight—it would not do to abandon it to the Fates after all they had been through together, he and this little painting. He placed a hand protectively on the parcel's brown wrapping.

After *L'Origine*'s untimely discovery by Nazli's servant, Khalil had summoned the master carpenter in charge of the ongoing renovations at his *konak*, his smaller residence in Findikli. Khalil had initiated plans to install a replica of the sultan's library at his *konak*, three towers of floor-to-ceiling bookshelves recessed within decorative arched chambers. When the carpenter arrived, Khalil requested a small alteration to the original plans: a concealed niche, measuring two inches deep, nineteen inches high, and twenty-two inches across, to be integrated seamlessly into the central bookshelf.

When the work was completed, Khalil removed *L'Origine* from the chest, detached it from its gilded frame, and spirited it to Findikli, where he often hosted young Turkish intellectuals who shared his enlightened vision for a modern Turkey. Nazli rarely visited. The

painting would be safe until he could return it to its native land. Khalil left the discarded frame by Nazli's bed as a peace offering, and nine months later, their ill-fated daughter, Hayya Khanum, was born.

When Khalil's ambassadorial posting to Paris was announced, Nazli had declined to accompany him, citing her fragile emotional state following the death of their child. On the eve of his departure, Khalil paid a quick visit to his new library in Findikli, on the premise of selecting a number of volumes for the long journey ahead. This time he would not abandon his precious cargo to an unsupervised trunk.

The cab driver turned onto the rue de Rome and pulled his horse up at number 35. Khalil stepped down onto the curb. He looked up at the grand edifice of the *maison particulière*, home of the renowned art dealer Paul Durand-Ruel. At the massive entrance door, he lifted the iron knocker cast in the shape of a hand and struck it twice against its back plate. Durand-Ruel opened the door himself, smiling broadly at the sight of his old friend. Unlike Khalil, Durand-Ruel had preserved his good looks and slim form, even though his fair hair was beginning to recede, and his temples were streaked with gray.

"*Mon cher ami,*" exclaimed Durand-Ruel, hiding his shock at Khalil's unhealthy appearance. "It's been way too long. Eight years? Nine?" The two men embraced and kissed each other's cheeks. "Ah, the years, they slip

through our fingers like sand. Come in, my friend!" said Durand-Ruel. "I was so happy to receive your note."

Khalil handed his hat and coat to the attending valet. Still clasping his package, he followed Durand-Ruel into the elegant drawing room. The dark paneling and tasteful Louis XV furnishings were unexceptional in their traditional, bourgeois sensibility. However, the paintings lining the walls from top to bottom were anything but traditional.

Durand-Ruel's eyes crinkled as he caught Khalil's surprised expression. "I see that you haven't lost your keen eye, Khalil," he said. It was he, Durand-Ruel, who had taught Khalil how to look at art, how to discern what made one painting superior to another, and how to trust one's gut. Khalil had been a quick study and, before long, had amassed an impressive collection of his own, sourced mostly from Durand-Ruel's robust inventory.

"And I see that you may have lost yours!" Khalil laughed, turning slowly to take in the modern paintings displayed on all four walls.

Leaning an elbow on the fireplace mantel, Durand-Ruel chuckled. Khalil wasn't the first to wonder whether he had lost his senses. He was used to people questioning his patronage of the young artists known as impressionists. Critics had skewered the exhibition of their works that he'd mounted three years earlier, but he was convinced that time would prove them wrong.

"What are these? Are these the same artists from the Salon des Refusés?" asked Khalil, remembering the

hoopla caused by a number of young artists who, after being rejected by the Paris Salon, had followed in Gustave Courbet's footsteps and defiantly held their own exhibition, christened "the Salon of the Rejected."

"You're right—most of these painters did exhibit in the Salon des Refusés. What you're looking at are the works of the impressionists, *mon vieux*," said Durand-Ruel. "You're looking at the future of art!" Placing an arm around Khalil's shoulder, he walked him around the vast room, calling out the artists' names as he did so. "That's Camille Pissarro, and that one's James Whistler. Here's a new one from Claude Monet, and above it, Édouard Manet. And I just purchased this one from Pierre-Auguste Renoir—"

"But they look so . . . unfinished," said Khalil, peering through his thick lenses at the disorderly brushstrokes of color and the ill-defined contours. The paintings captured scenes of people walking in sun-dappled streets, strolling by the Seine, sitting in cafés, or picnicking by the beach. The "future" looked very much like the present.

"Those glossy scenes of goddesses or landscapes dotted with happy peasants are a thing of the past," said Durand-Ruel, stopping suddenly to look at Khalil with a mortified expression. "Khalil—please forgive me! I got carried away. I've left you standing this whole time and haven't even offered you any refreshments!" He strode to the fireplace and pulled on a thick silk cord. The two men settled themselves on the tufted leather settee, and a

valet appeared shortly thereafter, pushing a cart laid out with a porcelain coffee urn, diminutive coffee cups, and a plate of bite-sized *petits fours*. "So," said Durand-Ruel, offering Khalil one of the little glazed pastries. "What is it you wanted to see me about? Can I assume it's related to that package welded to your side?"

"Yes," admitted Khalil. "It's a delicate situation. It concerns a painting by Gustave Courbet—a very special painting."

"Ah . . . Courbet. You must have heard what happened to him after the fall of the Commune?" Khalil nodded, and Durand-Ruel shook his head and clucked his tongue. "What a pitiful state of affairs—between you and me, the whole thing is outrageous. The government is demanding he pay more than three hundred thousand francs to replace the Vendôme Column! How can one person be held responsible in the midst of such chaos? The poor man is ruined. He had no choice but to take off for Switzerland. Who can blame him? The alternative was to remain here as the Third Republic's whipping boy."

Durand-Ruel himself had escaped to London during the Franco-Prussian War and was no devotee of the current government.

"But let's see what you've brought me," he said, clearing a place on the low table in front of them.

Khalil carefully unwrapped his painting, and Durand-Ruel's breath caught in his throat. "So, it *is* true! I heard rumors that you commissioned a daring

painting from Courbet . . ." He shifted uncomfortably as blood rushed to his face and engorged another, less visible part of his anatomy. With his eyes riveted on the painting, he patted his pockets for his pince-nez. His own private collection included two works by Courbet, but the painting before him was unmatched in both content and execution. Pince-nez in place, he carefully examined its surface before declaring it the genuine article. For a lengthy pause, no words were exchanged as both men studied the painting and retreated into their private realms of fantasy.

The patter of little feet running across the parquet floor brought Khalil's head whipping around in confusion. Durand-Ruel scrambled to cover *L'Origine* just as two little girls, dressed in blue velvet pinafores and matching ribbons, burst into the room in a cloud of giggles.

"Papa, Papa!" they cried as they flung themselves into Durand-Ruel's arms.

"Marie-Thérèse! Jeanne! *Dites bonjour au monsieur*! Say hello to our guest," reprimanded their father. But his reprimand was sheer bluster; he doted on his five children, even more so since their mother's untimely death. The little girls disentangled themselves and shyly greeted the dark, bespectacled gentleman, who smiled kindly back at them. Khalil was grateful for the tinted lenses that hid the tear threatening to form in the corner of his eye.

"*Bon, allez-y*," said Durand-Ruel to his daughters. "Off you go. I'll come up soon, my darlings." At that, the little blond nymphs disappeared as quickly as they had appeared. Durand-Ruel and Khalil exchanged a mirthful, slightly guilty look.

"Listen, Khalil," said the art dealer. "Things have changed in Paris. The government censors are more vigilant than ever, and collectors want works that make them feel good about life again. They don't want any trouble, and let's face it, Courbet's name spells trouble. It would be impossible to exhibit this painting in any of my public auctions. It's far too controversial. I can't even think of one collector who'd be willing to pay a good price for it. And if the Ministry of Justice got wind of it, they could seize it to cover Courbet's debts. That's what happened to some of the paintings we were keeping in storage for him. A dreadful situation. We've secretly been in contact with Courbet in Switzerland—we buy some of his newer works for the British and American markets. Heaven knows the poor man needs the money."

Durand-Ruel looked at Khalil's crestfallen expression and pulled pensively on his earlobe. "All right, my friend. I'll take it off your hands," he said reluctantly. "But I won't enter the transaction into my logs. As you said yourself, it's a sensitive matter. I'll have to think of a way to hide it in plain sight until the right buyer comes along. My assistant, Jean-Claude, might have some ideas."

"I couldn't have hoped for more," said Khalil, beaming. "I feel responsible for the painting, and to know that its future is in your trusty hands now . . ." He was surprised to feel a measure of guilty relief similar to what he'd experienced when ditching a troublesome lover who had outstayed her welcome. His eyes lingered on the familiar fleshy buttock peeking out from beneath the hastily covered wrapping. In keeping with his promise all those years ago, he'd never divulged the model's identity and was not about to break that promise. He'd heard through the rumor mill that Constance Quéniaux had reinvented herself, becoming a respectable member of society through her charitable work with orphans and her support of the arts. He secretly wished her well.

Khalil stood up resolutely and held out his hand to the man who had been his teacher and guide through the chimerical world of art. Durand-Ruel grasped the hand with genuine warmth. He understood what it meant to feel passionately about a work of art—he'd banked his entire fortune on the impressionist paintings hanging in that very room. He walked his guest to the door and offered his personal carriage to take Khalil to his next appointment. The two men agreed to meet again soon.

Khalil's heart skipped a beat as he gave Durand-Ruel's driver the address he'd memorized. He sat back and stole a look at his pocket watch. His sources had informed him that Jeanne de Tourbey, who now held the title of Comtesse of Loynes, received visitors at her new residence every day between the hours of five and seven.

According to the gossipmongers, her husband, the Count of Loynes, had skipped off to the Americas, leaving her conveniently sans spouse but with a noble title as compensation. Khalil could not remember feeling so happy in a long while.

13

La Tour-de-Peilz, Switzerland, nine months later
January 3, 1878

Régis Courbet thought that he'd shed all the tears a man could possibly shed. He was wrong. The salted rivulets that slid silently down his cheeks had soaked the moth-eaten fur trim of his collar. To bury one's child was the greatest punishment God could mete out, and he would not wish his pain on any father. His concave cheeks seemed to have collapsed entirely, and his tall form was hunched in suffering. Walking beside him at the head of the funeral cortege, his daughter Juliette was not silent in her grief. Her wails and heart-wrenching cries had persisted since she'd arrived at Gustave's deathbed, and her face, shadowed beneath a curious hat constructed of felt and fur scraps, was contorted with grief.

The doctors had summoned Gustave's father five days previously after having exhausted their medicinal arsenal and curative procedures. Gustave Courbet was at death's door. Their patient was suffering from acute cirrhosis of the liver, and the resulting edema had so swelled his midportion with fluid that on a recent train journey, he had been unable to fit into a passenger compartment

and had been forced to ride in a carriage designated for cargo. Gustave's discomfort was such that for the past few weeks, he'd finally agreed to being tapped of excess liquid, marveling at the liters that flowed out from his own person. He'd felt such relief after those procedures that he insisted on meeting with friends at the local café, and even ventured naked into the lake, where the water's buoyancy was a welcome respite from his bedridden existence. But the tapping was but a temporary cure.

For months, Gustave's doctors and friends had begged him to cut back on his excessive drinking. Beer, absinthe, white wine, and cognac were his constant companions. They helped him forget his dire financial situation and the treachery and betrayal of friends, lovers, and countrymen. He longed to return to Ornans but was threatened with arrest should he step one toe across the border into France. At times, when the alcohol washed those dark clouds away, he returned to his gregarious self, endearing himself to the local villagers of La Tour-de-Peilz, where he'd taken up residence in a small fisherman's abode.

On good days, he painted small canvases of wintry vistas and local fauna, buying the cheapest pigments available from the local drugstore. He seemed content with this simple, rustic life, far from the machinations of scheming dealers and dishonest gold diggers who took advantage of his generous nature. The worst of the lot was his estranged sister, Zoé, with whom he had been

feuding for years over her attempts to sell his paintings and steal away the family holdings.

Since his exile, Gustave spent most of his time trying to extricate himself from his impossible predicament. He corresponded almost daily with his father, his few remaining supporters, and his lawyers, positing new solutions. His father's responses especially grated on his nerves, for they always insinuated a failing on his part. Only his dearest, younger sister, Juliette, steadfast and faithful since childhood, saw him through his every trial. She had been his earliest supporter and remained his most devoted defender. An eccentric spinster, Juliette sacrificed her life to caring for their widowed father and speaking out on her brother's behalf.

By mid-December, Courbet's health took a turn for the worse. His abdomen expanded to a terrifying circumference as his arms, legs, and face withered to skin and bones. He began consuming huge quantities of milk, but ate little. The slightest movement was painful. Yet when some of his fellow exiles called on him, he mustered a welcoming smile and managed to sing a naughty ditty or two. Periods of sharp lucidity alternated with spells of delirium. He could no longer keep up with the incessant barrage of letters. After years of contesting his innocence to the crime of destroying the Vendôme Column, he had finally surrendered to the government's exorbitant demands. His first installment of ten thousand francs for the reconstruction of the column had

been scheduled for the first day of the fast-approaching new year.

Walking behind his son's coffin, Régis Courbet wished he could shake the pitiful image that had greeted him when he'd entered the low-ceiled bedroom where his son lay dying. Gustave's swollen body, surrounded by his grim-faced doctors, was grotesquely silhouetted against the low window overlooking the lake. His hair and beard were totally white, and he had a wild look in his eye as he ranted against his imaginary tormentors. He was further afflicted with severe bouts of hiccups. Régis sunk to his knees, sobbing uncontrollably into the sheets that strained to cover Gustave's bulk. Fearing for the old man, Doctor Collin checked his pulse and urged him to his feet.

Régis sent word for Juliette to come at once. Over the next two days, he stayed by his son's bedside, holding his hand. He was grateful for the spells of wakefulness, when Gustave was aware of his presence. Régis loved his son but had never understood him. Gustave's lifestyle was an exercise in excess, debauchery, and grandstanding. Of what use were those hundreds of paintings? If only his son had heeded his advice to pursue a career in law, Gustave's life would have been so much easier. But Gustave had always had a mind of his own. No amount of cajoling or threats had ever swayed him from his goals, even as a child. Years back, Régis and his dear, departed wife had been at their wits' end just to keep Gustave in school.

"Papa." The small voice broke into Régis's reminiscences like a knife. He moved his armchair closer to his son.

"*Je suis là,*" answered Régis. "I'm here." Encouraged by Gustave's alert expression, he added, "I brought you something." He reached under the bed for the lantern he'd brought all the way from their home in Ornans.

Gustave smiled. Then, with great effort, he raised his head and pointed weakly to the little desk in the corner of the room. "The photograph," he said with a grimace of pain. Régis walked over to the desk, unsure of what he was looking for. He rifled through a stack of letters and sketches and found a photograph taken of Gustave shortly before he'd left Paris. The smiling, portly gentleman sitting assuredly on a high-backed chair held no resemblance to the deformed creature lying supine on the bed. Régis brought the photograph over to the bedside, and Gustave weakly mimed the act of writing. He took hold of the pen Régis placed in his hand and in a spidery script, scribbled on the back of the photograph: *I hereby will all my worldly possessions to my sister Juliette. Signed, Gustave Courbet.*

He collapsed back onto the pillow and regarded his father. "I do not think I will live through the night," he whispered. Régis choked back his tears as Gustave began to writhe and mumble agitatedly, twisting his head from one side to the other. "Virginie! Why did you leave me? Where's my boy, my beautiful boy? Émile! Why was your

life cut so short . . . ? Joanna! Sing, sing, my lovely Jo. Alphonse, my friend, is that you? Maman, Maman . . ." Alarmed, Régis called for the doctor, who hurried back into the room. After a brief examination, he shook his head and prepared Régis for the worst as he administered an injection of morphine into Gustave's side.

Juliette arrived in time to see her brother take his last breath. He passed away peacefully just as the sun crested the mountains to illuminate the last day of the year, 1877. Juliette wasn't the only one to wonder at the ironic timing of his passing—one day before his first payment to the French Republic was due. His enemies might have exacted their pound of flesh, but Gustave had had the last laugh.

News of his death had spread far and wide, swelling the number of mourners who made their way to La Tour-de-Peilz. The solemn procession snaked its way through the blinding snow. The air was bracingly cold, and the clear blue sky afforded an unobstructed view of the snowcapped mountains in the distance. Gustave would have been elated by the sincere respects paid to him by the hundreds gathered at his graveside. Edgar Monteil, friend and fellow *communard*, spoke for them all in his earnest eulogy.

"It seems to me, gentlemen, that we cannot disband without bidding adieu to the great painter whom we have just lost. . . . In the name of artists, in the name of art critics, and in the name of art itself, a supreme adieu

to the one who is there, in that coffin, who certainly is—
such is my profound conviction—the greatest painter of
modern times."

PART TWO

1879–1948

14

A ntoine de la Narde held the porcelain plate by its delicately scalloped edge. The orange-and-blue geometric border lent the perfect counterbalance to the loosely painted floral motif in the center. He turned the plate over and blew at a few curls of sawdust that still clung to it. No chips or cracks, not even a fine hairline fissure. He guessed it was Nabeshima ware—late eighteenth century, judging from the orange glaze on the border. The new arrival would be put on display in the shop's vitrine. It would stand out next to the more common blue-and-white Imari bowls and ginger jars, and hopefully draw a more moneyed clientele than the young impressionist artists, who were crazy for *japonisme* but always low on funds.

What other treasures were buried in the newly arrived crates? Unpacking a new shipment was the most rewarding part of being a dealer of antique objets d'art from the Far East, a profession Antoine had more or less stumbled into. After serving honorably as artillery captain in the National Guard—and earning the distinction of chevalier of the Legion of Honor for his pains—he

had been at loose ends to find a suitable profession. It was at the inauguration of the reconstructed Palace of the Legion of Honor that he was introduced to Siegfried Bing. Tall and thin, with a bristly mustache and lively eyes, Siegfried Bing was distinguished for having introduced the French to the wonders of Japanese art. He had all but singlehandedly unleashed a national mania for the exotic wares—and profited handsomely in the process.

Listening to Bing's avid discourse on Japan and its alien culture fired Antoine's imagination. Several days later he made his way to Bing Frères et Cie on the rue de Provence. Siegfried was delighted to show a fellow legionnaire around the premises, stopping every so often to point out the attributes of various scrolls, prints, porcelains, and silks. Antoine had always coveted the finer things in life, and he left Bing Frères et Cie that day with a stack of volumes written by Bing himself, and an idea for a future enterprise.

Over time, Antoine developed a discerning eye for Far Eastern antiques. He would never reach Bing's status in the field, but his contributions to the Japanese art pavilion at the World's Fair the previous year had given his new establishment on the rue Saint-Georges a tremendous boost. The World's Fair had drawn millions of visitors to Paris curious to see the latest in technological developments, architecture, and fine art from around the globe.

Despite his enhanced sales, Antoine chafed at the mundane routine of his trade. At times he felt like nothing more than a glorified peddler. He brushed an annoying lock of fair hair off his forehead and reached deeper into the crate, feeling his way through the sawdust. He fantasized that a priceless, one-of-a-kind porcelain lay in wait at the bottom. The first thing he planned to do with a hypothetical windfall was to set his mistress up in a fancy apartment building with a concierge. Augustine had been pouty of late, and he feared that other admirers were sniffing around. Securing an apartment on the boulevard des Capucines, or perhaps furnished rooms near the Île Saint-Louis overlooking the Seine, would eliminate any potential rivals.

He imagined her welcoming him at the door of her new residence, dressed in nothing but the silk kimono he'd given her, her round cheeks rouged and her hair loosely tied with a ribbon. She would indulge him in his favorite game, blindfolding him with a perfumed handkerchief and squealing as he lumbered around with outstretched arms. The very thought of her sweet, moist honeypot set his loins on fire. The sooner he could arrange their next rendezvous, the better. Returning reluctantly to his fishing expedition inside the sawdust-filled crate, he retrieved a small plate from the late Edo period. Its painted cranes were praiseworthy, but it was by no means a route to instant prosperity. He thought to offer it to Edmond de Goncourt when the latter made his Saturday rounds of the antique stores.

The bell above the front door alerted him to the arrival of a new customer. He straightened up, dusted off his trousers and sleeves, shrugged into his frock coat, and strode into the main shop area. Antoine's welcoming smile faded when he recognized Claude Monet, one of the more persistent of the young impressionist artists. Monet was besotted by *japonisme*, particularly the ukoyo-e wood-block prints. It had been months since his last visit, and Antoine noticed that the younger man looked even more dejected than usual. His soft-brimmed cap was pulled low on his prematurely lined forehead, and the eyes in his boyish face had a sad, haunted look.

"Bonjour, Monsieur Monet," said Antoine. "It's good to see you again. How have you been?"

Monet did not meet Antoine's gaze. "*Ça va*," he mumbled into his beard, shifting a bulky package from one arm to the other.

In response to Monet's disheveled appearance, Antoine involuntarily straightened his own cravat. "What brings you in today?"

Monet mistook Antoine's shop banter for concern, having become accustomed to well-meaning people inquiring as to his welfare following the premature death of his beloved wife, Camille. "I just got in from Vétheuil," he answered softly. "I'm in Paris to see the children, but first I'm going to drop some paintings off at Durand-Ruel's."

Antoine recalled hearing that Monet was recently widowed and that his two little boys were boarding with

a lady friend in Paris. He formed his features into an expression of compassion and coughed sympathetically into his closed fist. As Monet's gaze drifted toward the wall of prints beside the curio cabinet, Antoine thought it an advantageous moment to mention the new shipment of prints by Katsushika Hokusai.

The artist's expression brightened considerably. "I'd be very interested in seeing the new arrivals," he said, placing his burdensome package on the floor by his feet. Despite the painful haggling that had preceded Monet's last purchase, Antoine dutifully went to the back room and returned with a large leather folio that he placed on the polished credenza. He carefully opened the folder's embossed cover.

"Hokusai's flower series!" cried Monet, seizing Antoine's sleeve in excitement. He brought his face closer to the delicate floral print and shook his head in wonderment at the simple but striking composition. He smiled at the little bee about to land on the cluster of yellow chrysanthemums. Nature had been his main solace in those difficult days. The next print featured peonies, and the one after, volubilis. He looked up at la Narde. "They're exquisite . . . I have to have them," he said, assuming a determined tone.

"Outstanding choice, Monsieur Monet. It's extremely rare to find twelve prints in such excellent condition. The whole set is valued at forty-five francs." Monet's face fell, and Antoine experienced a pang of conscience. But

business was business, even when it came to a relatively small sum such as that.

Suddenly, Monet remembered the paintings resting by his feet. *"Pas de problème,"* he said boldly. "No problem. I don't have the money on me at the moment, but I will, as soon as I deliver my paintings. Why don't you come with me? It's Tuesday, Durand-Ruel's open-house day. We can complete the transaction there and then!"

At first, Antoine thought that Monet was joking. Did he think that la Narde was some lowly debt collector, going from house to house with hat in hand? But Monet's fervent tone said otherwise. Antoine looked at the artist's shabby suit with its patched elbows and fraying collar, and a rare wave of compassion overcame him. His clients fell into three groups—the wealthy collectors, whose homes were crammed with gaudy possessions; the petit bourgeoisie, who convinced themselves that purchasing an exotic tea set elevated them in the eyes of their peers; and the handful of starving artists, who were inspired by Japanese design and style. Of the three, Antoine reaped the greatest pleasure from this last group, despite his grumblings that they barely made it worth his while.

La Narde consulted his pocket watch. It was closing time in ten minutes and he'd always intended to drop in on Durand-Ruel's salon to see his much-maligned art collection. Perhaps he could squeeze in a visit to Augustine before returning home—he could use the excuse of an official visit to Durand-Ruel's to explain his

tardiness to his suspicious wife. In hindsight, Antoine would often wish that he could shake some sense into his younger self. That scheming little slut of a mistress Augustine had thrown herself into the arms of the first wealthy industrialist who had come along. Thank heavens her cowardly new lover had refused his challenge to a duel.

But on that late afternoon, Antoine had been blinded by love. He gathered the folder of prints, lifted the heavy bunch of keys off the brass hook, and beckoned to a cheerier-looking Monet.

15

After years of waiting for a big break that never came, Antoine de la Narde had grudgingly resigned himself to a life of mediocrity. The wave of *japonisme* fever was in decline. If he'd learned anything over the years, it was that customers were fickle, always on the lookout for the latest trends. Even Siegfried Bing had developed an innovative new style of design that was proving immensely popular—*l'art nouveau*, he called it. His current showrooms featured Japanese antiques alongside his art nouveau creations. By contrast, Antoine's store had changed little, although his inventory was now comprised mainly of imports from China.

He'd attempted several forays into new markets, with little to show for his efforts. At one stage, he'd naively believed that he could corner the market on erotic art. The unassuming painting that hung on the wall behind his desk was a daily reminder of his foolish aspirations. That painting, featuring a gloomy château set against a snowy backdrop, was to have been his ticket to a brighter future—or more to the point, the wanton

painting concealed behind it. But he'd long accepted the fact that he'd never recoup the impulsive purchase he'd made at Durand-Ruel's all those years ago.

When he and Monet had arrived at the art dealer's home that fateful evening eleven years ago, Durand-Ruel had greeted him warmly, but not as warmly as he'd greeted Monet. He'd fussed over the young artist like a mother hen, treating him as if he were a fragile piece of china. *My, how times have changed!* These days, Monet's economic standing surpassed Antoine's. It was common knowledge that the artist had purchased a large property in Giverny, no doubt funded by the paintings that Durand-Ruel had been so keen to acquire. Antoine had cursed himself many times over for not having had the foresight to buy one, or even two, of those impressionist paintings. At the time, he had been perplexed by the art dealer's unbridled enthusiasm for the garishly colored canvases, and by his exclamations of delight when Monet unwrapped his parcel to reveal a few hazy paintings of Saint-Lazare train station. If truth be told, Antoine thought that Durand-Ruel had lost his senses when he slipped the artist a thick envelope of banknotes in return. But true to his word, Monet had counted out the bills and paid for Hokusai's flower prints without the slightest quibble.

After Monet's departure, Antoine had been eager to leave, hoping that Augustine would agree to see him on such short notice. But as fate would have it, an altogether

different temptress had commandeered his attentions that evening.

Durand-Ruel had insisted that Antoine join him for a liqueur, and the two dealers were soon deep in conversation about the capricious art market.

"Last year," lamented Antoine, "the blue-and-white porcelains were flying off the shelves, but this year, I can't move them. The only items that sell consistently are the erotic wood-block prints. My buyers like to pretend that the prints aren't really erotic—merely exotic," said Antoine, snorting at the childishness of this convoluted pretense.

"Erotic prints from Japan aren't my specialty," said Durand-Ruel, "but I can imagine that their flat perspective softens their explicit subject matter. Do you have a regular clientele for those works?"

"I do have clients who request that I put aside new prints when they come in, and I predict that the demand will keep growing," replied Antoine confidently.

Durand-Ruel appeared to hesitate for a moment. "I have something to show you that may be of interest," he said. "But I must insist on your absolute discretion . . ."

Intrigued, Antoine put his liqueur aside and followed his host to a small private office off the main drawing room. Durand-Ruel closed the door behind them. The room was dominated by a magnificent carved desk inlaid with ivory marquetry, uncluttered save for one of those new telephone contraptions. Unlike the crowded walls of the salon, the room boasted only one modestly

sized painting. Durand-Ruel walked briskly over to his desk, retrieved a little key from the top drawer, and motioned Antoine over to the solitary painting, a wintry landscape presided over by a turreted edifice.

"This is one of Gustave Courbet's last paintings," said Durand-Ruel. "It's the château of Blonay, in Switzerland. Our gallery acquired it shortly before he died."

Antoine approached the painting and nodded his head but was frankly underwhelmed. A Courbet was not exactly an attractive investment in those days. Since the artist's death, the auction houses continued to sell off his paintings for a fraction of their worth. The government was determined to punish the artist even when the miserable bastard was six feet underground.

With a twinkle in his eye, Durand-Ruel waved the little key in front of Antoine's nose as if he were about to perform a magic trick. He inserted it into the side of the gilded frame, and to Antoine's surprise, the frame swung open to reveal a second painting that had been hidden beneath. His mouth formed a silent O, and he almost tripped backward. Raking his hands through his hair in disbelief, he could feel the heat rising to his scalp.

"Astounding, isn't it?" said Durand-Ruel. "Gustave Courbet's *The Origin of the World*. I've been holding on to it for the foreign gentleman who originally commissioned it, but he passed away after a prolonged illness. As you can see, this is an exceptional, one-of-a-kind painting. But it requires the right buyer . . ." Durand-Ruel had yet to find the right buyer, but he was always prepared

when opportunity presented itself. If la Narde had clients interested in erotica, he may well want to take *L'Origine* off his hands for a decent price.

Antoine barely registered what Durand-Ruel was saying. He was fixated on the painting. It was unlike any of the erotica that came from the East, and so much more sensual than the collection of suggestive photographs that he kept locked in his secretaire. This—this was extraordinary. Courbet had captured that nebulous world between reality and fantasy. What man would not want to possess such a thing? Antoine could ask the world for such a painting! His head spun with visions of riches and notoriety.

Durand-Ruel discreetly dipped his pen into the inkwell on the corner of his desk and inscribed the price on a sheet of monogrammed notepaper. He folded it in half and, like a giant cat stalking his prey before the kill, he stealthily placed the note in Antoine's sweaty palm. "If you'll excuse me for just a moment, Monsieur de la Narde," he said. "I have something to attend to. I'll be right back." He left the room, closing the door behind him. *L'Origine* could close the deal without his help.

Antoine's dreams of a burgeoning business in erotica hadn't materialized, and the accursed painting had never fulfilled its whispered promises. He had not anticipated the protracted impact of the Paris Commune and its brutal aftermath. The city had not fully recovered from the trauma, and the government, in cahoots with the Catholic Church, conspired to suppress any memory

of the heady, seventy-two-day uprising with its prom-
ise of a rosy, egalitarian utopia. An air of paranoia had
woven its way into the city's social fabric, along with an
unspoken, collective shift to the safer shores of temper-
ance and tradition. For ten years, *L'Origine* had hung in
Antoine's antique store, gathering dust. The select few
for whom Antoine had unlocked the frame had acted
as if he'd tossed them a lump of red-hot coal. One gen-
tleman had threatened to call the gendarmes, agreeing
to forget the incident only after Antoine offered him a
length of embroidered silk for his wife.

At the sound of the bell, Antoine looked up from his
ledger, flicked an errant lock from his brow, and rear-
ranged his scowl into what he thought was a welcom-
ing mask. The resulting impression, however, was one of
mild aggravation. Deep lines bracketed his pursed lips,
and his gray eyes had lost their youthful ray of hope. The
new customer looked vaguely familiar. His dress and
general comportment indicated an aristocratic bearing,
but Antoine couldn't place him. Murmuring a bonjour,
he returned to his accounts. Barely had he entered the
previous day's meager earnings than the sound of rus-
tling brought his head up from his ledger.

To his surprise, the customer was standing in front
of his desk staring directly at the painting on the wall
behind him. Rarely did the snowy countryside with its
dark château catch the attention of his patrons. A keen
observer occasionally wondered what the unmistak-
ably European landscape was doing in an antique store

specializing in treasures from the Far East. But few had done so. And none had bothered to decipher the signature scrawled in red over a clump of dark-brown earth on the bottom right-hand corner of the painting: *G. Courbet.*

Antoine rose clumsily from his seat.

"May I be of assistance, Monsieur . . . ?"

"Vial," responded the gentleman, raising his top hat to reveal a full head of graying hair. "Louis Charles Émile Vial."

"Of course!" responded la Narde, flustered. "I apologize for not recognizing you immediately." He suddenly remembered meeting the tall, highbred gentleman at Siegfried Bing's booth at the previous Universal Exposition. Bing had exhibited a selection of Monsieur Vial's unique Ming vases in his booth alongside Antoine's choicest Imari ware. Vial had not made a notable impression on Antoine, whereas Bing had treated Vial solicitously, remarking afterward that Monsieur Vial was among the few men of science who truly appreciated the tactile beauty of a handcrafted object.

"How can I be of service today?" Antoine inquired.

"Edmond de Goncourt tells me you are in possession of a particularly *unique* painting," he said, boring into Antoine with his steel-blue eyes. Everything about the man was as spare as his words.

"Monsieur Goncourt . . . ," said Antoine, hoping to extract more information. Monsieur Vial raised his

walking cane and pointed it toward Courbet's snowy château, jogging Antoine's memory.

Of course . . . Edmond de Goncourt, the eminent writer and critic, had dropped by two Saturdays before on one of his weekly antiquing jaunts. Unable to interest Goncourt in any of the new arrivals, Antoine had thrown caution to the wind and, in a furtive whisper, offered to show his persnickety customer something so spectacular that he would think his eyes were deceiving him. Goncourt had looked on skeptically as Antoine turned his shop sign around to *"Fermé"* and returned to his corner desk, where he extracted an ornate key from a lacquered box.

Goncourt had been neither repulsed nor shocked once the frame swung open. Instead, he'd lurched toward *L'Origine,* his large patrician nose leading the way. Smoothing down his prominent whiskers, he inspected every square inch of the canvas, devouring *L'Origine du monde* with his eyes and making noises normally associated with a decadent meal. His bushy eyebrows almost collided with his hairline when he recognized the artist's signature. "I never gave Courbet enough credit! Just look at the paint quality!" he exclaimed. "Those flesh tones could rival those of Antonio da Correggio. And that tufted mound of Venus with its little pink rose peeking through . . . exquisite!"

Antoine held his breath. Could the long-awaited sale be imminent? But after Goncourt had his fill of the painting, he adjusted the front of his trousers, thanked

la Narde for a most interesting diversion, and continued on his way. Antoine had given *L'Origine* a withering look before locking her up again.

He was almost afraid of raising his hopes again, but with Vial watching his every move, he scooped up the little key from its lacquered box and released *L'Origine* from her dusty hideaway. The painting seemed to vibrate, as if gasping for every molecule of light while it had the chance. Vial stood stock-still but for a barely discernible twitch at the corners of his thin lips. Inhaling deeply, he motioned with his walking stick for Antoine to close the frame and, without further ado, reached into his pocket for his money pouch.

16

Paris, fifteen years later
Spring 1905

Louis Vial ambled along the length of the bookcase, his arthritic fingers caressing the leather spines. He stopped every so often to extract a volume from its designated slot and open it at a random page. It was a little game he played when his writing stalled and he felt incapable of unraveling the jumble of embryonic thoughts that filled his head. Once, when he had opened Charles Darwin's *On the Origin of Species*, a phrase had leapt off the page, leading him to a conclusion he might not have arrived at otherwise. But he'd already flipped open books on physics, anatomy, chemistry, and philosophy, and was no closer to formulating the thoughts that eluded him.

He resorted to fondling the legionnaire's rosette on his lapel, another habit he'd fallen into when stumped by a particularly thorny problem. The rosette had been awarded to him as a young man for his inventive new printing technique. Over the years, Vial had moved on to greater and more complex intellectual challenges, leaping impetuously from subject to subject. As a result, the rosette was fraying badly. With the dawning of the

twentieth century came discoveries and inventions previously unimaginable—telephones, radio waves, and moving sidewalks powered by electricity! But the age-old question about how life itself began eluded any definitive answers. Vial was humble enough to realize that in all probability, he wouldn't be the one to solve the riddle. That didn't prevent him from trying, however.

His latest manuscript was particularly ambitious. He'd tasked himself with exposing the errors of science—specifically, the theory regarding the role of unity in the creation of the universe. He believed that established theory didn't sufficiently account for the conflicting forces without which there would be no unity in the first place: Right and left. Positive and negative. The divine and the terrestrial. He had arrived at the conclusion that the mysteries of the universe lay in the realm of metaphysics rather than pure physics. The ancients might have philosophized without experimenting, but his peers experimented without philosophizing. He returned to his desk, an unwieldly affair stoically supported by four carved lions. Standing over his ink-blotched sheets, he re-read his last sentence: *Unity is a duality of two opposite halves, just as an apple is composed of two half-apples.*

With a grimace of pain, he straightened up and shuffled over to the narrow French doors that led onto a small balcony. Stepping outside, he rested his hands on the wrought-iron balustrade and inhaled the fragrant air. A gust of warm wind ruffled his toupee, and the sun

warmed his face. He noticed the greening of the Bois de Boulogne in the near distance and was surprised to hear birdsong. Spring had arrived, but he'd been so immersed in his writings those past few weeks that he'd failed to notice. It wasn't only the seasons he'd neglected—his long-suffering wife let it be known at breakfast each morning that her patience for his lofty preoccupations was wearing thin.

Returning to the penumbra of his study, his gaze fell on the somber painting that hung on the wall directly across from the balcony. The desolate winter scene stood in stark contrast to the budding flowers and chirping birds outside. He smiled in recognition as one does when one bumps into an old friend during a stroll in the park.

At the time that Vial had come across Courbet's double painting in the antique store, he had not touched a woman in over three years. He hadn't realized until that moment just how great were his needs and how lonely his existence. *L'Origine du monde* portrayed the type of woman he dreamed of—submissive and non-judgmental, at once docile and beckoning. As a young man, he had had all the makings of a successful lady's man, but he lacked the social graces. He was tongue-tied and awkward when introduced to prospective young ladies and had no patience for dances or balls. His head was "always in the clouds" according to his mother and later, his wife. His marriage to Jeanne-Marie Lepont had been one of convenience—his petite noblesse family tree in exchange for the Lepont fortune (attributed to his

father-in-law's suspiciously prescient unloading of his vast stock portfolio before the devastating stock market crash of 1882). The betrothal had satisfied all parties and left him free to pursue his intellectual calling.

It was not a happy union. Following the birth of his son, even the rare conjugal visits had petered out, and his first and only attempt to acquire a mistress had ended in utter humiliation. The memory of that ill-fated caper still haunted him. The object of his desire had been none other than the lead dancer at the Folies Bergère. From the moment he set eyes upon the spry creature embellished with ostrich feathers and sequins, he could think of nothing but her sloped shoulders and doe-eyed countenance. His metaphysical treatises were put aside in favor of long-winded love notes, and he languished for hours outside her dressing room like an abandoned puppy.

On the night that she finally admitted him into her private lair, his clumsy attempts at lovemaking had come to an inglorious standstill due to her uncontrollable fits of laughter prompted by the diminutive size of his penis. Never had he experienced such shame. He fled the scene as though he were escaping a burning building and ordered his coachman to whip the horses into a frenzy in his haste to return home. It was during that thunderous equine getaway that he vowed to buy one of those new automobiles making their belching appearance on the streets of Paris.

What greeted him at home was no better than the scene he had escaped. His wife was waiting in the parlor, arms crossed over her heavy bosom, a fierce look upon her glowering face.

"Do you think I don't know where you've been?" she growled the minute he crossed the threshold. She unfolded her arms and approached him menacingly. "You listen to me, you good-for-nothing, pathetic excuse for a man," she spat, flecks of spittle spraying into the air. "If I *ever* hear of you cavorting with tarts or stepping foot in those disgusting dance halls, I shall get Papa to instruct the bank to cut you off from any access to my dowry. Mark my words—we will ruin you, and you will never see your son again."

Thoroughly trounced by wife and mistress alike, life had returned to its numbing, but not unpleasant routine—Vial, meekly retreating to the sanctuary of his books and the occasional gentlemen's dinners at L'Escargot Montorgueil, and Jeanne-Marie returning to her legendary shopping sprees at the Galeries Lafayette.

It had been many months since he had paid *L'Origine* the attention she deserved. Needing a distraction from his work, he slipped his hand behind the painting and detached the hidden key from its hook. With a barely discernible click, the key released the lock's tiny bolt, and the top canvas swung open. He gazed at the splayed genitals with the wonder of a lover and the curiosity of a scientist, satisfied to simply contemplate the mystery of creation. The painting had occasionally slaked his sexual

fantasies, and he was glad to note that its spell still had the power to awaken his drooping genitals.

He'd often wished that he could see the face that belonged to the woman's torso. Was she pretty? Would her eyes be closed in slumber or ecstasy? Just as he began to fondle his stiffening member through his trousers with rhythmic strokes, a flurry of fully formed sentences accosted him like a swarm of incessant bees. Halting midstroke, he rushed back to his desk as quickly as his legs could carry him and picked up his fountain pen before the words flitted away into the ether.

Vial scratched furiously on his writing pad:

> *The Universe is a grand, dynamic coupling of male and female Force and Matter whose generative powers lie entirely in their contradiction . . . It follows that Creation, which is in question here, is but a grand love story in which every action and reaction of its heroic protagonists begins as a positive force transformed into its polar opposite, negative force, and vice versa . . . The source of life itself is fundamentally based on universal mechanical principles that are symbolic of the highest level of divine thought.*

Transported into the far reaches of his mind, he was oblivious to the darkening sky and the receding sounds

of traffic. When he finally looked up, he noticed that he'd left *L'Origine*'s frame open in his excitement to set down his thoughts. With a promise to call upon her soon, he locked the frame and returned the key to its hiding place. She was his secret helpmate, and he would never divulge her existence until his dying day.

17

Paris, seven years later
Winter 1912

Madame Vial stood over her husband's crumpled corpse, paralyzed by shock. The uneven rasping sound of her own breathing gradually permeated her stricken senses. One by one, she unfurled her fingers from their vise-like grip around her throat. How long had she been standing there? An hour? Ten minutes? It felt like an eternity. Steeling herself, she opened one reluctant eye, wishing away the scene before her. But *hélas*, it was as before—Louis's lifeless body lay on the floor in flagrante, his face tinged a purplish-blue, a hue not dissimilar to his exposed, shriveled member, nestled like a deplumed sparrow in his inert palm. A small whimper rose up in her throat, but she clamped her lips shut. Under no circumstances could she risk any member of the household witnessing that shameful sight.

Her eyes drifted up from the rigid corpse to the incomprehensible sight of the familiar landscape painting swinging like an open door and revealing a second painting whose depraved subject made her instantly light-headed. Sheer willpower and revulsion prevented

her from keeling over on top of her husband. She strug-
gled to make sense of the spectacle before her, but there
was only one conclusion to be drawn—that miscreant
of a husband could not even leave this earth without
disgracing her. All aquiver, she reached into her sleeve
for a lace handkerchief and dabbed at her watery eyes,
sobbing quietly. What had she done to deserve this
calamity?

When Louis Émile hadn't appeared at breakfast,
she'd sent the housemaid up to his bedroom to fetch
him. He'd become absentminded of late, and his rheu-
matism made it difficult for him to descend the staircase.
She'd waited impatiently, sipping her bowl of café au lait
and eyeing the tray of warm pastries. The maid returned
empty-handed. Grunting with the effort, Madame Vial
rose from the table and grabbed the speaking tube that
connected the dining room to her husband's study.
Irritated by his lack of responsiveness, she lumbered into
his study and entered without knocking. Nothing could
have prepared her for what awaited her.

Having somewhat composed herself, Madame Vial
took stock of her predicament. The situation was far
too delicate to involve a third party. She would have to
do what needed to be done. Fury bolstered her resolve.
Gathering her skirts to one side, she bent creakily down
toward the body and, with a liver-spotted hand, gingerly
tucked Louis's flaccid penis back into his trousers and
buttoned up the fly. Then she approached the hideous
artwork. The little key was still dangling from the lock.

Averting her eyes, she closed the frame, turned the key in its lock, and placed it between her bosoms. She would dispatch of the abomination in due course, but she could no longer hold in her pent-up emotions. Her howls of rage brought the servants running to the study.

The black-hatted undertakers were summoned. They placed the body in a casket, threw in some scented powders, and screwed on the lid, as per the widow's wishes. The funeral was held the following Sunday. It had been well attended, with a good turnout from the scientific community and fellow legionnaires. Madame Vial, propped up by her son and grandson, could remember very little about the day except for having been revived with smelling salts during the pastor's laudatory eulogy.

For the next week, she took to bed with her little dog, Bijou. The trays of food left by her bedside remained untouched, and the general consensus was that the widow Vial was in deep mourning. Nothing was further from the truth. She spent her days and nights regurgitating the horror of her discovery, unable to accept that for twenty-five years, she'd unknowingly shared her husband with a femme fatale (a painted one at that!) whose company her husband had preferred over his own warm-blooded wife.

On the eighth day, Madame Vial rang for her maid.

"I will be going out today, Colette. Lay out my mourning clothes and bring up my breakfast. And tell the chauffeur to meet me in the study."

"*Oui, madame,*" replied her maid with a curtsy, relieved to see her mistress returned to the land of the living.

An hour later, Madame Vial, resembling a giant crow in her black crape-trimmed frock, matching cape, and black widow's cap, descended the staircase with Bijou yapping at her heels. She hadn't set foot in the study since that foul morning. Feeling bile rising up her throat, she entered with ponderous steps and advanced toward the deceptively innocent painting that hid her husband's dark secret. She startled when the chauffeur coughed tactfully at the open door.

"Ah, Pascal. Come in," said Madame Vial tremulously. "Take this painting to the car. You can wrap it in the travel shawl I keep in the trunk." When Pascal removed the painting from its hook, its ghostly imprint left a dark rectangle on the faded, flocked wallpaper. Madame Vial stifled a cry. That accursed painting not only had killed her husband but was leaving behind an indelible reminder of the whole sordid affair. She turned defeatedly away from the wall and shuffled out to the courtyard, dog and chauffeur in her wake.

Pascal steered the Renault beneath the *porte cochère* and into the busy morning traffic. Madame Vial sat stiffly in the back seat. It was rare for her to venture out those days, the exception being Bijou's regular visits to the dog barbers by the Seine. Paris was barely recognizable anymore. New roads, department stores, underground trains. There was a frenetic quality to the city.

Even pedestrians scuttled about—strolling was a thing of the past and apparently did not belong in the modern, industrialized world. And the fashions! Women were abandoning their bustles and boned petticoats for streamlined styles that molded to their bodies in most unbecoming ways. Everything appeared foreign and hostile to the old widow in the back seat of the shiny black Renault.

Pascal pulled up at the corner of rue Richepanse and boulevard de la Madeleine. He turned off the engine, but Madame Vial made no move to get out. Some five minutes passed before she tapped him on the shoulder with a gloved hand, and, gathering Bijou under one arm, she hoisted herself onto the sidewalk, leaning heavily on Pascal's arm. While he retrieved the painting from the trunk of the car, she looked up at the corner storefront emblazoned with a sign that read "Bernheim-Jeune et Cie." She'd never visited the premises of Bernheim and Company, although she'd been a client of the elder Bernheim. The old Jew had been a reputable art dealer as well as a shrewd businessman. After his death, his two sons had taken over the enterprise and moved the gallery to its current location.

Gaston Bernheim stood up from his desk as the bell jingled above the door. Recognizing the woman's mourning attire, he clasped his hands in front of his chest in a universal gesture of condolence. "Bonjour, madame," he said, approaching her. "How may we be of assistance this morning?"

Bijou let out a sharp yip, compelling the dapper young man to take a step backward. "Naughty boy," cooed Madame Vial, caressing the dog's head. "I knew your father, young man. My name is Madame Vial. I've brought you a picture I wish to sell," she said, pointing vaguely behind her at the blanket-wrapped package in Pascal's arms.

"Of course, madame. Please accept our most sincere condolences. Why don't we step into our viewing room?" Gaston led the way solicitously into a paneled room illuminated by rows of windows and fitted out with a wide felt-lined bench. He pulled out one of the two leather armchairs, and Madame Vial sat down, settling Bijou in her lap and dismissing Pascal.

Gaston placed the painting on the felt bench and carefully unwound the heavy shawl that smelled faintly of mothballs. He was curious to see what he would uncover. It wasn't usual form for a woman in mourning clothes to appear unannounced at the gallery with a single painting. Under normal circumstances, he or his brother Josse would be asked to assess a collection in the privacy of the deceased's home. But in the art world, one never knew what to expect. That was part of the thrill.

The painting was undeniably accomplished, and even before verifying the signature, he thought he recognized Gustave Courbet's unique style—the black underpainting and the exuberant palette-knife markings that animated the dazzling drifts of snow. Gaston removed a compact magnifying glass from his waistcoat,

and starting at the top left corner, he worked his way methodically around the canvas. It was a skillful yet ultimately minor work by the great realist master.

Since taking over the business, he and his brother had been focusing primarily on modern impressionist art, as well as representing more risqué works like Auguste Rodin's ink drawings. The gallery already owned one of Courbet's larger works, and Gaston was tempted to turn down the widow's offering, despite Courbet's place of honor in Bernheim family lore. In the artist's early years, he had purchased his paints in Besançon, from the art store owned by Gaston's own grandfather. It was Courbet himself who had encouraged Gaston's father to move down to Paris to open a gallery.

Gaston was about to politely decline the painting when he noticed the frame's unusually deep profile. Always eager to learn more about his trade, he began to examine the frame's construction through his magnifying glass. Madame Vial, who had been watching him like a hawk, wiggled an index finger inside her bodice. She extracted a key from her cleavage and placed it beside the painting with a nonchalant air.

18

Paris, eight months later
Summer 1913

Even at three o'clock in the afternoon, every wicker chair on the sidewalk terrace outside the café de Flore was occupied. Not to be dissuaded, the two elegant foreigners tried their luck inside, where the air reeked of cigarettes, sweat, and perfume. They scanned the room for a vacant table, squinting through the fog of smoke. Their faces lit up as they spied a couple in the back getting up to leave. Squeezing between tables of raucous patrons, they homed in on the vacated seats like hounds on the scent of a fox.

They'd barely situated themselves when a waiter swooped in, clad in a black vest and long white apron draped at the hips. With a clatter of china, the waiter cleared the marble tabletop, hovering just long enough to take their order. With only the slightest accent betraying his Hungarian origins, Ferenc Hatvany ordered a glass of champagne for himself and a coffee for his companion. The waiter emptied the overflowing ashtray and disappeared into the haze.

The two men lit up their cigarettes and chatted amiably in their native tongue, discussing the exciting—and

not-so-exciting—art they'd seen in Montmartre earlier
in the day. Both had hoped to find hidden gems to add
to their respective art collections. Ferenc Hatvany and
Mór Herzog were in friendly competition as to who
would go down in the annals of history as the most cel-
ebrated Hungarian art collector of their time. Money
was no object—both men were born into wealthy Jewish
families, and both carried the noble title of baron before
their names.

Wine-fueled voices rose and fell around them in
melodic French cadence. Ferenc took a deep drag of his
cigarette and feasted his eyes on the pretty French girls
in their summer finery and straw boater hats, twitter-
ing gaily through red-painted lips. On the far side of the
room, a bareheaded man was crammed into a corner
sketching, and at a neighboring table, another patron
was writing furiously in a notebook, the green hue of
absinthe in his glass visible even through the smoke.
Ferenc recognized a familiar face across the room. He
placed his elbows on the table and leaned toward Mór,
shouting over the din.

"Do you know who that is, sitting over there?" he
said, motioning to a rowdy table with a jerk of his head.
Many of café de Flore's habitués were known to him
from his days as an art student in Paris.

Mór Herzog followed Ferenc's gaze to a table occu-
pied by three men and a very beautiful woman.

"Who are they?"

"You see the young guy with the straight black hair? The one with the bulging eyes, smoking a pipe? That's the Spaniard Pablo Picasso."

Mór's expression remained blank.

"Remember those two paintings you absolutely detested at Berthe Weill's shop? They were Picasso's!" Ferenc said, laughing.

"*Igen, igen,*" Mór said, nodding, as images of fragmented bottles and guitars floated before his eyes. Stroking his neat goatee, Mór stole another look at the dark-featured young man gesticulating wildly at the young woman. "So that's what a painter with no talent looks like!" said Mór, grinning.

"That's harsh, my friend!" Ferenc laughed. "I thought his paintings were interesting, certainly different from anything else we've seen."

"I think I've had my fill of 'interesting' and 'different' on this trip!"

"If you're talking about the ballet last night, I couldn't agree more," replied Ferenc, leaning back to give the waiter room to place their drinks on the tiny tabletop. "I never thought that going to the Ballets Russes would be a risky venture. Have you ever seen an audience react like that? Only in Paris! With all the catcalls and booing, you couldn't even hear the music!"

"You call that music? Stravinsky went too far this time. No melody whatsoever. All I remember is that damned bassoon blasting off-key the entire evening. And the dancing! Diaghilev had those poor ballerinas

plodding up and down like deadweights. Instead of calling it *The Rite of Spring*, it should have been called *The Demise of Spring*! It's no wonder the performance sparked a riot—we're lucky we got out of there in one piece!"

"The papers this morning had scathing reviews. But maybe we're missing something. Maybe, just maybe, these younger artists and musicians deserve credit for trying out new ideas."

"I don't think so," said Mór, stirring more sugar into his coffee. "Listen—I appreciate modern art as much as you do, but one has to draw the line somewhere. Why can't they experiment without abandoning beauty and harmony altogether! I'd like to see what the more established art dealers have to offer if we still have time. I'm not going to be back in Paris anytime soon—Erzsébet's due any day."

"Congratulations, old man! You're going to be a grandfather! That's cause for celebration—now you *really* can't leave Paris without a new painting!" They spent the next few minutes debating the merits of the leading art dealers, eventually settling on Bernheim-Jeune over Durand-Ruel or that cantankerous eccentric Ambroise Vollard.

Outside on the pavement, the two friends squinted in the bright afternoon sun after the dank interior of café de Flore. With Ferenc leading the way, they headed down the busy tree-lined boulevard Saint-Germain toward the quai Voltaire. Walking along the Seine,

they passed the green *bouquinistes* stalls and watched the barges and pleasure boats going about their business. They gaped at the summer throngs cavorting in the floating swimming pools and speculated about whether the novel idea would ever reach the banks of the Danube.

Crossing over the pont du Carrousel, they took a shortcut through the manicured lawns and shaded gravel paths of the Tuileries Gardens. Couples basked in the sun or stole kisses under parasols. Old women colonized the park benches, watching children chasing hoops and launching little sailboats in the lake. Along the rue Saint-Honoré, pretty girls in frilly aprons enticed them with bouquets of violets and lilies from their flower carts. Everywhere they looked, Paris flaunted her charms as shamelessly as a courtesan.

Arriving at Bernheim-Jeune et Cie, Ferenc was greeted effusively by Gaston and Josse. He was a valued customer, and the brothers knew him as an astute collector. They also recognized Ferenc's companion, Mór Herzog—every art dealer in Paris was familiar with the latter's impressive collection of Van Dyck and El Greco masterpieces. What a windfall to have two such esteemed collectors in the gallery at the same time!

Ferenc made a beeline for the collection of portraits by Auguste Renoir displayed in the front of the gallery. He hoped to pick up a technique or two to help him solve a problematic portrait commission waiting for him back in Budapest. Mór, hands clasped behind his back,

moved purposefully from room to room. Josse Bernheim, speaking through his exuberant mustache, attempted to interest him in their new acquisition, a colorful village scene by Signac. Mór pinched the bridge of his nose. The painting's over-bright palette and chaotic, pointillist brushstrokes were enough to give a man a headache. Josse threw a coded look at his brother: *We can't allow these two to leave empty-handed. Do something!*

Gaston approached the two collectors. "Messieurs," he said in a confidential tone. "We have some artworks in our inventory that are for private view only. I have something in mind that may interest you—will you give me a moment?"

"Certainly," answered Ferenc before translating Gaston's proposition for Mór's benefit.

Returning a few minutes later, Gaston invited the Hungarians into the gallery's viewing room, where he'd hung the double-framed Courbet painting above the green felted bench. The natural light from the north-facing windows showed the snowy landscape to full advantage. Mór was immediately struck by the expressive, gestural sky and stark countryside. In the far distance, beyond the bare-limbed trees and snow-bound castle, he detected the emerald horizon line of a distant lake. Unlike that gaudy village painting, the work had depth and emotion and expressed an ephemeral sense of longing. It was just the kind of vista that spoke to his Magyar soul.

Gaston's experienced eye could tell that Mór Herzog's interest was piqued. "The château of Blonay. Gustave Courbet painted it while in exile in Switzerland."

"Ah, Courbet," said Ferenc excitedly. Turning to Mór, he continued in Hungarian. "He's a hero to a lot of us artists, but you'd be surprised how many Parisians still blame him for that whole Vendôme Column fiasco. I think his work is undervalued—I bought two of his nudes just in the last year."

Mór had yet to add the noted realist to his own collection, and Ferenc's words had the effect of doubling his interest in the painting.

"What's the asking price?" he inquired.

Gaston Bernheim's answer took both gentlemen by surprise.

"Surely that's a very high price for one of Courbet's later works?" said Ferenc.

"This is no ordinary painting, messieurs," said Gaston, holding up a small key. He closed the door to the viewing room and inserted the key into the concealed lock on the frame. "I present you with . . . *L'Origine du monde.*"

As the frame swung dramatically open, Ferenc unloosed a disbelieving guffaw. The older, more conservative Mór was shocked rather than amused. His cheeks were splotched with crimson, and though his mouth was open, no words sounded. Of the eighteen hundred works of art in his collection, none had ever rendered him speechless.

Ferenc was the first to speak up. "It's magnificent! So daring! So *real*!" He alternated between bringing his nose up flush with the canvas and leaning back to look at it from different angles.

"*Too* real for me, I'm afraid," said Mór. "I can't see acquiring a work of this sort. I don't want my collection tainted by scandal."

Gaston Bernheim might not have understood Hungarian, but he understood body language. His hopes for a sale dimmed. With Gallic discretion, he excused himself and left the two collectors alone with their delibera-tions. He was surprised, therefore, when not five min-utes later, they emerged from the viewing room looking pleased and declared their interest in buying the double painting. Gaston was delighted—and relieved. When he'd purchased the painting from the widow eight months earlier, his brother had blamed the painting's erotic subject for clouding his judgment. These days, their collectors wanted their salons hung with works that captured enticing, vibrant scenes from the modern world. A painting that had to be hidden from view—not to mention one whose creator's name was tarnished by his prominent role in the Commune—was a difficult sell. But now the contentious work would be off their hands, and they stood to profit handsomely.

Back in the glittering frescoed lobby of the Hôtel de Crillon, two very satisfied Hungarian barons toasted a mutually advantageous transaction, one that would aug-ment both of their distinguished collections.

"*Két legyet egy csapásra,*" said Ferenc, his green eyes twinkling. "Two flies with one hit."

"*Egészségére.* I'll drink to that!" said Mór, clinking his brandy glass against Ferenc's champagne flute.

Each man believed that he'd scored the better deal. While Mór was pleased to be bringing Gustave Courbet's moody landscape back to Budapest, Ferenc was sure that he'd walked away with the prize. A work of such unsurpassed, flagrant originality as *L'Origine du monde* came along but once in a lifetime. He would worry about what to do with it once he got back to Budapest.

19

Budapest, eleven years later
Early spring 1924

Ferenc looked at himself in the bathroom mirror. *Really* looked. Not the distracted myopic glance while shaving or parting his receding, but still black, hair. Instead, he registered the protruding cheekbones, the weary set of his eyes, and the two worry lines that had recently etched themselves horizontally across his prominent forehead. *Only two?* he thought humorlessly. He wondered which calamities had caused the pair of furrows to appear. There were more than two contenders, many more. The Great War alone would have been enough to corrugate his entire forehead with creases—at the very least, one for each of the four long years it took until the "war to end all wars" had staggered to a halt under the weight of blood spilled by sixteen million young men.

Ferenc Hatvany had been among the lucky ones. He had been too old, and his son too young, to have been called upon to fight for his country. Outwardly, his circumstances appeared privileged by any measure—the palatial mansion on the hills of Buda, his wife and four children safe and sound, their bellies full. But even so,

his burdens were great. The war's end had brought new and unforeseen troubles. The popular revolution that ousted Hungary's wartime leaders had inadvertently replaced them with a string of failed regimes that shared one thing in common—a zeal for passing anti-Semitic measures into law.

To Hungary's war-weary, defeated citizens, the wealthy Jews in their midst were easy targets for their woes. Budapest, with its Jewish community numbering over two hundred thousand, was rife with anti-Semitism. Ferenc recoiled every time he heard his beloved Budapest referred to as "Judapest." He'd always thought of himself as a Hungarian first and foremost, but in that new post-war reality, his ancestry marked him as a Jew. In the space of a few short years, he found himself stripped of his title, and the family's banks and sugar refineries targeted for nationalization. His children were subjected to minority quotas imposed by the universities, and his brother, Lajos, had fled Hungary, fearing retaliation for his subversive writings.

How has it come to this? Ferenc often wondered. His ancestors had served as financiers to Hungarian royalty dating back to the fifteenth century. His own father, may he rest in peace, had been a member of the senate, and Ferenc himself had garnered a gold cross for his contribution to Hungary's cultural heritage. Centuries of liberal laws and assimilation seemed to have been swept away in the blink of an eye. When dark thoughts threatened to overwhelm him, Ferenc invoked the words with

which his stalwart grandmother, his dear *nagymama*, had soothed away his childish grievances: "This too shall pass." *And so it shall*, he told himself, straightening his shoulders. He had to remain strong for Lucia and the children, and for the villagers who depended on the Hatvany estate for their livelihood.

He leaned over the sink and splashed cold water over his face, patting himself dry with a monogrammed towel. Adjusting his tie in the mirror, he caught the reflection of the painting on the wall behind him, a pleasant pastoral scene of the grounds surrounding the family castle at Hatvany. It had hung in the same spot since he'd painted it close to a decade ago. And like all overly familiar objects (and people), it had begun its inevitable slide into obscurity. Turning around to face the painting, Ferenc regarded it with the same critical eye he had submitted to his own features just moments ago. As always, he was his own harshest critic. *Van Gogh would never have painted such a boring blue sky. I should have used more pink. But that purple highlight in the fields is a nice touch, I must admit . . .*

Flaws aside, the painting had served its primary purpose well. On impulse, Ferenc lifted the painting and its boxlike frame off the wall, leaning it against the baseboard and locking the bathroom door. Although his son knew of the secret Courbet hidden in his father's bathroom, it wouldn't do for one of the girls to come barging in unexpectedly. Ideally, he would have wanted to display *L'Origine du monde* in the main house along

with the rest of the collection, but some things were not meant for a woman's gaze.

He carefully prized his landscape out of the frame, exposing the curvaceous hills and fertile valleys of a very feminine kind beneath. "Hello, my lovely!" whispered Ferenc, admiring the painting anew. When he'd first brought it home, he'd spent time studying the exquisite rendering of the woman's torso, the plump inner thighs, and the wiry mass of pubic hair. The painting was so realistic, one could almost feel the heat rising from the model's skin and see the coursing of blood beneath its surface. Who was she? What had she looked like? As an amateur artist, Ferenc could appreciate that Courbet had succeeded in resurrecting a living, breathing woman from the flat surface of a canvas. Ferenc had painted countless nude figures and portraits of his own, and had struggled to bring each and every one of them to life.

Art had always been the salve that calmed his nerves, a world of swirling images that transported him beyond the banalities of his daily existence. But in his current state of mind, looking at Courbet's *L'Origine du monde* was bittersweet. It reminded him of a time when the world had been a simpler, safer place. On that beautiful sunny day when he and Mór had scoured Paris for undiscovered masterpieces, no one would have believed that within a year, the shadow of war would eclipse not only Paris, but the entire continent and the world beyond. The erotic thrill that *L'Origine* had once elicited had dissipated. He could not totally dissociate the

model's unprotected, defenseless sex from his memories of the terrified, half-naked women who had run screaming through the streets of post-war Budapest, pursued by the brutish Lenin Boys set on avenging Béla Kun's short-lived Communist regime.

Ferenc closed his eyes. He willed himself to recapture the same enthusiasm and excitement that he'd initially felt for Courbet's painting. It had once been a revelation, an inspiration, and even a lesson in humility. Ferenc blushed at his own hubris—to have once presumed he could surpass the master himself! He recalled the eagerness with which he had set about copying *L'Origine du monde* in the privacy of his ground-floor studio, confident that his painting would stand up to scrutiny beside Courbet's original. But with each subsequent session, Ferenc failed to unlock the painting's secrets and waited in vain for the master to enlighten him.

After weeks of frustration, he surrendered his brushes in defeat. His friends had teased him mercilessly.

"One pussy isn't enough for you, you old coot! What will it take—a harem?" teased Tibor, looking at the two paintings side by side.

"What happened to your copy? She looks like she's seen better days!" Imre taunted.

Ferenc had accepted their gibes with aristocratic grace. Pouring them each a shot of amber-hued Unicum, he raised his crystal glass.

"To Gustave Courbet. For putting me in my place!"

"Hear, hear!" laughed his friends, their faces puckering as they downed the bitter spirit.

The studio no longer resonated with laughter, and the still-life painting sitting on his easel had remained untouched for months. Ferenc mounted the paintings back on the bathroom wall. He straightened the frame with his long tapered fingers and searched the surface of his landscape for any residual hints of his aborted copy of *L'Origine* he had painted over. None was evident to the naked eye. He was suddenly overcome with the desire to inhale the potent odor of linseed oil and clutch the warm wooden handle of a sable brush. How sweet it would be to surrender once again to the act of creation, blotting out the world and all its problems.

But that was not what the Fates had in store for him.

20

Budapest, twenty years later
Summer 1944

Ferenc tried to swallow, but his mouth was too dry. Sweat filmed his deeply lined forehead and trickled down inside his collar. He flinched involuntarily as the thump of heavy boots from the floor above was followed by the clatter of breaking china and the thud of overturned furniture. He clenched his fists to control the trembling. He longed for a cigarette and fought the urge to search the pocket of his jacket that, once so beautifully tailored, now hung gracelessly off his spare frame and bore a yellow star stitched onto its lapel.

The two crisply uniformed SS officers standing at attention by the entrance to the main drawing room could have passed for fresh-faced farm boys—until one looked into their eyes. Flat, sinister, and cold. Any shred of humanity long gone. The skull-and-bones insignia on their caps and the winged eagle on the buckles of their gun belts glinted malevolently in the filtered light. Through the French doors and beyond the garden that had long since stopped blooming, smoke rose from the bombarded city, smudging the pale, anemic sky. A

mortar shell exploded in the distance, a sound so familiar that Ferenc barely flinched.

SS-Obersturmbannführer Adolf Eichmann brought his weasel-like face unnervingly close to Ferenc's. *"Wo sind die anderen, Herr Hatvany?"* he asked in a soft, velvety voice that barely concealed the rage and revulsion that Ferenc knew lurked just below the surface. "Where are the rest of them, Mr. Hatvany?" They had been going back and forth in this manner for the last half hour, and Adolf Eichmann's patience was wearing thin. With no forewarning, Eichmann flung an outstretched arm across the polished sideboard, sending crystal goblets and decanters shattering to the floor. Ferenc leapt as cognac sprayed his shoes and the cuffs of his trousers. His heart pounded erratically in his chest, but he looked straight ahead and stood his ground amid the shards. *This too shall pass; this too shall pass.*

Adolf Eichmann flicked a tiny droplet of cognac off the swastika-emblazoned sleeve of his metal-gray uniform and sighed. "You people are all the same," he said reproachfully, as if nothing were amiss. Clasping his manicured hands behind his back, he turned away from Ferenc and spoke to a point two feet in front of his elongated nose. "You take us for fools, Herr Hatvany? Most unwise," he added, giggling at his own joke like a schoolgirl. He pointed at the paintings and sculptures that the Waffen-SS unit had begun stockpiling haphazardly in the far corner of the room. "Do you expect me to believe that this sorry hodgepodge of artworks is the full

extent of your collection? Come, come, Herr Hatvany,"
he said, laughing snarkily at the terror he saw mounting
in the baron's eyes. "I have it from informed sources that
your collection is as extensive, if not more so, than the
Herzog collection. And that one is on its way to Berlin,
where it belongs. So, I ask you once again—where is the
rest of it?"

Ferenc licked his lips. "Herr Obersturmbannführer,
I assure you that what you see is the entire collection.
I have always kept my art at home, close beside me.
Your discerning eye can surely appreciate the value of
what you see here." He pointed an unsteady finger at the
stacked paintings. "That's a T-Tintoretto . . . and there's a
Renoir, and next to it, the Ingres and the Céza—"

"*Ruhe!*" shouted Eichmann, silencing Ferenc. "I don't
need a Jew lecturing me."

With deliberate steps, he picked his way through
the broken glass and approached the crudely stacked
paintings. He stopped to put on his leather gloves and,
with thumb and forefinger, picked up a glass-framed
ink drawing of two women embracing. "This? This is
what you call art? You Jewish Bolsheviks think you can
corrupt the purity of the German *Volk* with your filthy
images?" He hurled the Rodin sketch against the wall. "I
should light a match to the whole *verschissene* pile!"

Blood drained from Ferenc's face. Eichmann bent
down and picked up another painting, grunting slightly
under the weight of the hefty frame. He held it up for
closer inspection.

"I see you consider yourself an artist, Herr Hatvany," he said, identifying Ferenc's name on the bottom right-hand corner of the painting that, until that day, had known only the confines of Ferenc's bathroom. Laying the painting almost reverently down on the floor, Eichmann lifted a knee and drove his polished boot viciously through the canvas. He extricated his heel from the mangled canvas and kicked the painting aside. A droplet of sweat dripped into Ferenc's eye, and he willed himself not to blink.

Eichmann's lips twisted into a sardonic smile. "We will meet again soon, after you've regained your memory. I hope you're not planning on taking a vacation, Herr Hatvany? Now, *heraus*! Out! And don't bother showing my men around on your way out. We're quite capable of making ourselves at home." The jab produced a snigger from the two junior officers.

Ferenc's legs refused to do his bidding. He took one last aggrieved look at his beloved paintings, books, and heirlooms. His eye stalled on his desecrated landscape, its gaping hole like a screaming wound through which could be seen the floral motif of the Persian carpet beneath. If Obersturmbannführer Eichmann had discovered *L'Origine du monde* behind his painting, he may well have shot Ferenc there and then. But there was no *L'Origine* there to discover. When the Soviets had begun bombarding Budapest two years earlier, Ferenc had taken drastic measures to protect his most precious artworks. With the help of a few trusted friends and allies,

he'd crated up sixty of his favorite works—*L'Origine du monde* among them—and delivered them for safekeeping to the Hungarian Commercial Bank of Pest under the name of his friend's devoted secretary, János Horváth.

"*Raus! Raus!*" barked Eichmann, waving a glove at Ferenc as if shooing away a pesky fly. The taller of the two SS officers grabbed Ferenc by the scruff of the neck and dragged him out of the home he would never see again. He was ordered into the same truck that he'd been forced into hours earlier when the Sonderkommando had stormed into one of the designated Jewish houses in Budapest and burst into the crowded room he shared with another Jewish family.

Hunched over in the back of the truck, his teeth chattering uncontrollably despite the mild weather, Ferenc forced himself to think clearly. He could no longer concern himself with possessions—the time had come to save himself, and time was running out, fast.

When war had engulfed the world for the second time in his lifetime, Ferenc had despaired for Hungary, and for mankind itself. He should have saved his pity and compassion for his own kind, he thought bitterly. The first reports that reached Hungary about the systematic mass murder of European Jews had been dismissed as wild and fantastical tales. But soon, witnesses had borne out those rumors. Yet, despite the increasingly debilitating laws restricting every aspect of Jewish life, the shaky alliance between Hungary and Germany

had spared Hungarian Jews from the same fate as their European brethren, lulling Ferenc into a false sense of security. But everything had changed the morning the Germans marched unchallenged across the border four months earlier. After that, every Jewish life hung in the balance.

The beatings and shootings and deportations began almost immediately. All Jewish property was seized. The Hatvany residence was appropriated and the family banished to one of the apartment blocks branded with a Jewish star. Ferenc would never forgive himself for having waited so long and placing his family at risk. Using all of his remaining influence and available moneys, he procured life-saving baptism certificates for Lucia and the children, who had become mere shadows of their former selves. He negotiated for them to be ferried across the border into Romania in a Jews-for-cash transaction brokered by the Relief and Rescue Committee. He had elected to stay behind, promising his distraught family to follow as soon as he'd secured the rest of his collection. But the Germans had begun methodically cutting off every avenue of escape, and Ferenc felt the noose tightening around his neck.

The truck screeched to a halt at Vörösmarty utca 14. The driver bellowed at Ferenc to get out, deliberately gunning the engine and driving off before Ferenc had a chance to get both feet off the truck's running board. He stumbled to the ground, grazing his palms. Picking up his battered hat, he hurried inside but didn't climb the

four flights to his allotted room. His legs had given way, and he collapsed on the bottom step of the dingy staircase. His breathing was ragged, and he bit at his lower lip until he tasted blood. Panic had begun to set in.

21

The hotel room said much about the Swiss—neat, practical, and bedecked in neutral tones. Ferenc, fully dressed, sat on the edge of the bed, his shoe beating out a nervous drumbeat on the parquet floor. He looked out the window at the bustling scene below. Lined with luxury stores and crisscrossed by clanging tramways, the thoroughfare teemed with a contented citizenry that seemed to have lived a parallel existence to the one he'd inhabited during the war.

He flinched as the radiator sprang to life with the hiss and clang of expanding pipes. Summer had passed the seasonal baton over to autumn, and he felt a cold draft on his neck. He lit another cigarette and tossed the match into the heavy glass ashtray on the bedside table. His hand shook like the hands of the soldiers who returned from the front after the First World War— those hollow-eyed walking cadavers who spooked like wild horses at the slightest sound. Shell shock, they'd called it. He was one of them now, one of the walking dead. Although he looked more or less like his old self on the outside, he doubted he would ever be whole again.

The night before, he'd woken drenched in sweat. The nauseating stench of unwashed bodies pressing against him, the barking of the German shepherd dogs, and the crack of pistol shots had seemed all too real. The recurring nightmare had plunged him back into his harrowing escape from Budapest. But instead of the distracted Wehrmacht officer, who had overlooked his forged Swedish papers and allowed him to board the train to safety, it was Obersturmbannführer Eichmann who plucked the papers from his hand and dragged him off the train. That was the moment he'd sprung up from his pillow with a strangled cry.

It was almost four years to the day since he'd fled Hungary, but he'd relived that day so many times that it felt like yesterday. He still found it difficult to account for his survival. Six hundred thousand Hungarian Jews had perished. Why had his body not ended up stacked like cord wood on the streets of Budapest? How had he evaded deportation to the Nazi death camps or the final death march from Budapest to Austria? What Fates had spared him from being tossed into the Danube by the Arrow Cross, Hungary's own homegrown fascists? His country had betrayed him with unforgivable relish; he could never return.

After the war, he and Lucia had settled quietly in the Swiss village of Montreux, following a short stint in Paris. They went through the motions of leading an unassuming, "normal" existence, but Ferenc's spirit was broken—as was his desire to paint. When faced with a

blank canvas, he wanted only to cover every inch of it with thick daubs of viscous red paint.

He brooded obsessively over his lost collection, fretting about the fate of each work of art. Semi-reliable reports, together with his own exhaustive investigative efforts, had pieced together the probable fate of the collection he'd naively believed would remain in the family for generations to come. The valuables that he'd been unable to hide in vaults and bank safes had been seized by the Germans, recorded, catalogued, and loaded onto trains overflowing with plunder destined for Berlin. Most would never see the light of day again. But then, in the winter of 1944, with Hitler on the run, the Russian army had swept into Budapest from the east, slaughtering every last German. Within days, Russian commandos armed with crowbars had raided the local banks, breaking into safety-deposit boxes and looting what remained of the precious valuables that had escaped the clutches of the German war machine.

A letter from János Horváth confirmed Ferenc's worst fears—the Commercial Bank of Pest had been ransacked. The Russians had plundered the three safety-deposit boxes that Horváth had secretly deposited on Ferenc's behalf. Another friend reported seeing an open jeep careening around Vörösmarty tér, with drunken Russian soldiers holding up a painting bearing a strong resemblance to the erotic painting he'd once seen in Ferenc's studio. It was a terrible blow. Ferenc suspected that the rest of the stolen works were among those

rumored to have been stashed in hidden caves before being funneled to museums in Moscow, Gorky, and Kiev.

He'd given up hope of ever retrieving his scattered treasures and was therefore justifiably skeptical that, within a matter of hours, he would be reunited with nine precious works from his collection. He would believe it when he saw them. The smugglers had instructed him to book a room at the Hotel Schweizerhof in Zurich and to wait there for the call. But the suspense was becoming unbearable. He extinguished his cigarette and paced the narrow hotel room. What if something went wrong? Or worse. What if the deal was no more than a cruel hoax? He replayed the telephone conversation that had set this waiting game in motion—a phone call that had shattered the quiet of a Montreux evening three months earlier.

"Ferenc Hatvany?" inquired a voice with a distinct Budapestian inflection.

"*Igen*," acknowledged Ferenc.

"I have some news of interest to you," said the caller without preamble.

"Who is this?"

"That's not important. I'm merely delivering a message regarding some works of art that may have belonged to you. Should I continue?"

Ferenc's stomach lurched and his heart skipped a beat. Lucia looked up from her book, sensing a change

in her husband's demeanor, but Ferenc held a finger up to his lips. He gripped the telephone receiver.

"What about them? Where are they?"

"You have one week to get to Budapest—and bring Swiss francs with you if you want to get your hands on them again. Don't contact the authorities. I'll call again tomorrow night." And with that, the line went dead.

Ferenc didn't know what to make of the ominous call. He knew only that he was prepared to go to any lengths to recoup the art that had been torn away from him like severed limbs. He ignored Lucia's plaintive objections about returning to a city that held only nightmarish memories. But he was not to be dissuaded and immediately began preparations for his return.

When he arrived in Budapest days later, he had been in such an agitated state that it was difficult for him to recall every detail of what had transpired. He remembered the moonless night, a dank warehouse on the outskirts of Budapest. Three men—two Russians and a Hungarian, who held up the lantern that illuminated a stockpile of partially opened crates. Ferenc had gasped as he recognized the top third of Renoir's *Woman in Pink and White* poking out of the first crate. He threw himself upon it, tears of joy streaming down his face. For the next few minutes, he darted from crate to crate like a madman, trying to determine which works were there and what state they were in.

The Russian with the fur hat pulled low over his face shifted impatiently. *"Поторопись,"* he said gruffly, anxious to be done with the transaction. "Hurry up."

Ferenc addressed the Hungarian, a shady character with dubious affiliations to the newly elected government. "I haven't had a good look, but I'll take the lot."

The second Russian stepped out of the shadows. "That depends on how much you're willing to pay." His steely, colorless eyes were unnerving, but Ferenc was emboldened by the proximity of his beloved paintings.

"I told you on the phone I was able to raise thirty thousand Swiss francs. That was the deal."

"Thirty thousand? We're risking our lives helping to smuggle them out of Hungary! Thirty thousand will buy you ten of them. *Ten.* Take it or leave it. And hurry up about it or the deal's off."

Ferenc looked at each of the three men in turn and realized he was in no position to negotiate. He'd had to sell a small Manet to raise the thirty thousand Swiss francs that he'd smuggled into Hungary in his boots. That alone could have landed him in jail if the Communist authorities had caught him with the money. But even rescuing ten works was worth it. Ignoring the splinters, he began uncrating the works with his bare hands, leaning them up against the wall of the warehouse. None of the three men made a move to help him.

Breathing heavily, Ferenc stood back to savor some two dozen paintings, the familiar faces and scenes radiant even in the dull light of the single lantern. How

could he possibly choose between them? He'd heard horror stories of the Nazis forcing parents to choose which child to save and which child to sacrifice. He was instantly ashamed of making such a hideous comparison, but his carefully selected collection had become part of his family. They *were* his children.

The first painting he selected produced a round of vulgar comments from the three onlookers. Ferenc ignored them, overcome with emotion at seeing Courbet's little painting intact. *L'Origine du monde* appeared more vulnerable than ever without the protective painting that had shielded her when she had graced the wall of his private bathroom. That distant life seemed to belong to someone else. Holding *L'Origine*, he felt a responsibility to prevent her from falling into the wrong hands and being exploited for the wrong reasons. He set her gently aside and then hovered his hand over the remaining paintings. Each one appeared to beseech him: *Choose me! Choose me!*

Finally, with a heavy heart, Ferenc indicated his ten selections. "These ones. But," he said, clasping *L'Origine* close to his chest, "this one comes back with me."

"As you like," said the Hungarian with a lurid smirk. "But if you get caught crossing the border with it, you'll have the Soviets to answer to. We'll be long gone by then, and no one will believe a money-hungry Jew about how you got your hands on it."

Ferenc winced at the slur but stood his ground. The two Russians were already gathering up the other nine

paintings. They refused to divulge details of how or when the "package" would be delivered to him except to say that its final destination would be Zurich. In the meantime, he was to return to Montreux and await further instruction. The Hungarian go-between hustled him out of the warehouse and into a black Magyar microcar. They drove in silence back to Ferenc's hotel, where Ferenc had insisted that the money exchange take place. As the car flew over an obstacle on the road, Ferenc had tightened his grip on the painting in his lap.

DRRIING . . . ! DRRIING . . . !!!

Whiplashed back to his claustrophobic Swiss hotel room by the shrill ring of the telephone, Ferenc grabbed the heavy black receiver and brought it to his ear.

"Platform six," intoned the voice on the other end. "Come alone."

PART THREE

1954–2014

22

O h là . . . !"

Sylvia's crimsoned lips parted of their own volition, allowing an audible escape of air from deep within her solar plexus. She blinked several times to confirm that the image searing itself upon her retina was no mirage. A delicate finger crept blindly up to dab at a tiny bead of sweat that had sprung unsolicited above her upper lip. Despite the conflicting emotions roiling beneath her Chanel-tailored exterior, she remained rooted to the spot, her green eyes aglow.

Pierre Granville, standing strategically off to the side, noted the rainbow of emotions playing on Sylvia Bataille's face. He'd been watching her—discreetly, of course. Ever since her brother-in-law, André Masson, had conveyed the message that she and her husband were interested in seeing the painting, Granville had been looking forward to meeting her in person. Like most men of his generation, the flame he'd been carrying for Sylvia Bataille—the starlet, the muse, the darling of pre-war French cinema—had never been entirely extinguished. Who could forget her starring role in *A*

Day in the Country? Her portrayal of a vulnerable young
ingenue who lost her innocence to a lowly rake had won
hearts as well as critical acclaim. And that tantalizing
scene on the swing, where the camera had teased the
audience with fleeting glimpses beneath wind-flurried
petticoats . . .

It had been well over a decade since Sylvia Bataille
had appeared in the public eye, but at forty-five she still
retained that star quality—her sensitive, heart-shaped
face and slanted eyes were as captivating as ever, and
she wore her hair in a fetching pixie cut like the famous
screen actress Audrey Hepburn. It would be most fitting,
thought Granville, if the grande dame of French cinema
and her eminent psychoanalyst husband, Jacques Lacan,
were to acquire Courbet's brazen painting. When Baron
Hatvany approached him about finding a buyer for the
work, he had given clear instructions that the painting
was not to fall into the hands of any old roué. Were it
not for his wife's objections, Granville would have pur-
chased *L'Origine du monde* for himself. He was confi-
dent that the baron would approve of the celebrated pair,
a star of the screen and a darling of French literati.

Jacques Lacan stepped down into the sunken living
room and joined his wife in front of the polished easel
upon which Granville had mounted Courbet's paint-
ing for maximum effect. Hunching his lanky frame,
he parked his wire-rimmed glasses on top of his shock
of bristly gray hair and peered closely at the painting.
He nodded his distinguished head sagely. There, at last,

was an image that encapsulated the female paradox—Creator of Life and Seductress. Holy and profane. But more to the point, thought Lacan, the artist had done away with everything but the cavernous hole that virtually screamed the absence of that great symbolic signifier of power, the phallus—the ultimate symbol of accomplishment and privilege that both seduced and eluded men and women alike.

Years of clinical practice in Paris's mental wards, as well as observations elicited from his private practice, had convinced Lacan that all human desire and unconscious yearnings arose from *lack*—the term he had cleverly coined to define that which is missing, unseeable, unpossessable. For such was the human condition: a lifelong struggle to come to terms with the eternally unattainable. Only the certainty of death made life bearable in the face of this unassailable truth. How apropos, then, that a painting whose subject portrayed the ultimate symbol of lack should itself have gone missing for over half a century—if Granville's account was correct. Oh, to possess such a rare thing! A little smile curled the corners of his mouth and deepened the prominent lines on either side of his sensual lips. He could already see the painting hanging in his study, keeping him company during those solitary nights as he struggled to untangle the jumbled filaments that made up the human psyche.

André Masson approached the easel, elbowing aside his old friend—recently promoted to brother-in-law now that Jacques had finally made an honest woman of his

wife's sister, Sylvia. It was about time. The two of them had been a couple for over two decades.

Annoyed by the male heads blocking her view, Sylvia stepped forward and pried the men apart like two panels of heavy drapes.

"Don't hog the show, boys," she said in that kittenish voice of hers.

Jacques's eyes crinkled in amusement. His wife was a woman of few words, but when she did speak, she came straight to the point. He suddenly noticed her flushed countenance and dilated pupils and realized, belatedly, that his wife was aroused by the highly sexualized painting on the easel, perhaps more so than he. His first reflex upon seeing the realistically painted *chatte* had been to recoil inwardly, an involuntary instinct he immediately identified as the subconscious flight response to the primal fear of castration. Like a Venus flytrap, a woman's sex was irresistible, yet laced with real and implicated dangers.

"*Chéri?*" inquired Sylvia. After twenty-four years together, she could read him like a book, and recognized the look that indicated a deep dive into the labyrinthian trappings of his mind. She was used to his indefatigable cerebral exertions. The cogs that turned in his head were never at rest. Semantics, mathematics, anthropology, etymology—all subjects held endless fascination for him. People flocked to his seminars, hanging on to his every word as he pontificated on psychoanalysis, literature, philosophy, and art. His post-Freudian theories

were so radical that they'd sent shock waves throughout the psychoanalytic world, elevating him to the intellectual darling of Paris.

Jacques reached for her hand and brought it up to his lips. "I think," he said, pausing to weigh his words, "that this painting has been waiting for us, *n'est-ce pas*?"

Sylvia turned to her brother-in-law. "André, you're the artist. What do *you* think about this naughty little painting?"

"What do *I* think?" asked André, his broad smile splitting his jovial face into clearly defined segments. "I think it's delightful! A tour de force! If you're interested in buying a Courbet, this is the one. Honestly, when Pierre told me he was selling an obscure Courbet nude, I was expecting a bovine peasant girl with huge flanks. Certainly not *this*!" he said, gesturing toward the easel. Like most French artists, André admired Courbet for his lifelong struggle against authority, but with the revelation of *L'Origine du monde*, André's esteem for the nineteenth-century *enfant terrible* had grown tenfold. As a leading pioneer of surrealism, André was no stranger to breaking rules and swimming against the current, but what balls it must have taken to tackle such a taboo subject back in Courbet's day!

"What's the asking price?" Jacques inquired of Pierre Granville.

The art dealer coughed delicately before responding. "One million five hundred thousand francs, Monsieur Lacan."

Jacques inhaled deeply, taking his time before responding. "That's a hefty asking price. What about the damage?" he said pointing at the painting. "Here, and here? And it looks warped on the left side."

"If you knew what this painting's been through, you'd be surprised there isn't *more* damage," replied Granville smoothly. "The painting belongs to Baron Hatvany—have you heard of him? He is, or at least he *was*, in his day, one of Hungary's foremost art collectors. But during the war, the family had to flee the Nazis, leaving everything behind. The baron lost his entire collection and only managed to recover a dozen or so works. *L'Origine* is one of them."

At the mention of Nazis, Sylvia and Jacques exchanged a quick, furtive glance, but Granville plowed on.

"The painting has quite an exciting history—I mentioned that its whereabouts were unknown for years before Baron Hatvany acquired it. In any case, after the war, some works from the Hatvany collection surfaced and were held for ransom. They weren't well treated, as you can imagine, but the baron was able to rescue a few." He placed a milky hand on *L'Origine*'s frame. "Hatvany smuggled this one out of Hungary right under the noses of the Russians. He had to roll it up and hide it in the bottom of his valise. Just imagine! You can appreciate that it's very painful for him to part with it. But the baron feels that the time has come to find it a new home, preferably in the city where it was conceived. He's looking

for a buyer who will treat the painting with the respect it deserves."

Pausing his sales pitch, Granville slipped a hand inside his jacket. He removed a cigarette case engraved with his initials and offered it to his guests. Sylvia was the first to pluck a Gauloise from the silver case. The tremor of her alabaster fingers was barely discernible. She leaned over Granville's lighter and inhaled the soothing smoke deep into her lungs.

Granville's glib narrative had angered her. He'd made Baron Hatvany's harrowing wartime experience sound like an exciting adventure. There was nothing remotely exciting nor adventurous about having to flee from the Nazis. If not for Jacques, she may well have been one of the six million victims of the Third Reich. When the Germans had marched into Paris in 1940, Sylvia was pregnant with Jacques's child, and it was Jacques who had singlehandedly deflected a Gestapo investigation into Sylvia's Jewish roots by storming into the office of investigations and stealing her file in broad daylight. Her Romanian Jewish origins might not have been a fact broadly known among her fans—and in truth, had not been of great import to Sylvia herself—but the war had catapulted this little-known biographical detail into a matter of life and death.

With Jacques's help, she'd fled to the south of France along with her mother and young daughter from her previous marriage, and there she stayed until the end of the war, eking out a living by selling homemade fig

preserves and helping refugees escape across the channel to London. Jacques had commuted back and forth from Paris to Sylvia's hideout, and it was there that she'd given birth to their daughter, Judith. Despite their ups and downs in the ensuing years, the war had forged an unbreakable bond between them.

Absently fingering the purple silk scarf draped around his neck, Jacques regarded Gustave Courbet's painting with a calculating eye.

"Monsieur Granville," he declared in his gravelly baritone. "Considering the damage—understandable though it is—my offer stands at one million two hundred thousand francs. Please make my bid known to Monsieur Hatvany with my deepest respects."

Sylvia looked over at her husband, her lucent, almond-shaped eyes glinting moistly. She drew on her cigarette and blew a thin plume of smoke toward the ceiling's crystal chandelier. *L'Origine*'s history was inextricably intertwined with theirs. It was destiny.

23

Paris, three months later
Late spring 1954

Sylvia sat at the kitchen table mechanically snapping the ends off the slender haricots verts that Jacques was so partial to. She looked out the window of her apartment at 3 rue de Lille. The splendid chestnut tree at the entrance was expectant with buds, and the geraniums in the window box of the apartment opposite hers were bursting with flares of cherry-red petals. On the ground floor, the pretty young woman from the bric-a-brac shop was shuttering the store for the midday break. Sylvia extinguished her cigarette and wrapped the bean trimmings in a sheet of newspaper, discarding them into the bin behind the door. Aside from the green beans, lunch was just about ready—the quiche was in the oven and the platter of crudités was in the small icebox, as was the homemade mayonnaise, her mother's recipe.

Her sister and brother-in-law would be joining them for lunch. Rose and André Masson were coming in from Aix-en-Provence to deliver the screen that Sylvia had commissioned for the newly acquired Courbet. She herself wasn't affronted by the licentious nature of the painting, but she thought it prudent to keep it hidden

from unsuspecting little children and the prying eyes of cleaning ladies. Very little could shock Sylvia—she had seen it all, and more.

As she filled a copper saucepan with cold water, she wondered ruefully what her first husband, Georges, would say about the painting. He would probably deride it for being too tame. Georges Bataille was possessed of a carnal energy that vanquished everything in its path. She had been an innocent young woman when she first met Georges. He'd swept her off her feet, mercifully distracting her from her infatuation with her older sister Bianca's husband. Once they were married, Georges was openly promiscuous and encouraged her to skirt the edges of sexual experimentation. Indulging one's primal urges was the credo that their close coterie of surrealist artists, writers, and philosophers lived by. Theirs was a generation caught between the wreckage of the Great War and the drumbeat of new hostilities looming on the horizon. Life was too short to be constricted by arbitrary, arcane morals. Drinking, opium, and making love was what it was all about.

However, when Sylvia fell pregnant, Georges's wild lifestyle and descent into ever more perverse behaviors was no longer bearable. She'd left him, taking their infant daughter with her. But it wasn't in Sylvia's nature to judge others. She continued to include Georges in her life. After all, he would always be Laurence's father, and she would never regret the lasting friendships that were formed during that period in her life—Dora, Picasso,

Breton, Dali, Miró, Prévert, Sartre, and Simone had all remained close friends. And of course, Jacques. Her Jacques, "hers" to the extent that Jacques Lacan would allow himself to be possessed by any one woman.

Even though she and Jacques had finally tied the knot after so many years together, she knew that he wouldn't remain faithful. She sometimes questioned why she wound up with philandering husbands. Perhaps it was all she knew. Her own father had returned home one day from his exotic travels bearing news that he'd sired a child on the so-called Dark Continent. She remembered the pain it had caused her mother, and as she matured, Sylvia experienced occasional pangs of guilt for the suffering she had caused Jacques's first wife by their openly adulterous relationship and the love child that their union had produced. At the time, Sylvia couldn't comprehend why Jacques's wife—who herself had borne him three children—had turned a blind eye to his infidelity. But experience had shown her that women don't easily leave men like Jacques Lacan. Men such as he were like planets, who took for granted that women revolved around them like moons caught up in their gravitational orbit.

The sound of a key in the front door was followed by the thud of a dropped satchel. Sylvia lovingly observed her youngest daughter as she bounded into the kitchen.

"Bonjour, Maman!" said Judith, kissing Sylvia hastily on both cheeks. "I'm famished. When do we eat?"

She snuck a raw haricot out of the pan and crunched it noisily.

Sylvia shook her head good-naturedly and smoothed Judith's glossy black hair off her forehead. "Go wash your hands and set the table, *chérie*. When Papa's done with his patient, we'll eat. Don't forget Uncle André and Aunt Rose are coming, and Laurence said she'd join us as well. They should be here any minute."

Judith clapped her hands in excitement and went to set the table in the cozy dining room overlooking the courtyard. *Almost thirteen and still so innocent*, thought Sylvia. Half child, half woman. Her eldest daughter, Laurence, had been far more precocious and willful by nature. Laurence was only sixteen when she'd run off to live with that old tomcat, Balthus. In retrospect, Sylvia recognized that she could have done more to thwart that inappropriate liaison, but that was over and done with—Balthus had predictably replaced Laurence with a fresher, younger model. *C'est la vie.*

Hearing voices by the front door, Sylvia lit the stove beneath the haricots. She removed the quiche from the oven and set it on the small kitchen counter. Jacques expected his lunch to be ready when he came in from the adjoining apartment that served as his private quarters and consulting rooms. She headed to the entryway, where Jacques, cigar clenched between his teeth, was helping Rose remove her coat. After a round of greetings, Sylvia divested André of the hefty package he carried under his arm.

"We'll look at it after lunch, *d'accord*?" she said, knowing that Jacques was probably impatient to get to the table.

Depositing the package in the salon, Sylvia resisted taking a peek. She had no idea what to expect—her attempts to pry any details out of her sister had been utterly futile. Nonetheless, she had full confidence that André had created the perfect screen to conceal the new Courbet painting. Sylvia had never considered commissioning anyone else but André Masson. Aside from facilitating the purchase of the painting, André was a great artist in his own right, and their friendship pre-dated his marriage to her sister, Rose. He'd been a close friend and colleague of Georges. The two men had even collaborated on a fetishist novel entitled *Story of the Eye*, written by her ex-husband and illustrated by André. She wondered if *L'Origine* reminded André of one illustration in particular—a graphic depiction of a spread-eagled woman whose vagina was stuffed with a human eye belonging to the priest murdered and sodomized by the novel's teenage protagonists. *Not his finest work,* thought Sylvia. That went for her ex-husband as well.

"Laurence!" cried Sylvia with a start as her eldest daughter appeared before her, flushed from running up the stairs and wielding a baguette.

Laurence kissed her mother lightly on both cheeks. "Sorry, Maman. I was reading on the métro and missed the stop. Hello, everyone!"

Sylvia marveled for the umpteenth time at her eldest daughter's beauty. The hourglass figure, the thick chestnut hair, and sea-green eyes. She could be a film star, another Brigitte Bardot! But as quickly as the thought entered her head, she dismissed it. Even though she secretly grieved for her own aborted acting career, she didn't want that for her daughter. The film industry was not what it once was—they no longer made directors like Jean Renoir, and the new crop of actresses was nothing more than a bunch of jejune puppets. Better that Laurence put her brilliant mind to use in other ways.

Untying her apron, Sylvia placed it over the back of a kitchen chair and picked up the platter of crudités. Jacques was already seated at the head of the table with his omnipresent cahier and fountain pen beside him, ready to record any itinerant thought, lest it escape. Sylvia had long ago mastered the vinegar trick to remove ink blotches from her tablecloths, but cigar burns were another matter altogether.

Judith sat to Jacques's right, looking adoringly up at her papa as he poured the wine. Lunch was served and conversation flowed effortlessly. Rose, true to form, made a disparaging remark about the mayonnaise, and Laurence, having just returned from Algeria, expounded passionately about that country's legitimate fight for independence. André listened politely, waiting until she came up for air. "I have to admit, it's difficult for me to comprehend this insatiable thirst for war," he said. "I spent three years in the trenches, and believe me when

I say that war is worse than any hell you could possibly imagine. But we never learn—we just got our asses kicked in Indochina after ten years of fighting. And for what?"

"Don't worry, Laurence," added Jacques. "It's just a matter of time before French colonies are a thing of the past. A country's no different than an individual—when the core nucleus is repressed, it revolts and exerts a repulsive force. I see it every day with my patients. And where national interests are concerned, war is practically inevitable because diplomacy is fundamentally flawed. Diplomacy relies on verbal expression," he said, warming to one of his favorite subjects. "Language is grossly inadequate at conveying meaning. It can actually obstruct—"

"Papa," interrupted Judith through a mouthful of quiche. "When can we see what Uncle André made to hide the vagina?"

The family erupted in laughter. Lacan wiped his mouth with his serviette, burped loudly, and pushed his chair back.

"You're right, *ma chérie*. Let's not forget the important things in life!"

Everyone trooped into the salon after him and gathered around as André removed a gold-framed wooden panel from its layered packaging. The panel's natural dark grain was undisturbed save for a few etched lines suggesting an abstract landscape beneath billowy clouds. Three faint smudges of green, red, and yellow

indicated sparse areas of brush. Judith tried to hide her confusion and disappointment. Lacan pulled at his ear in puzzlement, but Sylvia could hardly contain herself.

"André! You're a genius! It's perfect. How clever!" Looking about excitedly, she realized that her brother-in-law's genius was not as apparent to her husband and daughters as it was to her. "Don't you see? Look! Squint your eyes a bit—that hill in the distance . . . the valley falling away from the bushes in the center . . . the land-scape follows the exact contours of *L'Origine*! No one would ever guess what they're really looking at. Bravo, André!"

Under his wife's tutelage, Jacques was able to distinguish the sensuous curve of buttocks, breast, and thigh. The overgrown brush in the center was clearly a forested pubic bush. "Bravo indeed, André," agreed Jacques. "Deceptively erotic . . . it's the perfect foil."

"Wait, there's more," said André, looking pleased with himself. With a flourish, he took hold of the frame's left side and gave it a tug. It separated from the rest of the frame, swinging down from a small hinge mounted at the bottom. With the left side of the frame out of the way, the wooden panel glided smoothly out to reveal Courbet's original painting beneath. His sleight of hand produced a round of applause from Judith and enthusi-astic praise from the rest of the family. Everyone agreed that *L'Origine*—with its disingenuous screen—should replace the pretty Monet that currently hung above the mantel.

The family drifted back to the dining room in high spirits, taking their places again for coffee and an assortment of chocolates from the new chocolatier down the street. Laurence lagged behind for a moment. She looked at the Courbet with a secretive smile. It wasn't all that different from the portrait that her ex-lover Balthus had painted of her in all her youthful, naked glory.

24

J acques leaned against the doorframe and surveyed the rambling garden with its overgrown rosebushes and lemon trees heavy with fruit. To his right, the staunch plane trees dappled the vine-covered manse with streaks of blue and violet. He smiled contentedly. Purchasing La Prévôté was without a doubt one of his better investments. He'd taken to spending almost every weekend at their country house in Guitrancourt. Sylvia saw to it that life was never dull thanks to a constant rotation of friends and colleagues who joined them for parties and Sunday lunches. But La Prévôté was also a place where he could write and think and receive the occasional analysand, as he preferred to call his patients.

He removed his hand from the pocket of his check-ered trousers and consulted his new Cartier wristwatch. Dora Maar was due to arrive in less than twenty min-utes. They'd terminated her regular psychoanalysis years ago, but every so often, when she felt herself veer-ing dangerously close to the gaping maw of depression, she requested a private consultation. His concern for her was genuine. She wouldn't survive a relapse of the

nervous breakdown she'd suffered after Picasso left her for Françoise Gilot. Jacques was hardly the one to pass judgment on Picasso for having his grizzled head turned by a stunningly beautiful art student, but Picasso's dalliance had had devastating effects. Dora's dangerous descent into mental illness had been hard to watch. After initially refusing Picasso's plea to take her on as a patient, Jacques had eventually relented. But it had been a long road to recovery.

Dislodging the cigar stub from the corner of his mouth, Jacques flicked the smoldering ash onto the gravel with his little finger. He turned back into his private study, a large floodlit pavilion that Sylvia had nicknamed "the aquarium" for its panoramic view of the garden. Her flair for understated elegance was evident in every corner of the property. She'd even convinced him to keep his enormous library of books in the main house, but nonetheless the shelves in the aquarium were filled with rare-edition books and an eclectic collection of objets d'art—a headless Roman statuette, an ivory figurine, a phallic terra-cotta talisman. Fondling those history-laden objects calmed his mind like worry beads. Trying to breach the hermetic seal of the unconscious was not for the faint of heart.

Art, in all its forms, had always fascinated him. Creativity was a tantalizing, intellectual enigma. He was never happier than in the company of artists and could lose all track of time gazing at art—whether standing before a Tintoretto altarpiece in Venice or sitting at his

desk in the aquarium, admiring Giacometti's study of a skull or the Balthus painting of a prepubescent schoolgirl and her feline companion. The true showstopper, however, took pride of place on the wall behind his desk, silently smoldering behind André Masson's wooden screen. *L'Origine du monde* was by far Jacques's favorite painting, even though it defied analysis and posed impossible riddles about the nature of desire, love, and sex. In true Freudian fashion, the painting morphed seamlessly between a chaste Madonna and a whore. Every so often, he even felt that the painting was mirroring back his own gaze—as if *he* were the object being gazed at!

Since its relocation to La Prévôté, Jacques had divulged the painting's existence to a handful of vetted visitors and the occasional lover. With a roguish twinkle in his eye, he invited these select few into his study, promising to show them an extraordinary sight. He then slid Masson's screen slowly out of its frame, building suspense before exposing his captive audience to the Courbet beneath. All that remained for him was to stand back and watch. What better litmus test than *L'Origine* to mine a person's psyche? As his innocent subjects struggled to process the startling image, he searched their faces with his piercing eyes, ferreting out any unconscious fears or desires unmasked in that uncensored moment, assessing if the hungry eye, in constant need of nourishment, was momentarily satisfied.

Jacques delighted in his cleverly devised psychological experiment, but Sylvia chided him for treating the painting like a cheap parlor trick and for behaving like a hustler outside the girlie shows in Pigalle. He dismissed her comments, confident in the knowledge that those privileged few who were party to his "parlor trick" were charmed, if not downright bedazzled by *L'Origine*. The exception to the rule having been Sartre and Simone de Beauvoir.

"Behold! A woman!" Simone had declared sarcastically, hand on hip. "Nothing but a sex organ, a womb, and a pair of ovaries!" She swatted irately at a wisp of hair that had escaped the braided crown encircling her head. "No face and therefore no brain, just the way men like it. Won't we ever be more than a bunch of biological parts?" She glared at Sartre and Jacques in turn.

Sartre had smiled enigmatically. "Come now, Beaver," he said, calling her by her nickname. "You know what I think about that. We shouldn't be defined by how other people look at us—we are what we *choose* to be. And as far as Jacques's painting goes, I'm not turned on, even if her cunt is quite magnificent. Desire requires the body *and* the mind—a mind such as yours, *mon amour.*"

Sartre laid a conciliatory hand on the nape of her neck, and Jacques had been relieved to see Simone's shoulders visibly relax, thus averting one of her rambling feminist tirades. The long-standing love affair between Sartre and Simone—the two leading lights of French intelligentsia—was the stuff of legend. But as one who

had treated an unfortunate victim of the couple's predatory sexual appetites, Jacques was privy to a more sinister side to their famously unconventional relationship.

The crunch of gravel underfoot announced Dora Maar's arrival. Jacques removed the cigar from the corner of his mouth and stood to greet her. She looked well, he thought. Perhaps a little drawn. Her dark hair was gathered in a flattering chignon, and the cowl of her dress showed off her generous cleavage.

"Bonjour, Jacques," she said as he held her arms and kissed her on both cheeks.

"It's good to see you, Dora."

Dora seated herself in one of the two armchairs by the picture window—she knew the drill by now. Unsnapping her leather handbag, she dug out a pack of Gitanes and fitted a cigarette into an ebony cigarette holder. Jacques leaned forward to light it for her and then dropped into the second armchair, throwing one leg over the armrest. He settled back and directed every fiber of his being toward the woman sitting opposite him. He always waited for his analysands to speak first, and then he would sift through their muddied gush of words to find a golden nugget with which to pry open their unconscious.

Dora crossed her long legs. She clenched the cigarette holder between her teeth at an acute angle and surveyed the room, looking for any changes since her last visit. Her eyes rested on the gilt-framed screen behind the desk. When Jacques had first revealed Gustave

Courbet's *L'Origine* to her years earlier, she'd found it exquisitely sensuous. It awakened sweet memories of when Picasso had gazed at her own sex with rapt attention, sketching furiously. Just thinking about it caused her stomach to clench.

"Did I ever tell you that Pablo sketched me like that?" she said, inclining her head in the painting's direction. Jacques steepled his hands beneath his chin and waited for her to continue. "Many times, in fact. I still have the sketchbook . . ." She frowned suddenly, forcing her thick eyebrows into a V above her pale-blue eyes. "But that's not how I'll be remembered, is it? No such luck! The bastard made sure I'd be immortalized as a grotesque, sniveling hag—the eternal *Weeping Woman*, that's me," she said, her voice rising in rancorous self-pity. "I'll never be rid of that goddamn image. She follows me wherever I go. Why did he humiliate *me* like that? You know as well as I do that every woman he's ever had cried oceans over him. I wasn't the only one, but I sometimes think that I—I've *become* that freakish woman in his painting."

She met Lacan's gaze and felt it pierce her innermost being. Jacques had been there for her in her darkest hour, and she surrendered herself to him. Nothing else existed in that moment. He'd digested her every word and his gaze enveloped her in a warm cloak of love and acceptance, akin to the comfort she derived from her newfound Catholic faith.

She uncrossed her legs and fidgeted with one of her pearl earrings. "I've been painting again, you know," she

said. "Going out, traveling. Things were going well. But then . . . then . . . he sent me a gift, a horrible, horrible gift," she said, her face crumpling. "I shouldn't have opened it, but I did. You know what that bastard sent me? A ring! Yes, a ring. A ring that only the cruelest heart could conceive." She balanced her cigarette holder clumsily on the ashtray and hunted frantically around in her bag until she found the small handkerchief-wrapped bundle. She dropped it into Lacan's hand as if it were radioactive.

It appeared to Lacan to be a standard signet ring, engraved with the letters *F-D*. "For Dora?" he asked, looking up at her. She nodded morosely. Turning the ring over, he saw that a sharp spike had been soldered to the underside of the ring's flat head. He grasped the ring between his thumb and index finger, held it close to one eye, and peered through it like an eyeglass while Dora silently wept.

Lacan sighed lengthily. "Dora. Dora, my dear," he said, soothing her in his ponderous, halting way. "Your time with Picasso is over. Finished. Life presents us with things we have no control over. It's difficult to accept, but to resist is like . . . like trying to shake chewing gum off the bottom of your shoe. Futile." He leaned forward, becoming more animated. "Do you remember that pet parrot of Pablo's? That bird loved him. But it also shat on him and bit him and made holes in his sweaters. The ring is symbolic of Pablo's struggle between his unconscious desire for you and his need to be free of you. He's

punishing you for his own conflicting feelings. Don't waste one more tear over him, my dear. It's time to stop being that weeping woman, once and for all!" And with that, he sprang out of his chair and extended his hand to Dora, whose eyes had miraculously regained some of their sparkle.

"Now, let's go have lunch," said Lacan. "I'm dying for some caviar, and Sylvia will be delighted to see you. Oh, and you can leave the money on the desk," he added before clattering headlong down the steps, leaving Dora to make her own way to the main farmhouse.

25

Paris, twenty-four years later
Late summer 1981

G randma, are you sure?"

"Yes, my angel," said Sylvia. "I'm fine. I'll see you in the morning."

Lena hesitated, unsure whether to leave her grandmother on her own—it had been only a week since Grandpa Jacques's funeral. But Sylvia tightened the belt of her satin dressing gown around her still-slender waist and gently but firmly ushered her granddaughter to the door.

"I'm fine, darling, really," said Sylvia. "I'm going to bed soon anyway."

That seemed to reassure Lena, especially when she recalled how stoic Sylvia had been throughout her grandfather's intimate funeral. Sylvia had walked resolutely at the head of the small procession that followed the coffin through the streets of Guitrancourt to the village's cemetery. At the graveside, her face had been a mask of control throughout the moving eulogy delivered by Thibaut, Jacques's son from his first marriage. Lena's mother, Laurence, had cried ceaselessly throughout the service, and her aunt Judith, who had taken care of all

the funeral arrangements, had broken down and wept on her husband's shoulder. Apart from the immediate family, only a handful of close friends had been invited. Pointedly absent was Jacques's estranged brother, a man of the cloth. He'd elected to lead a private mass organized by Jacques's first wife at the church of Saint-Francois-de-Sales. In view of Jacques's staunch atheism, Sylvia openly expressed her disapproval, vowing that she would have refused to attend even if her presence had been welcome.

Lena shrugged into her jean jacket.

"OK, Grandma, I'll see you in the morning—I'll pick up some croissants. Call me if you need anything."

For a split second Sylvia saw Laurence standing there, so alike were her daughter and granddaughter. She felt a heaviness descend on her chest. For almost a year, both of her daughters had kept their distance. Apparently, her maternal instincts had been found lacking, time and again. In spite of her best efforts, she'd failed them as a mother, whereas they had found in Jacques a father figure to their liking. Her inability to muster the love and dedication necessary to care for Jacques in his declining years had further exasperated her daughters and confirmed what they saw as her selfishness and heartlessness. Toward the end, it was Judith who had cared for Jacques in the apartment that she shared with her husband, Jacques-Alain.

But what did children know of what passed between their parents? The betrayals, the steady subjugation of

her career in favor of his, the undercutting of her wifely role—was it any wonder that she couldn't bring herself to put up with Jacques's increasingly erratic mood swings or wipe the drool from the corners of his mouth as his health declined? Besides, she wasn't getting any younger herself.

Sylvia kissed Lena good night. As she closed the front door, she felt her body release its pent-up tension. As much as she adored her granddaughter, she hadn't had a moment to herself since Jacques's passing. Gathering up her lighter and cigarettes from the console by the front door, she wandered into the sitting room and curled up on the chaise longue, tucking her feet beneath her. She welcomed the stillness. For four decades, Jacques had loomed large in her life, and it was hard to envision a future without him, despite the fact that they had led very separate lives in the latter part of their marriage. The demands of his seminars, his patients, his television appearances, and his mistresses had left little room for her. Sylvia sat in silence and waited for tears that didn't fall.

Who could have predicted that the mighty Jacques Lacan would breathe his last in a hospital bed, released from his corporeal suffering by a mortal dose of morphine? It was almost anticlimactic when the great man was felled by a mutinous uprising of his own cells. Sylvia had always assumed that he would meet his demise in a high-speed car crash that would engulf his white Mercedes in a fiery ball. Or she'd speculated that the

constant jabs by Freudian diehards would eventually sap the life out of him, like a bull brought to its knees by the repeated thrusts of a matador's spikes. But true to form, he'd left the world cognizant of his own impending death. "I am disappearing . . . ," he'd uttered with his last living breath. Sylvia suddenly realized that she'd outlived both of her husbands, and a single, salty tear trickled down her cheek.

She blew her nose and stubbed out her cigarette. On impulse, she headed for the front door. It was dark outside. No one would see her in her dressing gown, and if they did, *tant pis*. She didn't care. She found the spare key, descended two flights of stairs, stole across the empty cobblestoned courtyard, and, clutching the curved banister, climbed the spiral staircase.

She faltered in front of the glossy black door. It had been years since she had cause to visit Jacques's neighboring apartment at 5 rue de Lille. When she and Jacques had first set up his private clinic there, it was she who had chosen the wallpaper, she who had picked out the couch upon which hundreds of his analysands had reclined and poured their hearts out. But years before, Jacques's devoted secretary, Gloria, had taken over the minutiae of his private and professional life—sending flowers, picking up his tailoring, and proofing his lecture notes. Jacques had even trusted Gloria to schedule trysts with his mistresses in between his heavy patient load and his pedicurist. Gloria's dedication knew no bounds. She mothered him, scolded him, and served

him his afternoon tea just the way he liked it—in his favorite porcelain teacup with two dried dates on the saucer.

Sylvia unlocked the door and crossed the small waiting room scattered about with unmatched chairs. She entered Jacques's study and almost tripped over the hefty black telephone that he liked to keep on the floor, for reasons unknown. She felt around for the desk lamp and switched it on. A warm orange glow suffused the room, illuminating the famous couch and the Napoleon III armchair, whose seat cushion was dimpled with the imprint of Jacque's rear end. African masks hung on the wall beside André's garish painting symbolizing male orgasm. She much preferred André's more muted paintings, like the screen he'd painted to cover up the Courbet painting. What would become of *L'Origine du monde* now? Its destiny lay in her hands, and the thought pleased her.

An acrid smell wafted up from the sodden mass of Culebra cigar butts in the heavy Lalique ashtray that doubled as a paperweight. Beside it, a younger Judith smiled out from a silver frame. A sea of jotted notes littered the desk, and a ping-pong ball covered with undecipherable scribbles sat on the blotting pad, weightless as a butterfly's wing. Moving absently around the desk, she opened the top drawer and gasped audibly. It wasn't the sight of all the crumpled banknotes that shocked her, it was Jacques's willingness to tempt fate. Years before, robbers had burst into his office at the end of the

day and demanded money at gunpoint. In his typical commandeering fashion, Jacques had stood his ground, earning him a solid punch in the face. He'd seemed constantly on edge after that violent episode, and from that time forward he was never without his solid-brass knuckle-duster.

The hundred-franc notes crackled like autumn leaves between Sylvia's fingers. Jacques had always had an ambivalent attitude toward money. He was a believer in the Marxist theory that money would lose all value were it to be stashed instead of circulated, yet he freely indulged his addiction for bespoke shoes, fast cars, and fur-trimmed coats. *He always wanted to have it both ways*, thought Sylvia. She lowered herself onto the dark-green settee and stretched out her legs. She slipped a pillow beneath her head, closed her eyes, and imagined Jacques sitting beside her with an attentive mien, dressed fastidiously in a collarless, button-up shirt, his glasses sliding down his nose. It was hard to resurrect the intimacy they once shared. What would she say to him now?

Sylvia awoke several hours later, feeling surprisingly refreshed and unburdened. Dawn was breaking and Paris was stirring. She made her way back across the courtyard to her own apartment. Puttering around the kitchen, she made herself a demitasse of espresso and sipped it through a sugar cube gripped between her front teeth. The kitchen table was piled with newspapers and mail that had accumulated since Jacques's admission into the

hospital. A telegram on the top of the pile conveyed the Ministry of Culture's deepest sympathies in punctuated, staccato sentences. The front pages of *Le Quotidien, Le Monde, L'Humanité* and *Libération* announced the passing of Jacques Lacan, each newspaper saluting the "great contemporary thinker" and "psychoanalytic renegade." One newspaper even rehashed his fabled act of rebellion in 1968, when he'd smuggled the leader of the student uprising out of the country in his Jaguar. Other articles, however, focused on his eccentricities and went as far as to call him a charlatan. Those she ripped into shreds.

She turned her attention to the pile of letters. Those addressed to Jacques from professional institutions she would hand over to Judith's husband, Jacques-Alain, whom Jacques had appointed as executor of his intellectual property. The rest of the mail consisted of condolence letters, bills, a note from Jacques's lawyer, and invitations to gallery openings and theater productions. Near the bottom of the pile was a thin blue envelope sent from the United States of America and addressed to Madame Sylvia Bataille. The name, Linda Nochlin, in the upper-left corner did not sound familiar. Sylvia slit the envelope open with her sharp lacquered thumbnail.

> *Dear Madame Bataille,*
> *Please allow me to introduce myself. My name is Linda Nochlin. I am an art historian whose area of expertise is the great realist painter Gustave Courbet.*

I attended the New York University's Institute of Fine Arts, and it may interest you to know that the subject of my doctoral thesis was Gustave Courbet's radical portrayal of women from the lower classes of society. I have since published multiple essays and research papers on his oeuvre, written from a feminist perspective.

My colleague Sarah Faunce and I are planning a major retrospective exhibition of Gustave Courbet's work at the Brooklyn Museum. Confidential sources have suggested that you may have information pertaining to the whereabouts of Courbet's most intriguing and elusive painting, L'Origine du monde. A painted copy of the work, attributed to the late Belgian artist Magritte, has recently appeared in a published text on the history of eroticism. The circumstances of the copy itself are a mystery considering that Courbet's original painting has never been seen in public and its whereabouts are unknown.

I have been chasing the painting's trail for many years without success. This is not my first attempt at contacting you, but I continue to hope that you will grant

*me an interview to discuss this matter. It
is my sincerest wish to locate the painting
so that it can take its rightful place in this
historic retrospective.*

*I eagerly await your response and
remain yours sincerely,*
Linda Nochlin

Sylvia removed her reading glasses and stared into
space. It was quite possible that the American had
indeed contacted her and that in all probability, she'd
ignored those calls or letters. She didn't welcome intru-
sions into her privacy and would certainly never have
agreed to speak with a stranger about *L'Origine.* Jacques
would never have allowed it—he'd been as possessive of
the painting as he was of all of his women. But that name,
Nochlin . . . A memory wafted up. Hadn't *Mademoiselle*
magazine named this Linda Nochlin Woman of the
Year? Something to do with her crusade to get more
women artists into museums.

The timing of Ms. Nochlin's request was uncanny.
Sylvia liked the idea of involving women in *L'Origine*'s
future—the painting really belonged to women rather
than the handful of male collectors who had selfishly
kept it for themselves, and in whose hands Sylvia sus-
pected it had been variously used and abused. She'd had
numerous discussions with Jacques about *L'Origine* but
always sensed that he regarded it as a psychoanalytic
puzzle, a delectable and naughty accessory. After living

with the painting for close to thirty years, Sylvia was curious to hear fresh impressions and interpretations, but it would have to be on her terms.

It was too soon to make any decisions, however. She folded the letter and placed it in the pocket of her dressing gown before getting stiffly up from the chair. *One day at a time,* she told herself. For now, she needed a bath and to get dressed before Lena returned with the breakfast croissants.

26

Paris, twelve years later
Winter 1993

The empty room hummed with the hushed vibrations of murmured condolences. Someone had brought a *buche de noel*, thinking that a touch of Christmas would bring some comfort, but the cream-filled log sat mostly untouched on its tray on the low coffee table. Dirty wineglasses were scattered about, some with lipstick stains on the rim and others still half-full. Judith hesitated before lowering herself into the Louis XVI armchair, where her mother had spent most of her days in the months leading up to her death. She noticed that the armrests were mildly stained, and she chose to fold her hands in her lap.

Feeling suddenly vulnerable and alone, Judith drew her cardigan around her narrow shoulders. She regretted having told her husband to go on home without her, and she wished that Laurence were still alive—at least then, she and her sister could have comforted one another. As a psychoanalyst, Judith had ferried countless patients through the mourning process, but that didn't mitigate her own painful loss. Her mother's death created an unexpected void in her life. Despite their

fractious relationship, Judith felt almost dizzy with longing. Overcoming her grief would take time. Lots of time, as she told her patients. She knew that the greatest challenge—as her father had so wisely articulated—was accepting that what had once existed, existed no longer.

Ironically, she and her husband had ensured that her father would live on in theoretical perpetuity. Since his death, they'd worked tirelessly to preserve and disseminate Jacques Lacan's psychoanalytic discourses. It was up to Judith to fulfill the same filial duty of perpetuating her mother's legacy—whatever that may be. None of the obituaries published in the major newspapers had veered from the stale, rehashed story of her mother's life: the young starlet; wife of the surrealist writer, Georges Bataille; and later, wife of the famous psychoanalyst, Jacques Lacan. Not one had succeeded in painting a picture of the resilient and independent woman who had raised her. Resting her head on the upholstered seat back, Judith closed her eyes. She turned her face and buried her nose in the cream-colored upholstery, inhaling any lingering notes of Nina Ricci L'Air du Temps, the scent that had announced her mother's presence for as long as Judith could remember.

At length, she opened her eyes, and the room came slowly into focus. Nothing much had changed since her childhood days. Uncle André's umber-colored screen had returned to its spot above the fireplace, its loosely defined lines etching out a hilly feminine landscape dotted with scraggly vegetation. She could still

remember the proud look on her uncle's face when he'd first unveiled his painting. How disappointed she'd been! She could make no sense of it at the time—not until her mother had gently taken ahold of her finger and guided it over the hills and valleys that mimicked the model's contours in the hidden painting beneath.

Not long after her father passed away, in a move that Judith thought inappropriately swift, her mother had removed the painting from his study at the country house and brought it back to Paris. Even though Jacques had monopolized the painting, her mother made no bones about the fact that she thought of *L'Origine* as hers. Judith never really understood why her mother felt such kinship with a painting that was so defiantly libidinous. Laurence used to say that their mother had been a feminist before the term was even coined. Sylvia had given her and Laurence each a copy of Simone de Beauvoir's *The Second Sex* when they turned fifteen and had brought them up to take pride in being independent young women. And when French women took to the streets to demand abortion rights and affordable birth control, Sylvia had clenched her wrinkled fist at the television set and cheered them on from her armchair.

Moving aside the wineglasses and ashtrays on the mantelpiece, Judith grasped the left side of André's frame and gave a familiar tug. It detached smoothly from the other three sides, allowing her to slide her uncle's painted screen out to reveal the Courbet. In the dim light, the model's creamy skin appeared to glow

with an inner light, and the dark pubic mass was even more suggestive than she remembered. Courbet's talent as a painter was undeniable, but her appreciation went only so far. From a clinician's point of view, she was more interested in what had possessed him to paint such a thing in the first place.

Sylvia had been insistent about keeping *L'Origine* under wraps—not to protect an innocent world from its shocking content (she had no illusions about that) but to protect *it* from the *world*. On more than one occasion, Judith had caught her mother flatly denying the rumors that she was the owner of a scandalous painting by Gustave Courbet. Whatever the reason for her mother's attachment to the painting, Judith knew that her mother's wish was for it to remain in the family. She let out a long sigh. Being a dutiful daughter had its price. She'd already spent ten years embroiled in a legal battle over her father's last will and testament. Jacques had named her and her husband sole beneficiaries of his estate, but the surviving children from his first marriage had actively contested the will on the grounds that they carried the Lacan name and were therefore the legitimate heirs.

There seemed no end in sight to the unpleasant court battles. At stake were multiple bank accounts, gold ingots, Parisian apartments, priceless works of art, and a library of rare books. But for Judith, it wasn't about the money. It was the principle—betraying the will of the departed was tantamount to attacking someone's honor.

She couldn't allow that to happen. Similarly, she would do her best to shield *L'Origine du monde*, although it was getting increasingly difficult to conceal its existence. The mystery surrounding the phantom painting's where-abouts had taken on mythic proportions. Speculation had grown after her mother had uncharacteristically agreed to lend it out—albeit on condition of strict anonymity—for a Courbet retrospective at the Brooklyn Museum in the United States. Judith had strongly advised against it, but the museum's curator had petitioned her mother relentlessly until she finally agreed.

The exhibition across the Atlantic had surprisingly met with little fanfare, and judging by her mother's elation at having the painting returned safely, Judith assumed that its traveling days were over. But two years before, Sylvia had once again loaned the painting out—that time, on French soil. The director of the modest Gustave Courbet Museum, in the artist's hometown of Ornans, had secretly contacted Sylvia and negotiated the inclusion of *L'Origine* in a retrospective of André Masson's erotic works. The museum displayed *L'Origine du monde* in its own darkened room behind thick protective glass and dramatically lit by a single spotlight. The staff hadn't planned for the fever pitch of excitement that this single work would generate. After narrowly avoiding a stampede, the museum was forced to limit each visitor to a seven-second time frame. As word spread, a cavalcade of journalists from major newspapers and

art publications made their way up north to the sleepy village of Ornans.

Their inflammatory descriptions of Courbet's painting alerted the nation of its existence. The public was bombarded with an onslaught of radio and television programs about a scandalous painting that had been hidden from view for close to a century and a half. Rumors swirled. Unconfirmed reports claimed it belonged to an anonymous Japanese collector, while others swore that the painting was owned by an eccentric Californian recluse.

The museum, respecting Sylvia's wishes, stayed mum in the face of persistent questioning. Jacques Henric, the outspoken art critic, took up the cause, heatedly denouncing foreign ownership of one of the most important French masterpieces ever created. He agitated for the return to French soil of "the most sensational cunt in the world, the supreme, ultimate hole." Fired by a sense of patriotic duty, public support mounted, and authorities responded by alerting border police to be on the lookout for anyone attempting to spirit the painting across the border. The hunt was on.

It was only a matter of time until they came knocking on the door, thought Judith. Overcome by a numbing fatigue, she called Jacques-Alain to tell him she was too tired to drive home and would be sleeping at her mother's. With considerable effort, she loaded stray wineglasses onto a tray and made her way to the kitchen, surprised for a moment to find her mother absent.

27

The black Citroën sedan transporting the French minister of culture eased smoothly into the traffic circling the Place de la Concorde. The small tricolor flag attached to the hood flapped about gaily. It was one of those early-summer days that bathed Paris in glorious splendor. The tip of the obelisk in the center of the expansive plaza blazed brilliantly in the sunshine, and the chestnut trees that lined the boulevards were in full bloom. The minister would have preferred to spend such a magnificent day attending an event less fraught with political stumbling blocks than the one awaiting him at the Orsay Museum. But he'd chosen a life in politics and it came with the territory.

With his reading glasses propped on the tip of his nose, he reviewed his notes, emphatically crossing out a line and scribbling a few illegible words in the margin. Beside him, his wife was peering into a silver-plated hand mirror, applying another coat of lipstick and making little smacking noises with her lips. He glanced her way and approved of what he saw. Emmeline's sleek, dark hair contrasted nicely against her white Dior suit.

They'd discussed her wardrobe at length and decided that a virginal look would help offset the controversial occasion.

The car slowed and came to a halt on the quai Voltaire. The minister folded his glasses and slipped them into the inside pocket of his slim-fitting peacock-blue jacket. He adjusted his tie and patted his well-coiffed head. He'd spent many hours at the Musée d'Orsay as a private citizen, but on that day, he would be executing his duty as the republic's minister of culture. He set a ministerial smile upon his face before exiting the car and reaching for his wife's hand as the first of her high-heels touched the curb. She gave his hand an intimate squeeze.

Since it was Monday, the museum was closed to the public. Normally packed with visitors waiting in line to purchase tickets, the statue-dotted plaza in front of the museum was relatively empty save for a cluster of local and international press on the lookout for the arrival of officials and dignitaries. The minister greeted them cordially as he and his wife walked toward the posse of upper-echelon museum personnel eagerly awaiting them at the museum's main entrance. The museum's director approached with a broad smile, closely trailed by the chief curator, who wore an equally ecstatic expression on her face. Both women had fought long and hard for this day, and they were understandably proud that their efforts had resulted in a prestigious coup for the museum.

"Monsieur le Ministre!" exclaimed the director, grazing the minister's cheeks with her own before greeting his wife in like fashion. "What an auspicious day. If you'll follow me, I'll introduce you to our protocol officer, who will walk you through the morning's agenda."

While the minister and his wife were hustled off to the administrative offices, the hundred or so invited guests drank cocktails among the sensuous sculptures in the museum's towering atrium. France's cultural elite mingled with scruffier, up-and-coming artists making the best of the networking opportunity. Two uniformed guards stood on either side of a red cordon at the entrance to the Courbet galleries to keep the crowd at bay. Standing off to the side, Jacques-Alain Miller discreetly placed his arm around Judith's waist. Her mood was constrained as she looked at the buzzing crowd. Unlike the guests who were there to welcome the museum's new acquisition, Gustave Courbet's *L'Origine du monde*, Judith was there to bid it farewell.

At the allotted hour, the director and her entourage approached, click-clacking their way across the museum's parquet floor. The excitement was palpable. The guards unlatched the cordon and the crowd moved en masse. Most of the guests were devotees of Gustave Courbet, but even the detractors among them held a grudging respect for the *enfant terrible*. Dozens of pairs of eyes scanned the walls of the gallery, skipping over his more familiar works in search of the star of the day's event. People pushed and shoved, and when the painting

came into view, the crowd responded as if an electric current had passed through it.

The honorable minister of culture had been asked to wait in the wings until the initial frenzy passed before being called upon to make his appearance. From the crescendo of exclamations that reached his ears, he deduced that the painting had been discovered. He recalled his own wonderment upon seeing *L'Origine* for the first time several months earlier. It had been at a private viewing by invitation of the Committee of National Museums. At the time, the painting was the subject of complex and secret negotiations between the heirs of Sylvia Bataille and Jacques Lacan and the Ministry of Finance. Although litigation over Jacques Lacan's estate had finally been resolved in the courts, there remained the matter of the substantial inheritance tax owed to the state. The Ministry of Finance had presented the heirs with a solution to their financial obligations in the form of *dation en paiement*, a "donation" in kind: Gustave Courbet's *L'Origine du monde* in lieu of taxes owed.

And so, like a sacrificial lamb at the altar of France's modern-day tax code, the legendary painting changed hands for the last time. Its assessed value was never divulged. After the parties agreed to the terms, the infighting between the major museums for custody of *L'Origine du monde* began in earnest. The Musée d'Orsay won the day.

The minister of culture was present at the Orsay on that sunny Monday morning to officially inaugurate the

painting into the museum's collection. He would have to walk a fine line. Before being appointed as a cabinet minister, he'd been the mayor of the town of Lourdes, where the faithful believed that the Blessed Virgin Mary had appeared before a tenderhearted peasant girl and performed miracles. The legend brought millions of Catholic faithful to Lourdes for an annual pilgrimage, and the minister could not afford to lose the support of his former constituents who lived their lives in accordance with strict Christian morals. It was an unfortunate coincidence that the appearance of the Virgin Mary in Lourdes had allegedly occurred in the same year that Gustave Courbet completed his salacious little painting.

The minister was in a quandary. Being photographed beside the painting of a woman's genitals would simply not do, but as the minister of culture, he was obligated to embrace the highly anticipated public debut of a painting created by one of France's most famous native sons.

It was decided that the small podium for the inaugural event would be placed against the wall opposite *L'Origine* so as to prevent the minister's image appearing in the same frame as the offending painting. It was all a matter of optics. When it was his turn at the podium, the minister delivered a fitting tribute to the painting while diplomatically avoiding any direct mention of its ribald subject.

The following morning, while having coffee and croissants with his wife, the minister scoured the stack of newspapers—*Le Figaro, Le Nouvel Observateur,*

L'Humanité, France-Soir, Info-Matin, and *Le Monde.* After verifying that there were no potentially damaging photographs, he breathed a sigh of relief and sat back to read the varying opinion pieces and critiques. Some publishers had taken the bold decision to splash a photo of *L'Origine* across their front pages. Others limited themselves to colorful descriptions and spicy comments. Though the media questioned the harmful effects a painting of a woman's exposed genitals might have on minors and those possessing a "sensitive soul," the general consensus was that the painting deserved its place of honor in one of France's most illustrious museums. Gustave Courbet's celebrity was sealed for eternity.

28

Claude Moreau swallowed a yawn. He checked his wristwatch and was disheartened to see that he still had two and a half hours left until the end of his shift. He rolled his neck first to one side, then the other. People had no idea how mind-numbing and physically taxing his job was. If the public ever gave museum guards a second thought, they probably assumed that they wandered around the museum all day long and got paid for doing nothing. Sometimes he swore he was invisible, the way some people pushed rudely by or carried on intimate conversations while he was within earshot.

He hadn't always worked as a museum guard. He'd apprenticed as a carpenter in Lille, where he was born. "Hands of gold," his mother used to brag. But then one day he caught his pinkie in a band saw and that was that. He had nine fingers left, and he wasn't about to risk losing any more. He went to work for the local municipality, where he met his wife, Sandrine. They moved to Paris after the birth of their second child, and it was Sandrine who encouraged Claude to apply for the

security guard position that her cousin, a janitor at the Orsay Museum, had told her about. It would be eighteen years next month. A good eighteen years in all and only two more until retirement, unless the damned government raised the national retirement age to a whopping fifty-eight! A national strike was in the works, and that always put a stop to those unpatriotic and despotic ideas quick-smart, but still, what was the country coming to?

The hard wooden chair was making his buttocks ache, and his feet were beginning to swell. He decided to sit for another few minutes before making the rounds but had to spring up a moment later to issue the sonorous warning he'd perfected over the years.

"*Pas de flash, s'il vous plait!* No flash!"

The culprit, a young woman, turned in his direction and reddened. She wasn't embarrassed at having broken the first cardinal rule of museums, but rather for getting caught photographing the scandalous *L'Origine du monde.* Claude saw that same guilty look at least twenty times a day whenever he worked this shift.

When the staff traded stories at the end of the day, the most entertaining anecdotes usually came out of the Courbet galleries. It was one of the security staff's favorite zones, never a dull moment and always bustling with visitors. Claude had stories galore. Like that creepy dude back in the late nineties. He could still remember the guy's face—thin, with a narrow blond mustache and glasses with dark frames and thick lenses. Always wore a beige raincoat, no matter the weather. The guy would

arrive at the museum every day at the same time, head straight for *L'Origine du monde*, and park himself in front of the painting, his nose about a centimeter away. Same thing day after day. It was disturbing. Claude was the one who eventually sounded the alarm. Mister Raincoat was banned from the museum, and Claude received a pat on the back from the head of security.

Ever since the raincoat incident, Claude had felt protective of *L'Origine*, especially after his eldest daughter had given birth. But *L'Origine du monde* wasn't his favorite Courbet. That would be a toss-up between the mottled trout (he had fond memories of Sunday fishing with his father at the base de Loisirs), and the immense *Burial at Ornans*, whose fifty or more somber funeral attendees had become as familiar as family. Nowadays, *L'Origine* was protected by a thick sheet of nonreflective glass and a cordon that kept visitors at a safe distance. Nonetheless, Claude had to remain vigilant—like *now*.

"Monsieur, please stay behind the cordon," said Claude admonishingly. He'd heard about men trying to kiss or even lick the painting, and he wasn't going to have any of that on his watch.

A gaggle of students entered the gallery like a single unruly organism, and the room filled with shrieks and giggles despite the teacher's attempts to impose order. A stricken American family inadvertently wandered in and gaped at the painting in horror. He never could understand the prudishness of the American visitors. But it was all par for the course. The multilingual visitors that

passed through tended to blend into one another. Every
now and then there was a welcome break in routine. Like
that cute copyist. He'd been sitting in that very same
chair some years back when a petite beret-clad woman
of a certain age clattered into the room in high-heeled
boots, dragging a museum-issued easel behind her and
toting a paint-flecked stool and a massive backpack over
her shoulders. A *copiste*, he'd concluded, although she
looked painfully self-conscious. He remembered his surprise
when she set up her gear in front of *L'Origine du monde*.
No wonder she looked terrified. There had been a num-
ber of artists over the years who'd made decent copies
of Courbet's luminescent limestone cliffs at Étretat, but
none so far had attempted to copy *L'Origine*.

Over the next two months, he kept track of her prog-
ress. The *copiste*, he noted, had taken to wearing more
sensible shoes and seemed to have grown more comfort-
able despite being a magnet for curious—mostly male—
onlookers. He would have liked to ask her why she'd
chosen to copy *L'Origine*, but it wasn't his place to ask.
As the weeks went by, they exchanged friendly nods and
he encouraged her with muted gestures. He happened
to be on duty the day that she placed the final high-
light. She'd produced a remarkable likeness to the orig-
inal, and when she cocked her head at him for approval,
he'd risen out of his chair and mimed a "Bravo!" What
became of her he would never know, and no one since
had attempted to follow suit.

Claude looked at his watch again. It was time to switch places with the rookie guard, Layla Mansour, whose turn it was to take a load off her feet. He had nothing against Layla. She seemed sweet enough and spoke French like a native, but he missed the old-timers. He pulled the jacket of his uniform down over his paunch (the food in the museum cafeteria was far too tempting) and went to trade places with Layla. He stationed himself at the entrance to the gallery, where he would no doubt spend the rest of his shift directing lost visitors to their destinations like a traffic cop.

Suddenly, he heard a loud commotion coming from the inner gallery. Against a background of cheering and dog whistles, he could make out Layla's voice raised in panic. Claude extracted his walkie-talkie from his back pocket and hurtled toward the disturbance with the determination of a soldier on the front lines. *Nom de dieu!* What in the name of . . . ? There on the floor directly in front of *L'Origine du monde* sat a pretty young woman facing the crowd, her bare legs parted wide and not a stitch of clothing beneath her sleeveless gold-sequined dress. Her hands were between her legs, parting the lips of her vagina in a reenactment of the painting behind her. Layla was trying desperately to shield the outrageous spectacle with her body. To his credit, Claude faltered for only an instant before bulldozing his way through the excited Instagram-snapping spectators.

"Mademoiselle!" said Claude, addressing the young woman on the floor with as much authority as he could

muster. "Get up immediately! Show some respect for the museum!" But she took no notice and merely recited, trancelike, the same few lines over and over:

Je suis l'origine
Je suis toutes les femmes . . .

I am the origin
I am all women . . .

Claude called for backup as he and Layla began herding the rubberneckers out of the gallery. A police-woman arrived on the scene, and the Luxembourgian performance artist was eventually escorted away. It was all over the internet within a matter of seconds, and the museum was none too pleased by the artist's publicity stunt. As loyal as Claude was to his place of employment, he looked forward to sharing this doozy of a tale with his friends when they met up on Saturday for their regular game of *boules*.

EPILOGUE

Musée d'Orsay
June 2019

Hello, old friend. Remember me? The copyist. It's been nearly a decade, and you haven't aged a bit. If anything, you look better than ever. I was passing through and wanted to see how you were doing. I couldn't find you at first. They've moved you to a larger space—I suppose that smaller room just couldn't accommodate all your admirers. Over a million a year! Could you ever have imagined your fate? Ending up in one of the most famous museums in the world, a world almost unrecognizable to the one that ushered you into existence.

It must be a relief to finally have a permanent home where you don't have to hide behind a curtain or be stifled behind a screen. But perhaps that's a curse rather than a relief. Parading you in front of millions of curious onlookers was not, after all, Gustave's original intent—you were painted for an audience of one, as you well know. Nowadays, people stare at you with impunity all day long, and, as beautiful as you are, there were times I wanted to cover you up, just to give you a break.

I learned a lot during our time together, not the least of which was to take pride in my body and to trust in my feminine powers—derived in large part from the fact that we women hold the key to the secret of creation. You taught me to be fearless in my art and to follow my heart. And you proved to me once again that art speaks a universal language.

Gratefully yours,
Lilianne

AUTHOR'S NOTE

L'Origine du monde did not loosen its grip once I returned home with my copy. With the frenzy of the copying experience behind me, I was left with a host of unanswered questions about the painting's genesis and the mysterious gaps in its provenance. Over the course of the next decade, I discovered a secret past as extraordinary as the painting's flagrant nakedness. I am indebted to the scores of books and the hundreds of internet sites that helped me piece together L'Origine du monde's story. This book would not have been possible without the painstaking and fastidious research undertaken by countless historians and academics.

L'Origine is a work of fiction based on the true story of the painting's astonishing and sometimes harrowing

journey through the centuries and across continents. Some of the characters and events are fictionalized in order to enhance the arc of the story.

Dear Reader,

If you enjoyed this book please leave a review to help new readers discover L'Origine.

To see more of my art and watch a short video of me painting at the Orsay Museum, visit www.liliannemilgrom.com.

Thank you,

Lilianne

To find out more about the author and watch the book trailer visit www.littlefrenchgirlpress.com.

ACKNOWLEDGMENTS

The French have a saying, *"On a besoin des autres pour avancer."* Loosely translated: "One doesn't get ahead on one's own." This book would not have been possible without the support and encouragement of family, friends, and colleagues over the ten years that this project took to come to fruition. First and foremost, my husband, Alan Merbaum, and my two grown children, Bianca and Anton, have to be congratulated for their unflinching support and for tolerating my obsession with a painting of a woman's genitals. It can't have been easy to hear one's wife or mother carry on incessantly about vaginas—or to be more exact, one particularly famous one perched on a wall in the Musée d'Orsay in Paris. I remain eternally grateful to the copyist department at the Orsay Museum for allowing me the opportunity to copy Gustave Courbet's *L'Origine du monde.*

It set me on a trajectory I was totally unprepared for, but ultimately embraced with open arms. Special thanks also to Magdalena Groszek for facilitating my extended stay in Paris. I want to acknowledge those cheerleaders who gave me the validation I needed to keep going along the way—some of you may not even realize just how much your words of encouragement fortified me: Yael Braverman, Chris Wilson, Paula Wilson, Richard Edelstein, Ruth Jacoby, William Wright, Sharon Victor, Alivia Tagliaferri, Rachelle Unreich, Ed Bull, Véronique Teboul-Bonnet, Donna Bechar, Lynn Goldstein, Irit Rosenberg, Malaga Baldi, Karen Anisfeld, Paige Lawson, Joan Dempsey, and the late scholar, Marion Deshmukh. To my faithful manuscript readers, Alfred Milgrom, Alan Merbaum, Bianca Merbaum, and Saúl Sosnowski: words cannot express how grateful I am for your investment in my burning desire to get this story out there. Having you there meant that I was not howling into the wind. My residency at the Virginia Center for the Creative Arts in Auvillar, France, was a turning point in my writing. How fortunate to be given the space and time to dedicate one's entire being to one's dream. There, in Auvillar, I also met Daniel Azuelos, whose ongoing patience and diligence in translating *L'Origine* into French know no bounds.

Thank you to the Gustave Courbet Institute in Ornans, France, who allowed me into their inner sanctum to wander among their precious repository of archived books, documents, and memorabilia. Another

high point in my research was gaining access to the archives at the University of Maryland, which possesses a treasure trove of original letters written by Gustave Courbet. My eyes filled with tears the first time I caressed the fragile paper covered with his gestural, urgent handwriting. Last but not least, a huge heartfelt thanks to the team at Girl Friday Productions, who held my hand throughout the painstaking publishing process and never let go. Not even once. A very special thanks to my editor, Erin Cusick, for her superb and exhaustive attention to detail.

But almost as terrifying as sending this labor of love out into the world is the prospect of having forgotten to acknowledge someone deserving of my thanks. I beg your forgiveness in advance.

BOOK CLUB DISCUSSION TOPICS

1. If you are a female reader, how has this book impacted the way you think about your body, or conversely, if you are a male reader, has this book changed the way you regard a woman's body, in particular, her genitals?

2. There are deep sexual, religious, sociological, and psychological factors in Western culture that have historically contributed to our conflicted emotions regarding female genitalia and, in particular, their public display. What, in your opinion, is the most influential contributor?

3. For the female reader—can you see yourself undertaking to copy *L'Origine du monde* in public? For the male reader—what might have been your reaction to coming across a woman copying the painting at the Orsay Museum?

4. Do you think the painting is beautiful? Racy? Boring? How would you describe it?

5. How do you think Gustave Courbet would react if he were to come back to life and see the fuss made over his painting?

6. Do you think there was any merit to the author's exercise in copying the painting? Did you gain any insights into the process of painting?

7. Which owner in *L'Origine*'s long history do you think treated the painting with the most, and the least, amount of respect?

8. What do you think truly motivated Gustave Courbet to paint *L'Origine*? Hundreds of contemporary artists around the globe have been inspired to re-create the painting or to create their own interpretive versions. Why do you think *L'Origine du monde* is still so relevant?

9. The author has openly admitted to her obsession with Gustave Courbet. Based on the author's depiction, does the artist deserve to be canonized?

10. Have you ever been powerfully moved by a work of art? What drew you to it? How did it make you feel?

11. What is the difference between a painting of a vagina and a woman baring her vagina in the museum? What is so shocking about each? Is it possible, or even desirable, for people to lose their shock and arousal at the sight of the human genitals?

12. The public "coming out" of *L'Origine* interestingly coincides with the sexual revolution and the struggles

women continue to face in this #MeToo era. Some bloggers have been outright antagonistic about Courbet's painting from a feminist perspective. Do you think it's fair to judge a nineteenth-century painting—or any artwork—out of context?

13. Has the book inspired you to visit the painting in person (if you haven't done so already)? Do you think it belongs in a world-famous museum?

RECOMMENDED READING

To those readers for whom this book merely whet their appetites for more, the following list represents a small selection of texts that enlightened and inspired me throughout my writing journey.

Chastre, Lucile. *Courbet l'anticonformiste*. Paris: Oskar, 2010.

De Goncourt, Edmond and Jules de Goncourt. *Pages from the Goncourt Journals*. Translated by Robert Baldick. New York: The New York Review of Books, 2006.

Easton, Malcolm. *Artists and Writers in Paris*. London: Edward Arnold, 1964.

Lindsay, Jack. *Gustave Courbet: His Life and Art*. England: Harper & Row, 1973.

Mack, Gerstle. *Gustave Courbet*. New York: Da Capo Press, 1951.

Musée Courbet. *Cet obscur objet de désirs: Autour de L'Origine du monde.* Catalogue of Musée Courbet. Paris: Lienart, 2014.

Nochlin, Linda. *Courbet.* New York: Thames & Hudson, 2007.

Ragon, Michel. *Gustave Courbet: Peintre de la liberté.* Paris: Librairie Arthème Fayard, 2004.

Rey, Pierre. *Une saison chez Lacan.* Paris: Robert Laffont, 1989.

Savatier, Thierry. *L'Origine du monde.* Paris: Bartillat, 2009.

Schopp, Claude. *L'Origine du monde: Vie du modèle.* Paris: Phébus, 2018.

Ten-Doesschate Chu, Petra, ed. and trans. *Letters of Gustave Courbet.* Chicago: The University of Chicago Press, 1992.

Teyssèdre, Bernard. *Le roman de l'Origine.* Paris: Gallimard, 1996.

Wolf, Naomi. *Vagina: A New Biography.* New York: HarperCollins, 2012.

ABOUT THE AUTHOR

Internationally acclaimed artist Lilianne Milgrom was born in Paris, grew up in Australia, and currently resides in the United States. Milgrom holds two degrees from Melbourne University and an associate art degree from the Academy of Art in San Francisco. She exhibits her artwork around the world and is the recipient of multiple awards. In 2011, she became the first authorized copyist of Gustave Courbet's controversial painting *L'Origine du Monde* (*The Origin of the World*), which hangs in the Orsay Museum in Paris and

draws over a million visitors a year. After rendering a near-identical copy of Courbet's masterpiece, she spent close to a decade researching and writing *L'Origine*. She lives in the greater Washington, DC, area with her husband while her grown children explore the world. *L'Origine* is her first book.